THE WORLD'S GREATEST
WAR CARTOONISTS
AND
CARICATURISTS
1792-1945

THE WORLD'S GREATEST
WAR CARTOONISTS
AND
CARICATURISTS
1792-1945

MARK BRYANT

GRUB STREET • LONDON

FOR MY WIFE, VENITA

Published by
Grub Street
4 Rainham Close
London
SW11 6SS

British Library Cataloguing in Publication Data
Bryant, Mark, 1953-
 The world's greatest war cartoonists, 1792-1945 : an A-Z.
 1. Cartoonists—Biography. 2. War—Caricatures and
 cartoons—History—19th century. 3. War—Caricatures and
 cartoons—History—20th century. 4. War—Caricatures and
 cartoons—History—18th century. 5. Political cartoons—
 History—19th century. 6. Political cartoons—History—
 20th century. 7. Political cartoons—History—18th
 century.
 I. Title
 741.5'3581-dc22
 ISBN-13: 9781908117083

Cover design and formatting by Sarah Driver
Edited by Sophie Campbell

Printed and bound in Slovenia

Grub Street Publishing only uses FSC (Forest Stewardship Council) paper for its books

CAPTIONS FOR FRONT COVER:
Top L to R: A Wellington Boot, or The <u>Head</u> of the <u>Army</u>, William Heath (Paul Pry), 1827; The Corsican and
His Bloodhounds at the Window of the Tuileries Looking Over Paris, Thomas Rowlandson, 16 April 1815; Fascism
Equals Conquering Peace and Serfdom for the People. The Red Army Equals an Amendment to the Situation
(detail). Victor Denisov (Deni) Soviet poster, 1943
Bottom L to R: True Portrait of the Conqueror, Johann Michael Voltz, 1814; The English Claw, Jean-Emmanuel
D'Aurian, 1899; The Blood Harvest of 1870, Faustin Betbeder, 1871
CAPTION FOR BACK COVER:
The Empress of China's Dream, Thomas Theodor Heine, *Simplicissimus* (Munich) 1900

ACKNOWLEDGEMENTS

As more than seventy years have elapsed since the first publication of the cartoons and caricatures in this book (or the death of their artists) most are now out of copyright under international law. With regard to the rest, the Publisher and Author have made every effort to trace the copyright holders. However, as a great many of the publications involved have long since ceased to exist, and very little is known about many of the artists, it has not been possible to contact all the parties involved. Advice on omissions would be greatly appreciated and any further acknowledgements will be included in future editions. Meanwhile the Author and Publisher would like to thank Park Art for supplying the images in this book and also the following companies and publications for the cartoons listed below:

Akbaba 33
Bystander 142
Cape Times 115
Careta 32
Chicago Daily News 30
Civil & Military Gazette 123
Daily Graphic 177
Daily Mail 91
De Amsterdammer 29
De Nieuwe Amsterdammer 173
De Notenkraker 82
Der Stürmer 152
Die Brennessel 136
Die Pleite 80
Evening Standard 61
Frank Leslie's Illustrated Newspaper 18
Fun 122, 168
Harper's Weekly 125
Iberia 60

Il 420 34
John Bull 92
Judge 83
Judy 28
Jugend 156, 182
Karikatür 75
Kladderadatsch 15, 31, 145
La Baïonnette 120, 150
La Caricature 13, 72, 146
La Charge 110
La Guerre Sociale 89, 94
La Reforme 99
L'Asino 70
L'Assiette au Beurre 56
Le Charivari 51, 116
L'Eclipse 73
L'Esquella de la Torratxa 65
L'Illustré Soleil du Dimanche 106
Le Journal 67, 78, 109, 183
Le Mot 95

Le Rire 106, 139
Le Rire Rouge 63, 105
Liverpool Courier 42
London Opinion 185
L'Opinion 68
Lustige Blätter 99
Manga 100
Miau! 46
Mucha 128, 129
Nebelspalter 27, 110
New York Evening Sun 36
New Zealand Observer 25
Numero 20, 41
Puck 79
Punch 69, 107, 153, 165, 170
Simplicissimus 14, 88, 156, 158
The Veldt 26
Vanity Fair 135, 179

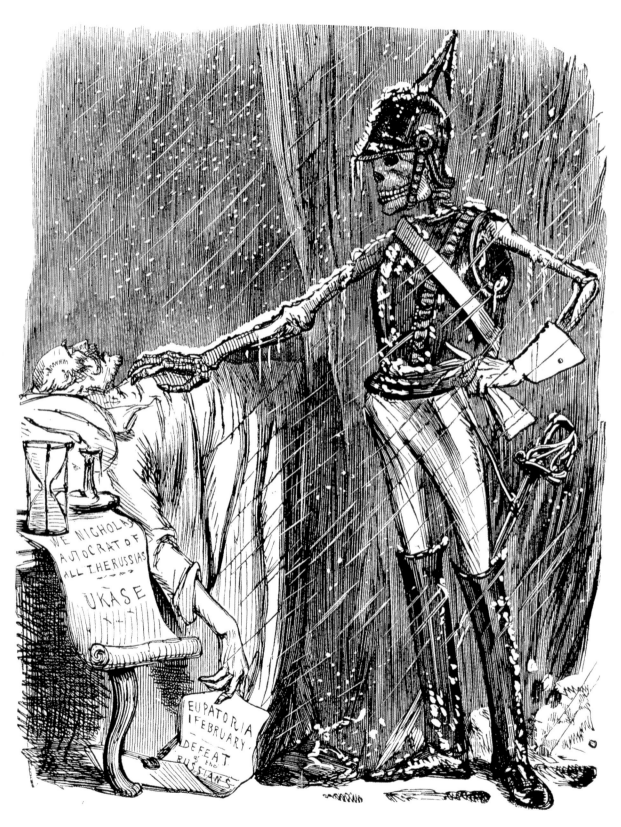

'GENERAL FÉVRIER' TURNED TRAITOR

John Leech, *Punch*, 10 March 1855

PREFACE

This is the first ever biographical dictionary specifically devoted to international wartime cartoonists and carica-turists. Though modelled in part on two earlier books, *Dictionary of British Cartoonists and Caricaturists, 1730-1980* and *Dictionary of 20th Century British Cartoonists and Caricaturists*, it is broader in scope yet less academically focused than these, and is primarily intended as a companion volume to my series of four pictorial wartime histories, *Napoleonic Wars in Cartoons*, *Wars of Empire in Cartoons*, *World War I in Cartoons* and *World War II in Cartoons*.

For reasons of space, only the biographical details which are relevant to the artists' wartime work have been in-cluded (together with brief information about their peacetime careers), and no attempt has been made to list bib-liographical information, exhibitions, collections, books illustrated and so forth. By the same token the book makes no claims to being a comprehensive account. Indeed, having decided on producing roughly 300 entries and 150 illus-trations over a period of three centuries, the main difficulty was choosing which artists to include, which to leave out and which to illustrate from the many thousands working in this field. Ultimately, and inevitably, it has been a very personal selection but includes most of the artists whose work appears in my four earlier wartime cartoon history books, plus a number of others.

The main emphasis has been on professional political/editorial cartoonists, joke cartoonists and caricaturists working for the national or international press or producing prints, posters and postcards. Strip cartoonists, comic artists, animators, 'lightning' caricaturists and humorous book illustrators have generally been omitted (except where they have also worked as one of the above) as these have usually been covered in other publications.

Cartoonists and caricaturists from more than thirty countries have been included, working from the beginning of the French Revolutionary Wars in 1792 until the end of the Second World War in 1945, when the power of the cartoon began to wane with the advent of new media, especially the arrival of television in the 1950s.

As far as possible the entries cover artists from both sides of the conflicts involved and the result is, hopefully, a rea-sonably balanced representation of prominent international war cartoonists from around the world during this period.

With regard to the pictures themselves, every attempt has been made to use different images from those that appear in the earlier books, both in colour and black and white, and to give as varied a selection of styles and tech-niques as possible within the limitations of time, cost and copyright availability.

In the preparation of this book I am indebted to Nick Hiley and Jane Newton of the British Cartoon Archive at the University of Kent, the British Library, the British Museum Department of Prints & Drawings, the Victoria & Albert Museum Department of Prints & Drawings, the Senate House Library of the University of London, the London Library, the Goethe Institute, the Institut Français, the Italian Cultural Institute, the Wiener Library and the St Bride Printing Library.

Many thanks also go to Jenny Wood and the members of the art department of the Imperial War Museum and in particular to her two former colleagues, Joseph Darracott and Michael Moody, both now sadly deceased.

Last but by no means least, my thanks also go to John Davies, Anne Dolamore, Sophie Campbell and all at Grub Street Publishing, and to the designer Sarah Driver, for producing such a handsome volume.

MARK BRYANT
London, 2011

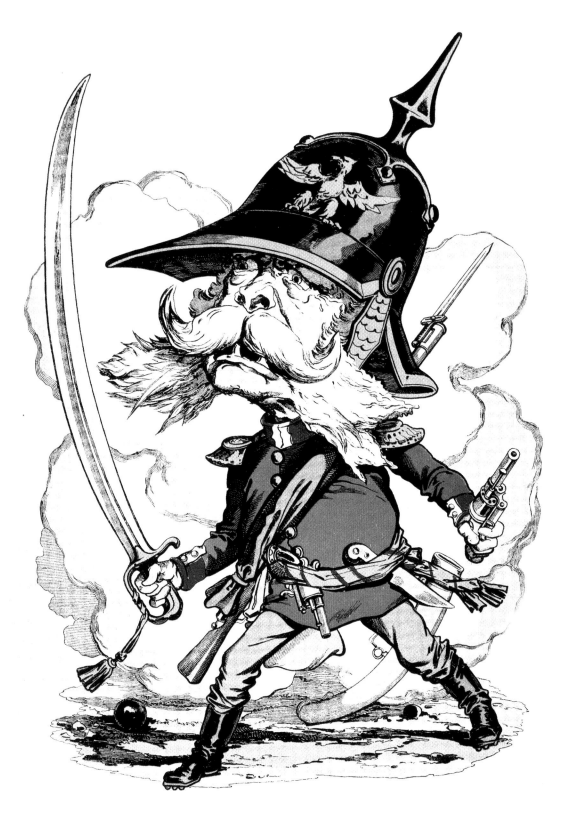

[KAISER WILHELM I]
French Epinal print, c.1871

INTRODUCTION

During the American Civil War, Abraham Lincoln described *Harper's Weekly*'s political cartoonist Thomas Nast as 'our best recruiting sergeant... his emblematic cartoons have never failed to arouse enthusiasm and patriotism'. Similar opinions by other military and political leaders have been expressed around the world about other wartime cartoonists and caricaturists over the past three centuries, yet satirical artists have often been overlooked in the histories of international conflicts. At best their images have been used to enliven the pages of scholarly treatises but even then their names have frequently been omitted and very little information is usually given about their lives.

The history of international war cartoons and caricature can be traced back at least to the graphic satirists of the 17th century such as the Frenchman Jacques Callot or the Dutchman Romeyn de Hooghe, but the first modern exponents appeared during the Seven Years' War between Britain and France in the 18th century. The first significant practitioner of the art was George, 4th Viscount Townshend (1724-1807). Himself a distinguished British Army officer (later a field marshal) Townshend produced a number of satirical prints on military figures during the conflict.

Townshend was essentially an amateur artist and the first professional cartoonists and caricaturists did not begin to emerge in Europe until the wars that followed the French Revolution. Later known as the Napoleonic Wars (after Napoleon Bonaparte became first consul of France in 1799) they began in 1792 with France's declaration of war against Austria and Prussia.

The first and most important of these artists was James Gillray (1756-1815), the son of a former soldier who had lost an arm in Flanders while serving under the Duke of Cumberland during the War of the Austrian Succession. Gillray also had first-hand experience of warfare himself as he was present in Flanders during the Duke of York's campaign in 1793, drawing on-the-spot portraits of the Allied commanders for Philippe de Loutherbourg's officially commissioned painting *The Grand Attack on Valenciennes*. Thus he also became the first cartoonist ever to be an official war artist. Creator of the image of Napoleon as 'Little Boney', Gillray's drawings greatly upset the French Emperor and his print 'The Plumb-Pudding in Danger' (26 February 1805), showing British Prime Minister William Pitt and Napoleon carving up the globe, is one of the most famous political cartoons of all time.

Technically speaking, these are not cartoons but rather caricatures (from the Italian, *caricare*, meaning to overburden or exaggerate), a style of drawing that can trace its origins to Ancient Egypt. The word 'cartoon' (from another Italian word, *cartone*, meaning a sheet of paper or card, from which we also get the word 'carton') was originally applied to designs or templates for tapestries, mosaics or fresco paintings. Its more widely used modern sense dates from 1843 and derives from a *Punch* spoof by John Leech (1817-64) of a British Government-sponsored competition held that year for pictures to decorate the walls of the new Houses of Parliament in London. Classical-style cartoon designs sent in for the competition were exhibited in Westmin-

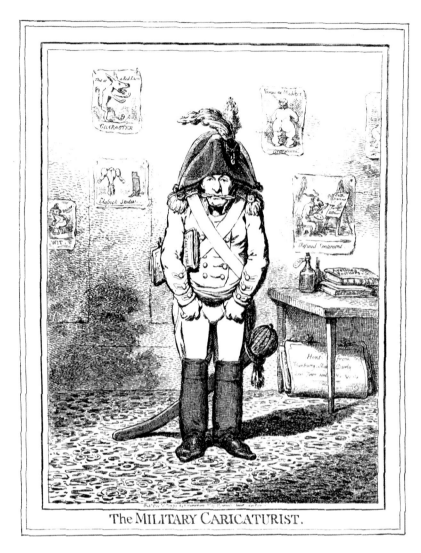

The MILITARY CARICATURIST.

THE MILITARY CARICATURIST
James Gillray, 6 December 1799

ster Hall and Leech attacked this as a waste of public money at a time when Londoners were starving. In a poignant satire he drew ragged and disabled figures attending the exhibition and headed his drawing 'Cartoon No.1: Substance and Shadow'. Five more drawings on social problems appeared over the following weeks (Cartoons Nos 2-6) and thereafter the main weekly full-page topical drawing of the magazine was referred to as 'The Cartoon' (and its artist as 'The Cartoonist'). By association the word gradually came to be applied to comic or satirical drawings generally.

Two other significant caricaturists who emerged in Britain during the Napoleonic Wars were George Cruikshank (1792-1878) and Thomas Rowlandson

(1756-1827). Indeed, Cruikshank's first published drawing was a war cartoon, 'Boney Beating Mack and Nelson Giving Him a Whack!!, or the British Tars Giving Boney his Heart's Desire: Ships, Colonies and Commerce' (19 November 1805). It appeared when he was only thirteen years old and featured Napoleon Bonaparte defeating the Austrian General Mack at the Battle of Ulm and Admiral Nelson presenting Britannia with the battered ships of the combined French and Spanish navies he had just defeated at Trafalgar. Thomas Rowlandson, meanwhile, not only produced some powerful coloured prints, such as 'The Two Kings of Terror' (November 1813) – Death and Napoleon – but also created the first ever war cartoon character, Johnny Newcome, a newly commissioned British officer serving in the Peninsular War.

French caricaturists in this period tended to remain anonymous because of strict censorship imposed on the media (satirical sketches of Napoleon were punishable as *lèse-majesté*). This also applied to the many countries, such as Spain and Italy (as well as their possessions overseas), which were then ruled by the French Empire. A notable exception was the Swiss Army officer, David Hess (1770-1843) whose lampoons of the French puppet government in the Netherlands were etched by Gillray and published in London in 1796.

It was not until Napoleon's fateful Russian campaign of 1812 that a long ban on caricature in Russia was lifted, and artists such as Ivan Terebenev (1780-1815) began to produce satirical prints, some of which were copied or adapted in Britain by Cruikshank and Rowlandson. There were also very few German drawings during the Napoleonic Wars before the French were defeated at Leipzig in 1813, after which Johann Michael Voltz (1784-1858) and Johann Gottfried

Schadow (1764-1850) produced some powerful images in colour and black and white.

By the early years of the nineteenth century prints began to be replaced with satirical magazines, led by *The Satirist* (1807-12), *The Scourge* (1811-16), *The Meteor* (1813-14) and *The Northern Looking Glass* (1825) in Britain, the *Zhurnal Karikatur* (1808) in Russia, and *Le Nain Jaune* (1814-1815), *La Caricature* (1830) and *Le Charivari* (1832) in France.

Punch magazine was launched in 1841 during the First Opium War with China and the First Afghan War. However, the first major conflict covered by its artists was the Crimean War. One of its most famous cartoons from this period was John Leech's 'General Février Turned Traitor' (10 March 1865), commenting on the death of Tsar Nicholas I of Russia. Other notable artists of the period included the Frenchmen Honoré Daumier (1808-79) and Gustave Doré (1832-83).

Another *Punch* stalwart, John Tenniel (1820-1914), the first cartoonist ever to be knighted and later famous as the illustrator of Lewis Carroll's 'Alice' books, made his reputation during the Indian Mutiny with 'The British Lion's Vengeance on the Bengal Tiger' (*Punch*, 22 August 1857). It was his first drawing to be published over two pages of the magazine and was later reproduced as a popular print.

Tenniel and his fellow countryman Matt Morgan (1839-90) of *Fun* also drew anti-Lincoln cartoons during the American Civil War (1861-5). In the USA itself the Confederacy's main artist was the German-born Adalbert Volck (1828-1912) while the Union cause was supported by Thomas Nast (1840-1902), Frank Bellew (1828-88) and others.

The Franco-Prussian War of 1870-71, and the subsequent short-lived Commune, took place during the heyday of some of France's greatest satirical artists, from Daumier and Cham to Alfred Le Petit and Faustin. Meanwhile, in Africa, the outbreak of the Ashanti and Zulu Wars, together with the conflict in the Sudan and other British colonial wars continued to be covered by *Punch* (Tenniel, Linley Sambourne et al.), *Fun* (notably Gordon Thomson) and *Judy* (William Boucher). And at the turn of the century artists like Grant Hamilton of *Judge* drew powerful cartoons about the USA's own colonial battles in the Spanish-American War and elsewhere.

However, the first conflict to attract significant attention from a wealth of international cartoonists and caricaturists was the Boer War (1899-1902). Political cartoonists working for the European press (notably those in Holland, France and Germany) were highly critical of Britain's actions in South Africa, and the French satirical weekly *L'Assiette au Beurre* even devoted an entire issue (28 September 1901) to cartoons about the horrors of the British concentration camps. Particularly savage in their criticisms were the Dutchman Johan Braakensiek, the Frenchmen Jean Veber, Jean D'Aurian, Charles Léandre and Caran D'Ache, the Portuguese Tomas Leal da Camara, the Brazilian Crispim do Amaral and the artists of the German magazines *Simplicissimus* and *Kladderadatsch* such as Thomas Theodor Heine, Bruno Paul and Gustav Brandt.

Gruesome 'hate' cartoons of this kind were also prevalent in the Russo-Japanese War of 1904-5 and during the Mexican Revolution (especially the *calaveras* or skeleton drawings by José Posada). The tradition continued in World War I, drawn in particular by the British Edmund Sullivan (1869-1933) and the Dutchman Louis Raemaekers (1869-1956). Indeed such was the power of Raemaekers' drawings attacking the Kaiser and alleged German atrocities that he was accused of endangering his country's neutrality and was forced to move to England to escape the threat of assassination after the German government offered a reward for his capture, dead or alive.

Other significant cartoonists of the period included the Australians Will Dyson (who also worked as an official war artist) and Norman Lindsay, the Frenchmen Jean-Louis Forain and Théophile Steinlen (another official war artist), the Americans Boardman Robinson, Robert Minor and W.A.Rogers, the Italians Golia (Eugenio Colmo) and Giuseppe Scalarini, the German Karl Arnold and the British Bernard Partridge, Leonard Raven Hill and F.H.Townsend.

On the lighter side, it was also during World War I that William Heath Robinson (1872-1944) became an international figure (the phrase 'Heath Robinson contraption' entered the *Oxford English Dictionary* in 1917) and in 1914 W.K.Haselden (1872-1953) created his series 'The Sad Experiences of Big and Little Willie'

(which the Kaiser himself reputedly said had been 'damnably effective'). The same year Alfred Leete (1882-1933) not only designed the famous 'Kitchener Wants You' recruiting poster but also began drawing 'Schmidt the Spy' for *London Opinion*. Also in 1914 came Bert Thomas's ''Arf a Mo', Kaiser' featuring a grinning Cockney soldier (later a famous poster) and in 1915 'Old Bill' Busby, the long-suffering Tommy character created by Bruce Bairnsfather (1887-1959), first appeared in his 'Fragments from France' series published in the *Bystander* magazine.

The lot of the ordinary soldier, sailor or airman continued to be a popular theme in World War II and led to the creation of a number of wartime cartoon characters. These included Bill Mauldin's 'Willie and Joe' and Dave Breger's 'GI Joe' (USA); Les Callan's 'Monty and Johnny' and Bing Coughlin's 'Herbie' (Canada); Gordon Minhinnick's 'Old Soldier Sam' and Neville Colvin's 'Fred Clueless' (New Zealand); Alex Gurney's 'Bluey and Curley' (Australia); and JON's 'The Two Types' and Raff's 'Pilot Officer Prune' (UK). Norman Pett's pin-up cartoon character 'Jane' was also very popular with Allied troops.

However, World War II is best remembered by many for its powerful political war cartoons. Amongst the foremost artists of this period were the Pulitzer Prize-winning Americans Daniel Fitzpatrick (1891-1969) and Vaughn Shoemaker (1902-91), Boris Efimov (1900-2008) and the Kukryniksi group from the USSR, the Japanese Hidezo Kondo (1908-79), the Dutchman Leo Jordaan (1885-1980), the Norwegians Ragnvald Blix (1882-1958) and Olaf Gulbransson (1873-1958), the Australian Mick Armstrong (1903-78), the Polish-born Arthur Szyk (1894-1951), and the Czechs Stephen Roth and Adolf Hoffmeister. British artists included the New Zealand-born David Low of the *Evening Standard* (whose drawings led to diplomatic protests from Germany, Italy and Spain), the German-born Hungarian Vicky (Victor Weisz) of the *News Chronicle*, Philip Zec (one of whose cartoons nearly led to the closure of the *Daily Mirror*) and Leslie Illingworth of the *Daily Mail*, some of whose drawings were found in Hitler's bunker after the war, date-stamped and catalogued by Joseph Goebbels.

Not to be forgotten too are the Nazi, Vichy and Fascist artists such as Goebbels' favourites Erich Schilling and Mjölnir (Hans Schweitzer), the US-born Arthur Johnson who worked for *Kladderadatsch* in Berlin until it closed in 1944, French Milice collaborator Ralph Soupault and Italian SS Division member Gino Boccasile, all of whom produced powerful, though often racist or anti-Semitic drawings.

Many wartime cartoonists worked in reserved occupations, but a number of them actually served their countries in the front line and some were badly wounded (such as Fougasse and Gus Bofa) or even died in battle (such as the SAS Major Ian Fenwick). Others were awarded decorations for valour. Amongst these were the Frenchman Jean Veber, who received the Croix de Guerre and the Médaille Militaire, and *Punch*'s political cartoonist E.H.Shepard (best known as the illustrator of A.A.Milne's 'Winnie the Pooh' stories) who served in the Royal Artillery in France, Belgium and Italy, achieved the rank of major and was awarded the Military Cross at Ypres in 1917.

Others still, such as Bert Thomas in World War I, and Bing Coughlin and JON Jones in World War II, received MBEs for their contribution to the war effort (the latter from Winston Churchill himself). Indeed, General Sir Bernard Freyberg VC said that JON's 'The Two Types' (*Eighth Army News*) were worth 'a division of troops'. And Sir Percy Robinson, the distinguished war correspondent of *The Times*, declared that the Dutch cartoonist Louis Raemaekers was one of the six great men – including statesman and military commanders – whose effort and influence were the most decisive during World War I.

In the light of this it is remarkable that so little information has hitherto been widely available on wartime cartoonists and caricaturists around the globe over the past three centuries and it is hoped that this modest volume will go some way to giving them the recognition they deserve.

AMARAL, CRISPIM DO (1858-1911)

Born in Olinda in Pernambuco state, Brazil, Do Amaral studied art in the city of Pernambuco (now Recife). He began work as a theatrical set designer in Pernambuco and Manaus and later moved to Paris, where he began contributing cartoons to French publications such as *La Caricature*, *Polchinelle* (1901-8) and *Le Bon Vivant* (1899-1900). Among his best known anti-British cartoons drawn during the Boer War were two colour covers for

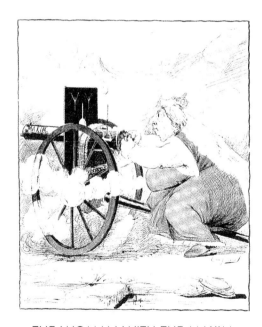

THE WOMAN WITH THE MAXIM
'In the Transvaal the Maxim gun is a marvel.'
Crispim do Amaral, *La Caricature* (Paris),
30 December 1899

La Caricature: 'English Correction' (25 November 1899) showing Kruger beating Queen Victoria's bare buttocks with a wooden bat (later reproduced on postcards) and 'La Dame de Chez Maxim' (30 December 1899) with Victoria manning a Maxim machine-gun. 'English Correction' led to a diplomatic protest by the British government and copies were seized by the censors. In 1901 he returned to Brazil, eventually settling in Rio de Janeiro in 1902. Here he continued to design sets and also drew cartoons for *O Mahlo* (he later became its first art director), *O Pau* and *O Seculo*. In 1903 he also founded the magazine *A Avenida* which he ran until 1905. His younger brother Amaro (1873-1922) was also a cartoonist. Do Amaral died in Rio de Janeiro in 1911.

ANSELL, CHARLES – see Williams, Charles

APA – see Elias i Bracons, Feliu

APE – see Pellegrini, Carlo

ARIAS BERNAL, ANTONIO –
see Bernal, Antonio Arias

ARMENGOL, MARIANO 'MARIO' (1909-95)

Mario Armengol was born in San Juan de las Abadesas, Catalonia, Spain, on 17 December 1909, the son of Benito Armengol, a textile manufacturer. After studying in Tarrassa, Madrid and Paris he returned to Tarrassa where he produced promotional material for the Republican cause and began to draw political cartoons and caricatures. He continued to draw throughout the Spanish Civil War and in 1938, shortly after the fall of the Republican government, fled to France. Here he enlisted in the French Foreign Legion, as 'Mario Hubert', and served in Algeria. On the outbreak of World War II, he was posted to Scotland and then Norway but after the failure of the Narvik campaign returned to the UK. By March 1941 he was a political cartoonist and graphic designer attached to the Latin American Section of the Ministry of Information, producing advisory booklets and pamphlets, and contributing cartoons to the London-based *Message* (a Belgian monthly review) and *France* (the Free French daily) as well as propaganda cartoons for neutral countries. He pro-

duced two collections of his wartime cartoons: *Those Three* (1942) and *According to Plan: War Cartoon Revue* (1943). After the war he worked for the MOI's successor, the Central Office of Information, and then spent twenty years as a designer for ICI (c. 1951-71), winning a number of awards for his work. He died in Nottingham on 27 November 1995.

ARMSTRONG, HAROLD BARRY (1903-78)

Mick Armstrong was born in Paddington, Sydney, Australia in March 1903, the son of a teacher. His first cartoon was published in the *Sydney Bulletin* when he was sixteen years old. After school he worked as a survey draughtsman for the New South Wales Lands Department while continuing to submit cartoons to the *Bulletin*, *Smith's Weekly*, *Melbourne Punch*, *Sydney Sun* and *Aussie*. In 1932 he joined the *Melbourne Herald*, producing political cartoons, a comic strip and illustrations. He moved to the *Star* in 1934 and when the paper collapsed in 1936 joined the *Melbourne Argus* as its first ever political cartoonist. He continued to work for the *Argus* throughout World War II until the paper folded in 1957 (he then moved to the *Sun News Pictorial*). One of his wartime drawings 'I've got a date', featuring an Australian 'Digger' and a picture of Hitler, was reproduced on 25,000 flags and sold during a military parade through Melbourne. Another, 'Cigar-in-the-Face "Win"' (featuring Churchill smoking U-boat cigars in front of Hitler), was reprinted in the *Daily Telegraph* on 27 January 1940. Armstrong's wartime cartoon collections were *Havoc! War Cartoons by Armstrong* (1939), *Mein Kranks: A Second Volume of War Cartoons* (1940), *'Blitzy'* (1941), *'Army' Stoo* (1944), *19-Foughty-3* (1943), *'Taxi!'* (c.1944) and *War Without Tears: 100 of the War's Wittiest Whimsies* (c.1945). He died in 1978.

ARNOLD, KARL (1883-1953)

Karl Arnold was born in Neustadt, near Coburg, Germany, on 1 April 1883, the son of a toy manufacturer. After attending the Academy of Fine Arts in Munich

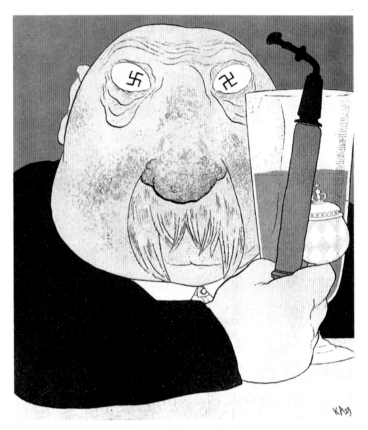

MUNICH MAN
'What I want is a bit of peace and a revolution,
Law and order and a pogrom for the Jews.
We should get hold of a dictator and then get rid of him.
We'll show you how to build up Germany.'
Karl Arnold, *Simplicissimus* (Munich),
3 December 1923

his first cartoon appeared in *Simplicissimus* (1907). He later moved to Paris (1910-11) from where he continued to contribute to *Simplicissimus* and *Jugend*. In 1913 he co-founded the Munich New Secession group with Paul Klee and others. In World War I he was attached to army headquarters staff producing the field newspaper *Liller Kriegszeitung* and drawing a series of war leaflets (*Kriegsflugblätter*), two collections of which were published (1915, 1917). In 1917 he became a shareholder in *Simplicissimus* (and one of its editors) and thereafter mostly worked for this single magazine — though he occasionally also drew for *Münchner Illustrierte Presse*, *Berliner Illustrierte Zeitung*, *Nebelspalter* (Switzerland), *Söndags-Nisse* (Sweden), *Vorwärts* (German Social Democratic Party newspaper) and others.

His early caricatures lampooning Hitler and the Nazis (such as 'Munich Man', *Simplicissimus*, 3 December 1923, published shortly after the Munich Beer Hall Putsch) became celebrated. However, 'Hail Prussia' (*Simplicissimus* cover 15 May 1932), and others so angered the Nazis that when they came to power in 1933 he was forbidden to work for a while. In 1938 books containing his drawings, such as *Berliner Bilder* (1924), were withdrawn from circulation and placed on the list of 'undesirable literature'. He retired in 1942 after suffering a stroke and died in Munich on 29 November 1953.

ASHTON, GEORGE ROSSI (1857-c.1910)

George Rossi Ashton was born in England, the son of Thomas Briggs Ashton, a wealthy American, and Henrietta, daughter of Count Carlo Rossi, a Sardinian diplomat. His older brother was the illustrator and painter Julian Rossi Ashton, later founder of the Julian Ashton School of Art in Sydney, Australia. After studying at the South Kensington School of Art he began work for the *Graphic* before being sent out to South Africa by the *Illustrated London News* in 1877. Here he joined the Cape Mounted Police and in 1879 fought under General Buller during the Zulu War. The same year he followed his brother to Australia where he worked for the *Illustrated Australian News* in Melbourne. He also worked on the *Sydney Bulletin* with Phil May and contributed to *The Sketcher*, *Illustrated Sydney News* and others. He returned to London in 1893, drawing for the *Daily Graphic*, *Lika Joko*, *St James's Budget*, *Pearson's Magazine*, *Punch*, *Fun*, *Illustrated Bits*, *Pall Mall Magazine*, *The Sketch* and others, and was one of the first cartoonists to be published in the *Daily Mail* when it was founded in 1896. He also worked as a lightning caricaturist in his own music-hall act at the Alhambra Theatre and other venues in London at the beginning of the Boer War. Dressed in tropical army uniform he would sketch, in exactly sixty seconds, accompanied by music, a scene or portrait linked to the war. Amongst the favourites were caricatures of Kruger, Generals Roberts and Buller, and 'One for Majuba' showing a Highlander bayoneting a Boer.

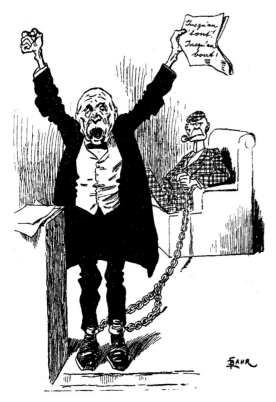

CLEMENCEAU – A MAN IN CHAINS
Johann Bahr, *Kladderadatsch* (Berlin), 6 January 1918

B

BAHR, JOHANN (1859-after 1918)

Born in Flensburg, Germany, on 22 June 1859, Bahr worked at first as a mechanical engineer on international cruise ships. He later studied at the Akademie in Berlin and became a painter and illustrator, contributing to *Fliegende Blätter*, *Lustige Blätter*, *Illustrierte Zeitung* and other publications, and specialising in stories without words. In 1896 he became founder and first president of the German Guild of Illustrators.

BAIRNSFATHER, CHARLES BRUCE (1887-1959)

Bruce Bairnsfather was born in Murree, India, on 9 July 1887, the eldest son of Lieutenant (later Major) Thomas Henry Bairnsfather, a Scottish officer in the Indian Army. He gained a commission in the Cheshire Regiment, but resigned to study art at John HASSALL's Art School in London (1907). He then worked as an electrical engineer specialising in country-house lighting. During World War I he served in France and Belgium as a machine-gun officer with the 1st Battalion, Royal Warwickshire Regiment, achieving the rank of captain. While stationed outside Armentières, near Lille, he drew the first of his famous weekly 'Fragments from France' cartoons ('Where did that one go to?' *Bystander*, 31 March 1915). Though the cartoons were popular with the troops at the Front (even the Germans appreciated the humour), the British establishment objected to them and questions were asked in parliament about 'these vulgar caricatures of our heroes'. None the less, his work so improved morale ('Well, if you knows of a better 'ole, go to it!', *Bystander*, 24 November 1915, is one of the most famous war cartoons of all time) that he was promoted 'officer-cartoonist' and transferred to the intelligence department of the War Office to draw similar cartoons for the French, Italian and American forces. His most famous character, the 'dim, dull and honest' pipe-smoking, walrus-moustached Midlands Tommy 'Old Bill' Busby, first appeared in 'When the 'ell is it going to be strawberry?' (*Bystander*, 15 September 1915) and became so popular that he appeared in books (250,000 copies were sold of the first anthology of the 'Fragments' cartoons in 1916 alone), plays, musicals, feature films and comic strips. In addition he was reproduced on pottery, playing cards, jigsaw puzzles, postcards and other merchandise. An Old Bill waxwork was produced by Madame Tussaud's (1930) and a bus named after him now resides in the Imperial War Museum, London (complete with 'Old Bill' radiator mascot). General Sir Ian Hamilton said of the artist: 'The creator of Old Bill has rendered great service to his Country, both as a soldier and as one who has done much to lighten the darkest hour.' Bairnsfather repeatedly denied that Old Bill was based on a single person, saying 'he was simply a hieroglyphic for a most prevalent type'. Bairnsfather also edited his own weekly magazine for the *Bystander* group, *Fragments* (1919-20). In World War II he was official war cartoonist (with the rank of captain) attached to the USAAF (1942-4), contributing to *Stars and Stripes* and *Yank* and painting nose-art on US bombers. He also drew posters for the 'Even the Walls Have Ears' campaign, featuring Old Bill, and a strip 'Young Bill' for *Illustrated*. After the war he continued to work as a lecturer and artist. 'Old Bill', along with his younger friends Bert and Alf, had considerable influence on the work of other cartoonists, notably (during World War II) the American Bill MAULDIN ('Up Front') and the Welshman W.J.P.JONES ('The Two Types'). His books include: *Bullets and Billets* (1916), *From Mud to Mufti* (1919), *Old Bill Looks at Europe* (1935) and *Jeeps and Jests* (1943). Bairnsfather died in Worcester Royal Infirmary on 29 September 1959.

BAKER, GEORGE (1915-75)

George Baker was born in Lowell, Massachusetts, on 22 May 1915. After studying art briefly at night school in Chicago he began work as a commercial artist. Moving to California to play professional baseball he later (1937) joined Walt Disney's studios as an animator on such films as *Pinocchio*, *Fantasia*, *Dumbo* and *Bambi*. In June 1941 he was drafted into the US Army (eventually achieving the rank of sergeant) and began producing animated training films for the signal corps at Fort Monmouth, New Jersey. He then won a cartoon competition sponsored by the Defense Recreation Committee and after *Life* magazine printed some of his work was taken on by *Yank*, *The Army Weekly*. He created the 'Sad Sack' (an abbreviation of the army expression 'Sad Sack of Shit') strip about a US Army misfit for *Yank* in May 1942. It was very popular with the troops and General George C. Marshall praised it as a morale booster. It later transferred to *Stars and Stripes* and at the end of the war was even used in a US Army recruiting campaign ('Don't Be a Sad Sack, Re-Enlist in the Regular Army'). After the war the character appeared as a regular newspaper strip, a comic book series, in a radio programme (1946) and in a film starring Jerry Lewis (*The Sad Sack*, 1957). Baker died in Riverside, California, on 5 May 1975.

BARRETO, BENEDITO CARNEIRO BASTOS 'BELMONTE' (1896-1947)

Born in São Paulo, Brazil, on 15 May 1896, Belmonte had his first drawings published in the São Paulo mag-

azine *Rio Branco* in 1912. He later contributed to *Dom Quixote*, *Carêta* (from 1922), *O Cruzeiro*, *Cosmos*, *Revista da Semana* and the humour magazine *Fon-Fon!* (for which he also wrote and worked as art director) amongst others. In 1921 he replaced Voltolino as daily cartoonist on *Fõlha da Noite* for whom he created the popular everyman figure of Juca Pato. His anti-Nazi cartoons, which were reprinted widely in South America as well as overseas, first began to appear in *Fõlha da Manhã* in 1936. Such was his impact that in a Berlin Radio broadcast in 1945 Goebbels even accused him of drawing for the Allies. He died in São Paulo on 19 April 1947.

BATCHELOR, CLARENCE DANIEL (1888-1977)

Clarence Batchelor was born in Osage City, Kansas, on 1 April 1888, the son of Daniel L.Batchelor. After studying at the Chicago Art Institute (1907-10) he worked briefly as a staff artist for the *Kansas City Star* (1911) and began freelancing cartoons to *Puck*, *Life* and *Judge*. Moving to New York in about 1912 he studied at the Art Students' League and contributed to the *New York Mail* and *New York Tribune* before becoming staff artist of the *New York Evening Journal*. In 1923 he became political cartoonist on the *New York Post*, leaving in 1931 to become the chief editorial cartoonist of the *New York Daily News*. He stayed with the paper for more than forty years until 1969 and also contributed to *Women's Journal*, *Woman Voter* and the *National Review*. Batchelor often depicted War as a glamorous woman with a death's head, notably in his 1937 Pulitzer Prize-winning cartoon 'Come on in, I'll treat you right. I used to know your Daddy' (*New York Daily News*, 25 April 1936) featuring 'Any European Youth'. He died in Connecticut on 5 September 1977.

BATEMAN, HENRY MAYO (1887-1970)

Born in Sutton Forest, New South Wales, Australia, on 15 February 1887, H.M.Bateman was the son of Henry Charles Bateman, an English export packer and shipper. The family returned to England in 1889 and Bateman studied drawing and painting at Westminster School of Art (1902) and Goldsmith's Institute, London, and later attended Charles van Havermaet's studio (1904-7). His most famous drawings, 'The Man Who . . .' series of social gaffes, first appeared in 1912 in the *Tatler* and he

began contributing regularly to the *Sketch* the same year and to *Punch* in 1916. In World War I he volunteered for the 23rd London Regiment but was invalided out with rheumatic fever in 1915. He was also rejected on health grounds when conscription was introduced. On a War Office visit to a bayonet training school at the Front in France in 1918 he discovered that a number of his war drawings, including 'The Recruit Who Took To It Kindly' (1917), had been enlarged and stuck to the walls. Others were reproduced in French magazines such as *La Baïonnette* and many of his war cartoons were later published in *A Book of Drawings* (1921). Another military-linked book was *Colonels* (1925). In World War II he also designed posters for the Ministry of Air Production, the Ministry of Power, and the Ministry of Health (notably the series 'Coughs and Sneezes Spread Diseases'). H.M.Bateman died in Gozo, Malta, on 11 February 1970.

BELLEW, FRANK HENRY TEMPLE (1828-88)

Frank Bellew was born in Cawnpore, India, on 18 April 1828, the son of Francis John Bellew, an Irish captain in the British Army. After working as an architect in London he came to the USA in 1853, contributing to *The Lantern* and *Yankee Notions*. He began to draw for *Harper's Weekly* from its very first number and later contributed to *Frank Leslie's Illustrated Newspaper*, *Harper's Magazine*, *Puck*, *Reveille*, *New York Daily Graphic*, *Scribner's* and others. He was the first person to portray the figure of Uncle Sam (*Lantern*, 13 March 1852) and in 1860 founded the short-lived paper *The Picayune* (he later also founded *Wild Oats*). One of the main political cartoonists working during the American Civil War he was particularly well known for his Lincoln caricatures. Amongst these was 'Long Abraham Lincoln a Little Longer' (*Harper's Weekly*, 26 November 1864), published after his re-election. Another notable drawing was 'Sinbad Lincoln and the Old Man of the Sea' (*Frank Leslie's Illustrated Newspaper*, 3 May 1862), featuring Gideon Welles, secretary of the navy, and published some fifty years before the similar World War I Kaiser and von Tirpitz cartoon by Raven HILL. He often signed his drawings with a triangle. Frank Bellew died in Metuchen, New Jersey, on 29 June 1888. His son Frank P.W.Bellew was also a cartoonist (he often signed his work 'Chip' for 'chip off the old block').

SINBAD LINCOLN AND THE OLD MAN OF THE SEA
Frank Bellew, *Frank Leslie's Illustrated Newspaper* (New York), 3 May 1862

BELMONTE – see Barreto, Benedito Carneiro Bastos

BENTLEY, NICOLAS CLERIHEW (1907-78)

Nicolas Bentley was born on 14 June 1907 in Hampstead, London, the son of the writer and journalist (and inventor of the 'clerihew') E. Clerihew Bentley. He studied at Heatherley's School of Art in London (1924-5) and then worked briefly as a circus clown and as a film extra before joining the W.S.Crawford advertising agency. Here he met the poster artist Horace Taylor with whom he subsequently worked (1927-8). In 1930 he joined Shell-Mex's publicity office, leaving in 1932 to become a freelance illustrator and commercial artist while also contributing cartoons to *Bystander*, *Lilliput*, *Men Only*, *Daily Express*, *Sunday Express*, *Night & Day*, *Punch* and *Radio Times*. During World War II he worked in the Ministry of Information and served in the Auxiliary Fire Brigade. He later worked for the *News Chronicle* (1955-7), *Daily Mail* (1958-62) *Sunday Telegraph* (1972-4), *Sunday Times*, *Punch* and *Private Eye* and was one of the founders of the book publishers André Deutsch. Influenced by Caran D'ACHE and the *New Yorker* cartoonist Ralph Barton (he even dropped the 'h' in his Christian name so that his signature could appear symmetrically in two lines like Barton's), he also admired STEINLEN, DORÉ, LÉANDRE and GULBRANSSON amongst others. Some of his wartime cartoons were reproduced in his book *Animal, Vegetable, and South Kensington* (1940). Amongst these was 'It's for the Braemar Games – like it?' (*Bystander*, 26 June 1940) featuring Goering, Hitler and Goebbels. Nicolas Bentley died in Bath, Somerset, on 14 August 1978.

BERGER, OSCAR (1901-77)

Oscar Berger was born in Presov, Eperjes, Czechoslovakia, on 12 May 1901, the son of Henry Berger. After studying at Berlin Art School (1920) he joined the staff of the city's largest daily paper as artist. When Hitler came to power he left the country, travelling to Prague, Paris and Budapest before arriving in London in 1935, and remained in England throughout the war years. He wrote and illustrated a popular series, 'World Adventures with a Sketch-Book', for the *Evening News*, and regularly produced work for *Daily Sketch*, *Sunday Dispatch*, *Lilliput*, *London Opinion*, *News of the World*, *Le Figaro*, *Illustrated*, *Saturday Review*, *New York Times*, *Life*, *New York Herald-Tribune*, *Picture Post* and others. He drew a wartime sixty-seventh birthday cartoon for Winston Churchill (*News of the World*, 30 November 1941) and also covered the signing of the United Nations Charter in San Francisco in 1945 for the *Daily Telegraph*. In addition he produced posters for the theatre and worked in advertising. Berger was held in such high esteem that many celebrities (including Roosevelt, Churchill and King Victor Emmanuel) actually sat to have their caricatures drawn. After World War II he moved to the USA and became a naturalised US citizen in 1955. Some of his wartime caricatures are reproduced in his book *Famous Faces* (1950). He died on 15 May 1977.

BERGOGLIO, CARLO 'CARLIN' (1895-1959)

Born in Cuorgnè, near Turin, Italy, on 1 April 1895, Carlin's first cartoons appeared in the Turin sports weekly *Guerin Sportivo* in 1912. While serving as an infantry officer in World War I he drew for *Numero* and later worked for *Cuor d'Oro* (1922-6) before returning to *Guerin Sportivo* (he later became its editor). In 1945 he left *Guerin* to become deputy director of the newly launched *Tuttosport* and in 1949 became its director. He died in Turin on 25 April 1959.

BERMAN, SAM (b.1906)

Sam Berman began drawing for the *Hartford Courant* while still at school. He then studied art at the Pratt Institute, New York, before beginning work as a staff artist on the *Newark Star Eagle*. He later drew for *Today*, *Newsweek*, *Liberty* and *Fortune*, devised the cover logo ('Esky') for *Esquire* magazine and contributed weekly caricatures for the King Features syndicate. His political caricatures for *Collier's* magazine included a series of more than fifty wartime drawings of Nazi leaders, 'The Guilty', which was continued by his friend Miguel COVARRUBIAS when Berman left for three years' service in the army as a propaganda artist in India and Burma. In addition to drawings Berman produced ceramics and clay sculpture caricature heads (notably a series which were photographed and printed in *Life* magazine).

THE BEGINNING OF THE END
Carlo Bergoglio (Carlin), *Numero* (Turin), 1916

BERNAL, ANTONIO ARIAS (1913-60)

Antonio Arias Bernal was born in Aguascalientes, Mexico, on 10 May 1913. In 1933 he moved to Mexico City where he studied briefly at the Academia de San Carlos. He then began to contribute to *Mexico al Dia*, *Excelsior*, *El Universal*, *Todo*, *Hoy* and others and helped found a number of satirical magazines including *Vea*. His anti-Nazi cartoons were very popular during World War II and collections of his wartime drawings were distributed in large numbers throughout Latin America by the US Office of the Coordinator of Inter-American Affairs. He died on 31 December 1960 in Mexico City.

BERRYMAN, CLIFFORD KENNEDY (1869-1949)

Clifford Berryman was born in Versailles, Kentucky, on 2 April 1869, the son of James T. Berryman, the owner of a general store. He began work in 1886 drawing illustrations for submissions to the US Patent Office in Washington DC and whilst there sold a cartoon to the *Washington Post*. In 1891 he joined the staff of the *Post* as an editorial cartoonist, becoming chief cartoonist in 1896 and publishing a book of his work, *Berryman Cartoons*, in 1900. Two years later he drew his most famous cartoon – 'Drawing the Line in Mississippi' (*Washington Post*, 16 November 1902), about Theodore (Teddy) Roosevelt on a bear hunt in Mississippi – which led to the creation of the teddy bear toy. He was also praised by President McKinley ('Your pictures never bring a blush nor leave a stain'). Berryman moved to the *Washington Star* in 1907 and remained with the paper until he suffered a stroke on 17 November 1949. A memorable World War II cartoon was 'Wonder How Long the Honeymoon Will Last?' (*Washington Star*, 9 October 1939) satirising the Nazi-Soviet Pact, with Hitler as the groom and Stalin as the bride. He also won the Pulitzer Prize in 1944 for his cartoon about F.D. Roosevelt ('But Where is the Boat Going?', *Washington Star*, 28 August 1943). C.K. Berryman died on 11 December 1949. His son James also won a Pulitzer Prize for his cartoons.

BERT, 'B' (fl.1930s)

Bert was a Czech cartoonist whose book of anti-Nazi cartoons, *Juden Christen Heiden im III Reich* (Jews, Christians and Heathens in the Third Reich, 1935) was published in Prague with captions in English, French and German. The cover shows the head of a huge bearded

Bert, *Das III Reich in der Karikatur* (Prague, 1934)

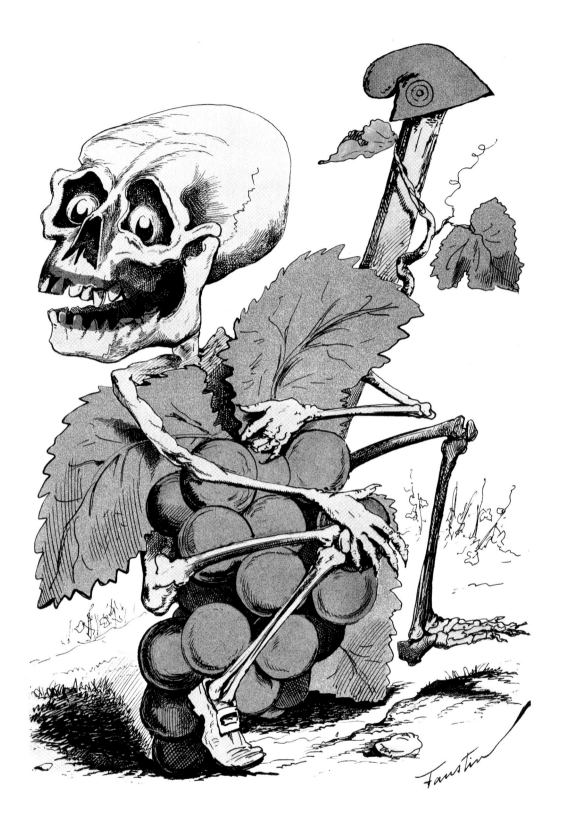

THE BLOOD HARVEST OF 1870
Faustin Betbeder, 1871

German monster (wearing a Viking helmet covered in swastikas) devouring a clergyman and a rabbi, while one of the cartoons inside, 'The German New Heathen', depicts the same giant (with the image of Hitler in the background) wielding a spiked club and trampling sundry churchmen underfoot. The subtitle reads 'Our Aryan myth is: "Love your neighbour – by tearing him to pieces!"' He also contributed to *Das III Reich in der Karikatur* (1934).

BETBEDER, FAUSTIN 'FAUSTIN'
(1847-after 1914)

Born in Soissons, France, Faustin was a student at the École des Beaux-Arts in Paris when the Franco-Prussian War broke out. He immediately began to caricature the French government for magazines such as *L'Eclipse* (1868-70), *La Charge* and others. However, not all his work was to his editors' tastes. One of these rejected drawings, depicting Victor Hugo crushing a tiny fallen Emperor Napoleon III after the French defeat at the Battle of Sedan, he printed himself on 6 September 1870 and personally distributed copies to Parisian kiosks. It was so successful that it reputedly sold 50,000 copies in a single night. Another powerful image of the Franco-Prussian War was 'The Blood Harvest of 1870' (1871). In addition he produced prints of Kaiser Wilhelm I and Bismarck as part of his series 'Les Guillotinés' (1870). After the fall of Napoleon III he attacked the new Government of National Defence in his own series 'Les Hommes du Jour' (Men of the Day) and contributed to another series, 'Nos Grrrands Généraux' (Our Grrrreat Generals). With the coming of peace he moved to London where he married and set up a colour printing business. He also contributed to *London Figaro*, designed theatrical costumes and worked as a painter, notably producing an oil painting of the coronation of George V. After the Boer War a painting by him of Lord Roberts and Peace published by the *Ludgate Magazine* was also reproduced on postcards published by Raphael Tuck.

THE 'SILENT' SERVICE'S LITTLE SURPRISE PACKET
E.G.O.Beuttler, *The Merry Mariners* (1917)

'BETTER 'OLE, THE' – see Bairnsfather, Charles Bruce

BEUTTLER, EDWARD GERALD OAKLEY
(1880-1964)

E.G.O.Beuttler was the son of Thomas Bream Beuttler, later one of the directors of education of Western Australia. He first went to sea in 1896 and joined the RNVR in 1898 as a midshipman, rising to the rank of lieutenant (1914) and later wing commander. He was also superintendent of Akbar Nautical School in Heswall, Cheshire (c.1907). Before and during World War I he contributed cartoons, many with a nautical flavour, to the *Bystander* (from 1915), *Punch*, *Sketch* and *Winter's Pie*. He was also a regular contributor to the *Tatler* (1916-42). Books of his cartoons include *Humours of the Merchant Marine* (1912), *Humour in the Navy* (1916), *The Merry Mariners* (1917) and *Humour Afloat* (1919). Some of his cartoons were also produced as sets of postcards by The Syren &

Shipping Ltd. The *Daily Sketch* said of him: 'Beuttler is to the navy what BAIRNSFATHER is to the army.' E.G.O.Beuttler died in Bovey Tracey, Devon, on 29 January 1964, aged eighty-four.

'BIG AND LITTLE WILLIE' – see Haselden, William Kerridge

'BILLY BROWN OF LONDON TOWN' – see Langdon, David

BING – see Coughlin, William Garnet

BIRD, CYRIL KENNETH 'FOUGASSE' CBE (1887-1965)

Kenneth Bird was born on 17 December 1887 in Cheltenham, the son of Arthur Bird, an iron merchant and cricketer. He trained as an engineer at King's College, London, and also took evening art classes at the Regent Street Polytechnic and the Bolt Court School of Photo-Engraving. A machine-gun instructor in the Artists' Rifles (1904-8), he then worked at the Rosyth naval base (1909-14). During World War I, he served in the Royal Engineers (achieving the rank of lieutenant), but was invalided out when shot in the spine at Gallipoli (1915). After studying by correspondence course at Percy Bradshaw's Press Art School he began contributing to *Tit-Bits*, *Bystander*, *Graphic*, *London Opinion*, *Sketch* and *Tatler* using the pen name 'Fougasse' (a small anti-personnel mine: 'its effectiveness is not always reliable and its aim uncertain') to distinguish him from Jack Yeats (whose pseudonym was 'Bird'). In 1916 he began contributing to *Punch* (1916-52), succeeded George MORROW as art editor of the magazine in 1937 and became editor in 1949 (the only cartoonist ever to hold the post). An air-raid warden in World War II, perhaps his most memorable cartoons from this period are the posters he designed for government departments, such as the 'Careless Talk Costs Lives' series (Ministry of Information) and 'Waste the Food and Help the Hun' (Ministry of Food). He also produced a number of books, including some with war themes such as *The Changing Face of Britain* (1940), *. . . and the Gatepost* (1940), *Running Commentary* (1941) and *Sorry – No Rubber* (1942). He was awarded a CBE in 1946 and retired in 1953. Kenneth Bird died in London on 11 June 1965.

BLADA, V. – see Volck, Adalbert John

BLANCHOT, GUSTAVE HENRI ÉMILE 'GUS BOFA' (1883-1968)

Born on 23 May 1883 in Brive-la-Gaillarde the son of a colonel in the French Army, Gus Bofa worked at first as an engineer in an aluminium foundry, then in a copper mine. His first drawings appeared in *Le Sourire* (1900-14) and he also contributed to *Le Rire* (1903-14, of which he was art editor from 1909 to 1912), *Le Journal* (1914-21), *La Baïonnette* (1915-20, including covers during World War I), *Gringoire* (1928-34), *La Charrette Charrie* (including the whole issue for 15 June 1922) and others. During World War I his legs were badly injured (December 1914) but he continued to draw cartoons. He later worked as a book illustrator and was literary critic of *Le Crapouillot* for seventeen years. He received the Légion d'Honneur. Gus Bofa died in Aubagne, France, on 1 September 1968.

BLIX, RAGNVALD 'STIG HÖÖK' (1882-1958)

Ragnvald Blix was born in Christiania (now Oslo), Norway, on 12 September 1882, the son of the politician and poet Elias Blix. After studying art briefly at the Harriet Backers School of Painting he began contributing caricatures to the satirical magazines *Fluesoppen* and *Trangviksposten* and later became publisher of *Tyrihans* magazine. In 1903 he moved to Paris where he exhibited caricatures of works of art in the Louvre (1905 and 1906) while also contributing to *L'Assiette au Beurre*, *Le Journal*, *Le Rire* (1906-8) and other publications. In 1908 Olaf GULBRANSSON invited him to draw for *Simplicissimus*, to which he contributed for the next ten years and throughout World War I. Returning to Oslo in 1918 he founded the newspaper *Exlex* (Outlaw, 1918-20) which he moved to Copenhagen shortly afterwards. He remained in Copenhagen contributing to *Berlinske Tidende* amongst other publications but moved to Lidingö, near Stockholm in neutral Sweden in May 1940 when the Nazis invaded. He drew strong anti-Nazi cartoons as 'Stig Höök' for the Swedish paper *Göteborgs Handles- och Sjöfartstidning*. A number of these were reprinted in his books *Stig Höök 1942-44* (1944) and *De Fem Arene* (1945). He returned to Copenhagen in 1945 and died there on 2 May 1958.

William Blomfield ('Blo'), *New Zealand Observer* (Auckland), 20 May 1916

BLO – see Blomfield, William

BLOCK, HERBERT LAWRENCE 'HERBLOCK' (1909-2001)

Herbert Block was born in Chicago, Illinois, on 13 October 1909, the son of David Julian Block, a chemist. After winning a scholarship to study at the Art Institute of Chicago at the age of eleven, he attended Lake Forest College. In 1929, aged twenty, he joined the *Chicago Daily News* as a cartoonist, deputising for Vaughn SHOEMAKER. In 1933 he moved to the Newspaper Enterprise Association as its syndicated cartoonist and in 1942 won a Pulitzer Prize for his cartoon 'British Plane' (*Washington Post*, 14 March 1941). This shows a worried German soldier in occupied France looking up at the sky as three French civilians chuckle on a street corner. He then joined the US Air Force producing information material. After the war he became the political cartoonist on the *Washington Post*, winning two more Pulitzer Prizes for his work (1954 and 1979) amongst other awards, and published some collections of his drawings. He died in Washington DC on 7 October 2001.

BLOMFIELD, WILLIAM 'BLO' (1866-1938)

William Blomfield was born in Auckland on 1 April 1866, the son of Samuel Blomfield, a carpenter. His uncle, Charles Blomfield, was a professional artist. After working in an art shop he began training as an architect. He sold his first cartoon to the weekly *Auckland Observer* and in 1884 joined the staff of the *New Zealand Herald*. In 1887 he moved to the *Observer's* successor, the *New Zealand Observer* and in 1892 became, with William Geddis (a sub-editor on the *Auckland Star*), one of its owners. Blomfield and Geddis later founded two more weeklies: the *Spectator* (1894) in Christchurch and the *New Zealand Free Lance* (1900) in Wellington. Blo was cartoonist on the *New Zealand Observer* for fifty-one years and drew a full-page cover cartoon for it each week as well as a number of smaller drawings inside. He was also mayor of Takapuna (1914-21). Blo died in Auckland on 2 March 1938. His younger brother, John C.Blomfield, was also a regular cartoonist for the *Free Lance* between 1903 and 1908.

'BLUEY AND CURLEY' – see Gurney, Alexander George

BOCCASILE, GINO (1901-52)

Gino Boccasile was born in Bari, Italy, on 14 July 1901, the son of a perfumer. He lost the sight of his left eye while a child but none the less studied at the school of fine art in Bari. After the death of his father in 1925 he moved to Milan and worked for the Mauzan-Morzenti Agency, producing posters and illustrations for fashion magazines. He then followed the poster artist Achille Mauzan to Buenos Aires before returning via Paris (exhibiting at the 1932 Salon des Independants) to Milan where he set up (with Franco Aloi) his own agency, ACTA. He then began contributing to *La Donna* (1932), *Dea*, *La Lettura* (1934), *Bertoldo* (1936), *Il Milione* (1938), *L'Illustrazione del Medico* (1939), *Ecco* and others and also designed book jackets for the publishers

HOW LONG?
D.C.Boonzaier, *The Veldt* (Cape Town),
February 1901

Mondadori and Rizzoli. Pro-Mussolini, he also designed racist and anti-Semitic propaganda posters for the Fascist cause, continued to support Mussolini when he set up a German puppet state in northern Italy and even joined the Italian SS Division for which he drew recruitment posters and other propaganda material such as a 1943 poster portraying US bomber pilots as machine-gun-carrying gangsters who kill children. After the war he was imprisoned briefly as a collaborator but by 1946 had set up his own agency in Milan, designing posters for cosmetics, footwear etc. He died in Milan on 10 May 1952.

BOFA, GUS – see Blanchot, Gustave Henri Emile

BOGDAN – see Nowakowski, Bogdan Bartlomiej

BOONZAIER, DANIEL CORNELIS (1865-1950)

Born in the Carnarvon district of South Africa on 11 November 1865, the son of W.D.Boonzaier, a farmer, he

LONDON
Gino Boccasile, Italian poster, 1940

AN EXTRAORDINARY DREAM
F. Boscovits, *Nebelspalter* (Zurich), October 1900

began work as a handwriting expert, first at the Magistrate's Office in Carnarvon and later at the Colonial Office in Cape Town. Self-taught as an artist, his first drawings were published in the Cape Town magazine *The Knobkerrie* in 1884. He later became South Africa's first ever professional cartoonist, contributing to *The Veldt*, *The Telephone* and the *Cape Punch*. His pro-Afrikaner Boer War cartoons and caricatures appeared in *The Owl* and he also published a book, *Owlographs: A Selection of Cape Celebrities in Caricature* (1901), which included political and military personalities of the war. He later worked for the *South African News* (1903-07)

and in 1907 joined *The Cape*. He then worked in Johannesburg for two years for the *South African Post* before returning to Cape Town to work for *De Burger* (1915-40) and other publications. He died in Cape Town on 20 March 1950.

BOSCOVITS, JOHANN FRIEDRICH
'F. BOSCOVITS' 'FB' (1845-1918)
Born in Budapest, Hungary, on 6 January 1845, Boscovits worked as a painter, illustrator and writer. He contributed to the Swiss satirical magazine *Nebelspalter* from its first issue in 1874 and was its publisher from

IN POSSESSION

Gladstone (not at all at home): 'Hadn't you better come out?'
Leo: 'I have paid enough for it, and you must show very good reason before I quit it.'
William Boucher, *Judy*, 15 September 1880

1902 to 1914. He also drew some notable caricatures of Kaiser Wilhelm II. He died in Zurich on 23 November 1918. His son, Franz Friedrich Boscavits (1871-1965) also drew for *Nebelspalter* as 'FB Junior'.

BOUCHER, WILLIAM HENRY (1842-1906)

The British artist William Boucher, who signed his drawings, 'W.B.', is best known as the main political cartoonist on *Judy* magazine (1868-87), covering such conflicts as the Boer War and Second Afghan War. He also illustrated George Fenn's book *The Kopje Garrison: A Tale of the Boer War* (1901).

BOYD, ALEXANDER STUART 'A.S.B.' 'TWYM' (1854-1930)

A.S.Boyd was born in Glasgow on 7 February 1854, the son of Alexander Boyd, a muslin manufacturer. His father died when Boyd was ten and he studied briefly at the Glasgow School of Art before starting work as a clerk in the Royal Bank of Scotland (1873-9), painting in his spare time (exhibiting in Scottish galleries from 1877 onwards). In 1879 he became a full-time artist and illustrator and after studying at Heatherley's in London (1880) returned to Glasgow to work as a cartoonist for the newly launched weekly *Quiz* (1881-8) under the pseudonym 'Twym'. He moved to the *Baillie* (still as 'Twym') in 1888 and in 1890 became the Glasgow correspondent for the newly launched *Daily Graphic*. Moving to London in 1891 he became the *Daily Graphic*'s main political cartoonist during the Boer War, signing his work with his own name (or 'A.S.B.'). Notable drawings were the front-page cartoon 'Slow but Sure' (1 January 1902), featuring John Bull and Lord Salisbury waiting for the Peace

JOHN'S BULL'S TRIUMPHAL JOURNEY TO PRETORIA
Johan Braakensiek, *De Amsterdammer* (Amsterdam), 1900

plant to grow, and '*Laus Deo* – Peace with Honour' (June 1902), which was reproduced as a postcard published by Raphael Tuck. Boyd also contributed cartoons and illustrations under his own name to the weekly *Graphic* (from 1893), *Punch* (from 1894), *Black & White*, *Idler*, *Sunday Magazine*, *Pall Mall Magazine* and others. He emigrated to New Zealand in 1912 and eventually became president of the Auckland Society of Artists. A.S.Boyd died in Takapuna, New Zealand, on 21 August 1930.

BRAAKENSIEK, JOHAN COENRAAD 'JOHB' (1858-1940)
Johan Braakensiek was born in Amsterdam on 24 May 1858, the son of the artist Albert Braakensiek. After studying at the Amsterdam Academy of Art (1876-81) he began drawing for *Het Politienieuws* and other publications. When the weekly *De Amsterdammer Weekblad* *voor Nederland* (later also known as *De Groene Amsterdammer* because of its green cover) was founded in 1883 he became its main cartoonist, drawing one large and one small cartoon for each issue, and by the turn of the century was regarded as Holland's leading political cartoonist. He published a book of his cartoons about the Spanish-American War and drew some celebrated pro-Boer images during the Boer War, many of which were reproduced as postcards. In addition he drew the cover illustration and contributed many other cartoons to the *De Amsterdammer* anthology *John Bull in Zuid-Afrika* (1900). He also drew anti-German cartoons during World War I, notably 'The Death's Head Airship' (1914) reigning terror on civilians with its caption: '*Voice From the Ship*: "Take note that we only hurt soldiers and sharpshooters! We don't fight against the unarmed and the inoffensive." ' Johan Braakensiek died in Amsterdam on 27 February 1940.

THE FINAL ANSWER?
Luther Bradley, *Chicago Daily News* (Chicago), 4 January 1917

BRADLEY, LUTHER DANIELS (1853-1917)

Luther Bradley was born in New Haven, Connecticut, on 29 September 1853, the son of an estate agent. His family moved to Chicago in 1857 and after studying at Northwestern University he attended Yale University. He then worked for his father's company from 1875 until 1882 when he went on a world cruise. However, while in Australia he missed his ship and, stranded, began work in Melbourne as a cartoonist for *Australian Tidbits*. He later contributed cartoons and journalism to *Melbourne Punch* and was editor of the paper for a year. In 1892 news of his father's illness brought him back to the USA and in 1899 he joined the *Chicago Daily News* as its political cartoonist and art director (his first cartoon for the paper was on 5 July 1899). He was one of very few cartoonists working for the big US daily newspapers who opposed the USA's entry into World War I and died at his home in Wilmette, Illinois, on 9 January 1917, four months before this happened. One of his best known war cartoons was 'The Self-Starter Worked All Right' (*Chicago Daily News*, 15 September 1914) with the figure of Europe trying to stop a car labelled 'War'. His last cartoon, 'The Final Answer?', featuring the figure of Death sharpening a sword labelled 'Renewed Efforts' (*Chicago Daily News*, 4 January 1917),

was published five days before his death. A book of his work, *Chicago Daily News*, was published in 1917.

BRANDT, GUSTAV 'G.B.' (1861-1919)

Born in Hamburg on 2 June 1861, Gustav Brandt studied painting in Düsseldorf and Berlin. He began contributing to *Kladderadatsch* in 1884 and quickly became, with Wilhelm SCHOLZ and Ludwig Stutz, one of its main artists, especially during the Boer War. A notable drawing was 'The Hero in South Africa' (1900) featuring John Bull drinking from a barrel labelled 'Gold Mines' as he tramples over bodies. He later drew cartoons on the Russo-Japanese War and World War I (including covers). Gustav Brandt died in Berlin on 25 February 1919.

BREGER, DAVE (1908-70)

Dave Breger was born of Russian parents in Chicago on 15 April 1908. His father owned a sausage factory whose motto was 'Our Wurst is the Best'. After studying architectural engineering at the University of Illinois he transferred to Northwestern University where he edited the college's humour magazine. Graduating in psychology in 1931, he spent a year abroad, selling cartoons to *Lustige Blätter* and others before returning to his father's factory where he became office manager. In 1937

Gustav Brandt, *Kladderadatsch* (Berlin), 1914

'THE MORE WE ARE TOGETHER...'
José Carlos de Brito e Cunha (J.Carlos), *Careta* (Rio de Janeiro), n.d.

he moved to New York and contributed to *Saturday Evening Post*, *Collier's*, *Parade*, *Esquire*, the *New Yorker* and others. In 1941 he was drafted into the US Army and in June 1942 sailed to London to serve as an artist-photographer for *Yank, The Army Weekly*. He was best known as the creator of Private Breger, a freckle-faced, bespectacled US soldier who first appeared in the *Saturday Evening Post* on 30 August 1941. The panel 'Private Breger Abroad' was then syndicated by King Features (19 October 1942 to 13 October 1945). For *Yank* Breger created 'G.I.Joe' which began on 17 June 1942. 'G.I. Joe' soon became the popular term for an American infantryman ('G.I.' stands for Government Issue). At the time of the creation of the strip Breger had the rank of sergeant but was later promoted lieutenant. The cartoons also appeared as a series of postcards ('Private Breger') and (as 'Private Breger Abroad') in *Ace Comics* (1943-6) and *Magic Comics* (1945). Book collections included *Private Breger: His Adventures in an Army Camp* (1942), *Private Breger's War: His Adventures in Britain and at the Front* (1944), *Private Breger in Britain* (1944) and *G.I. Joe* (1945). A civilian version, 'Mister Breger', was syndicated after the war from 15 October 1945 until 22 March 1970. Breger also drew a series called 'G.I.Jerry' about Hitler and the Nazis. He died on 16 January 1970.

'BREGER, PRIVATE' – see Breger, Dave

'BRITISH CHARACTER, THE' – see Laidler, Gavin Graham

BRITO E CUNHA, José Carlos de 'J. Carlos' (1884-1950)
Born in Rio de Janeiro, Brazil, on 18 June 1884, Carlos studied art in Rio de Janeiro and began work in 1902 as a cartoonist for *O Tagarela* magazine. He later worked for *Avenida* (1903-4), *O Malho, O Tico-Tico* (1905-7), for which he became the first Brazilian to draw Mickey

Ratip Tahir Burak, *Akbaba* (Istanbul), 10 June 1943

Mouse), *Fon-Fon* and others. However, he is perhaps best known for his cartoons, caricatures and illustrations for *Careta* (1908-21 and 1935-50), especially his anti-Nazi drawings during World War II. From 1922 to 1930 he was also art director of all the publications in the *O Malho* group. A collection of his cartoons was published by the Brazilian Ministry of Education shortly before his death in Rio on 2 October 1950.

BUNBURY – see Lancaster, Sir Osbert

BURAK, Ratip Tahir (1904-76)
Born in Istanbul, Turkey, Ratip Tahir graduated from the Maritime School in the city and had his first cartoons published in *Aydede* in 1922. After working as a

THE TRIUMPHANT ENGLISH RETREAT
Antonio Burattini (Buriko), *Il 420* (Florence), 1940

clerk at the Turkish Ministry of External Affairs (1925) he studied art in Paris (1926-8). He then returned to Turkey to work as an art teacher, illustrator and cartoonist for *Akbaba*, *Politika*, *Milliyet* and others. In 1936 he settled in Ankara but returned to Istanbul in 1950 to work for *Hürryet*. In the 1950s he was imprisoned for criticising the press laws of the time. He died in Istanbul on 28 October 1976.

BURATTINI, ANTONIO 'BURIKO' (1891-1969)
Born in Ancona, Italy, on 26 January 1891, Buriko worked for the Florence satirical weekly *Il 420* (named after a German long-range cannon) in the 1930s and 40s. He also contributed to *Il Giornale di Civino e Franco* and *Pinocchio* and in 1932-3 drew for the early issues of *Topolino* (the Italian Disney magazine) and created the character 'Pisellino'. A good example of his wartime work was 'Churchill Sees Swastikas Everywhere' (*Il 420*, 4 August 1940), featuring the British prime minister who says: 'Hell! I must have had a drop too much tonight – this cross is really my cross.' He died in Ancona on 3 June 1969.

BURCK, JACOB (1907-82)
Jake Burck was born near Bialystok, Poland, on 10 January 1907, the son of Abraham Burck, a bricklayer. His family emigrated to the USA in 1914, settling in Cleveland, Ohio. After a period at the Cleveland School of Art he studied at the Art Students' League in New York under the cartoonist Boardman ROBINSON. He worked at first as a portrait painter and signwriter and began to contribute cartoons to the Communist *Daily Worker* and weekly *New Masses* in 1927. He joined the staff of the *Daily Worker* in 1929 and in the 1930s was a contributing editor for the Communist monthly, *Labor Defender*. During this time he produced two books of his cartoons, *Red Cartoons from the Daily Worker* (with Fred Ellis, 1926) and

Hunger and Revolt: Cartoons (1935). After a short trip to the USSR in 1935 he returned to the USA and began work at the *St Louis Post-Dispatch* as political cartoonist in 1937, moving to the *Chicago Times* and *Sunday Times* in 1938, where his cartoons were later syndicated to 200 newspapers in the USA. He won a Pulitzer Prize in 1941 for his cartoon 'If I Should Die Before I Wake' (*Chicago Sunday Times*, 2 June 1940) depicting a small girl saying her prayers in what remains of her bedroom as bombers fly overhead. Threatened with deportation during the McCarthy era, the charges against him were eventually dropped in 1957 and he continued to work for the *Chicago Times* (and its successor the *Chicago Sun-Times*) for forty-four years, his last drawing appearing on 23 February 1982. He died in Chicago on 11 May 1982.

BURIKO – see Burattini, Antonio

BUTTERWORTH, GEORGE GOODWIN (1905-88)

George Butterworth was born in Woodsmoor, Stockport, Cheshire, on 5 January 1905. He won a scholarship to Manchester College of Art and at the age of seventeen was employed as a caricaturist and sports cartoonist on the *Stockport County Express*. Five years later he joined Kemsley Newspapers as a staff artist, working (from 1932) as 'Gee Bee' on the *Daily Dispatch* (sports cartoons). From 1939 he was political cartoonist on various papers within the group (*Evening Chronicle*, *Empire News* and *Sunday Chronicle*) but mainly the *Daily Dispatch* (1939-52). He briefly joined the RAF in 1939 but returned to political cartooning as a service to his country. In 1941 he published a collection of his war cartoons, *Hitler and His Crazy Gang*. He died in Haslemere, Surrey, on 17 October 1988.

CABRAL, ERNESTO GARCIA (1890-1968)

Cabral was born in Huatusco, Veracruz, Mexico, on 18 December 1890, the son of Vincent Garcia Cabral. He studied art at the San Carlos Academy of Painting and Sculpture in Mexico City (1907-9) and became a full-time cartoonist in 1910, contributing to magazines such as *La Tarántula*, *Multicolor* and *Frivolidades*. In 1912, aided by a government grant, he travelled to Paris where he studied at the Académie Colarossi while also contributing cartoons to *Le Rire* and *La Vie Parisienne*. On the outbreak of World War I he remained in Paris and drew strong anti-German cartoons for *La Baïonnette* (1915) and *Le Rire* (1915-17). He became cultural attaché at the Mexican Embassy in Paris in 1917 (he later served in Madrid and Buenos Aires) and returned to Mexico City in 1918. Here he became a very successful cartoonist, contributing to *Revista de Revista* and other publications, and also designed posters and painted murals. He died in Mexico City on 8 August 1968.

CABROL, RAOUL (1895-1956)

Born in Curlande near Bozouls, France, on 12 March 1895, Cabrol was the son of a farm worker. His drawings were first published in *Le Journal du Peuple* (1920) and his first exhibition (1922) was opened by the French minister of education and was later turned into a book, *Masques et Sourires* (Tales and Smiles). His caricatures appeared in a wide range of publications, including *Le Petit Parisien*, *Le Matin*, *Le Ruy Blas* (1921-30), *Le Miroir des Sports* (1922-35), *Le Cri de Paris*

(1923-39), *L'Oeuvre* (1923-40), *L'Humanité* (1924-39), *La Vie Ouvrière* (1927-39), *Le Carnet de la Semaine*, *La Charrette* (including covers), *Le Voltaire* (including covers), *Marianne* (1933-38), *Le Canard Enchaîné* (1939-56), *Franc-Tireur* (1944-50), *La France au Combat* and others including overseas journals such as the *New York Times*, *Life*, *Graphic*, *Sketch* and *Berliner Illustrierte*. His work was praised by Churchill. However, a 1938 drawing of Hitler published in the Luxembourg newspaper, *Escher Tageblatt*, so incensed the Nazis that legal proceedings were taken out against Cabrol (an outcry by fellow artists and the media later led to the case being dropped). He died in Quincy-sous-Sénart on 13 September 1956.

CALLAN, LES (1905-86)

Les Callan was born in Ignace near Kenora, Ontario, Canada. After taking a correspondence course in art he moved to Chicago in 1926 to study at the Chicago Academy of Art. He began as a freelance cartoonist on the *Winnipeg Free Press* and later joined the staff of the *Vancouver Sun* (1928-37), moving to the *Toronto Daily Star* in 1937. He enlisted in the Canadian Reserve Army in July 1940 and joined the Artillery in 1942 before being transferred to the Army Public Relations Branch in Ottawa as a cartoonist for army publications. In 1944 he was sent to France to work for the north-west Europe edition of *The Maple Leaf* (the Canadian Army newspaper) with the rank of lieutenant. Here he created his popular 'Monty and Johnny' daily cartoon featuring Field Marshal Sir Bernard Montgomery and his companion Private Johnny Canuck (the name for an average Canadian).

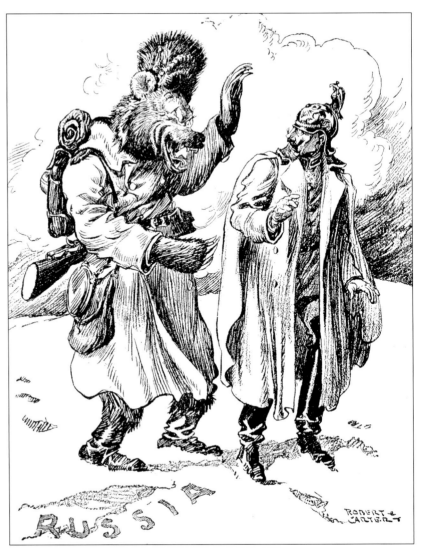

The Bear: 'Glad to see you out again. I feel better myself!'
Robert D. Carter, *New York Evening Sun* (New York),
18 January 1916

Callan followed the Canadian forces through France, Belgium, Holland and Germany, and a book of his cartoons from D-Day to VE-Day was published, *Normandy and on – with the Fighting Canadians: A Cartooniqué by Les Callan* (1945). In its foreword General H.D.G.Crerar (commander of the Canadian Land Forces in Europe) said: 'To be able to see the funny side of a situation, with death lurking around the corner, is a saving grace to a fighting man. Callan's cartoons provided just that requirement.' After the war Callan returned to work for the *Toronto Daily Star* until 1961 when he left to be-

come a freelance illustrator, notably of children's books. He died in Vancouver in October 1986.

CAMARA, LEAL DA – see Da Camara, Tomas Leal

ČAPEK, JOSEF (1887-1945)
Josef Čapek was born in Hronov, Bohemia (then in Austria-Hungary) on 23 March 1887, the elder brother of the writer Karel Čapek (author of the play *R.U.R.*) who credited him with the invention of the word 'robot'. After studying weaving in Vrchlabi (1901-3) he attended the School of Applied Arts in Prague and the Académie Colarossi in Paris (1910-11). At first a painter, poet, novelist and playwright he also worked as a cartoonist for *Lidové Noviny*, the leading Prague daily newspaper, and illustrated children's books. In addition he contributed to *Das III Reich in der Karikatur* (1934), a Czech collection of anti-Nazi cartoons, and produced two series of satirical drawings 'A Dictator's Boots' and 'Principles of German Education' (1933). Arrested on the German invasion of Czechoslovakia in 1939, he spent World War II in Bergen-Belsen concentration camp where he died in April 1945.

CARAN D'ACHE – see Poiré, Emmanuel

'CARELESS TALK COSTS LIVES' – see Bird, Cyril Kenneth

CARLIN – see Bergoglio, Carlo

CARLOS – see Brito e Cunha, José Carlos de

CARTER, ROBERT D. (1875-1918)
Robert Carter was born in Chicago in February 1875 the son of Consider Carter. He began work as a court sketch artist in his home town. Spotted by the newspaper proprietor William Randolph Hearst he then moved to New York in about 1910 to work for the *New York American*, drawing large half-page political cartoons. He later worked for the *New York Evening Sun* for which he notably produced 'Contraband of War' (11 May 1915), after the sinking of the *Lusitania*, which de-

picted Uncle Sam holding a drowned child. He moved to Philadelphia in 1916 where he drew for the *Philadelphia Press*. He died in Philadelphia aged forty-four, after a sudden illness, on 28 February 1918.

CESARE, OSCAR EDWARD (1885-1948)
Oscar Cesare was born in Linköping, Sweden. After studying art in Paris at the age of eighteen, he emigrated to the USA, continuing his studies in Buffalo, New York State. In 1903 he moved to Chicago where he worked as an artist and cartoonist for several papers including the *Chicago Tribune* before moving to New York City c.1911. Here he drew for the *World*, *New York Sun*, *New York Post*, *Harper's*, *Outlook*, *Fortune*, *New Yorker* and others and in 1920 became a regular contributor to the *New York Times*. In addition he worked as an interviewer (notably of Lenin in 1922), illustrating his articles with his own sketches. Amongst his notable World War I drawings is 'Out of the Depths' (*New York Sun*, 1915) showing a huge figure of Death wearing a German helmet emerging from the sea having speared *Lusitania* with its trident. In 1916 he married Margaret Porter, daughter of the writer O.Henry (William Sidney Porter, who was himself also a cartoonist) and continued drawing during the 1930s and 40s. Some of his best drawings from World War I were published in *One Hundred Cartoons by Cesare* (1916). He died at his home in Stamford, Connecticut, on 25 July 1948.

'CHAD' – see Chatterton, George Edward

CHAM – see De Noé, Charles Amédée

CHARLES, WILLIAM (1776-1820)
Born in Edinburgh, Scotland, William Charles worked at first as an engraver and political caricaturist in Edinburgh and London in the early 1800s. In about 1806 he moved to the USA and began producing prints and book illustrations in New York and Philadelphia. His best known cartoons concern the war of 1812 between the USA and Great Britain. Amongst these are 'Bruin Become Mediator of Negotiation for Peace' (1813, featuring the Russian Bear acting as intermediary between Columbia and John Bull), 'Johnny Bull and the

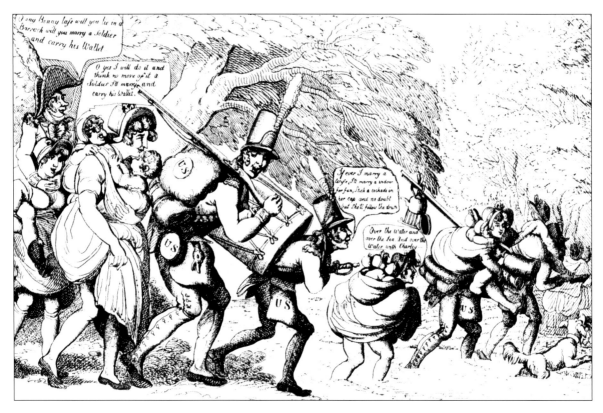

SOLDIERS ON A MARCH TO BUFFALO
William Charles, 1812

Alexandrians' (1814, after the British captured Alexandria, Virginia) and 'A Scene on the Frontiers as Practiced [*sic*] by the Humane British and Their Worthy Allies!' (1812, with Red Indians presenting American scalps to the British). A number of his drawings were derived from GILLRAY originals. William Charles died in Philadelphia in 1820.

CHATILLON, PIERRE (1885-1974)

Pierre Chatillon was born in La Chaux-de-Fonds, Switzerland. During World War I he drew some powerful anti-German images for *L'Europe Anti-Prussienne* (1914-15), *La Victoire* and *La Baïonnette* (1916) amongst others. One of his best known cartoons was 'L'Envoyé de Dieu' (The Envoy of God, *L'Europe Anti-Prussienne*, 25 December 1914), a grisly caricature of Kaiser Wilhelm II as a butcher. Some of his cartoons were also reproduced as postcards. He died in Berne, Switzerland, in 1974.

CHATTERTON, GEORGE EDWARD 'CHAT' (b.1911)

George Chatterton was born in Kidderminster, Hereford, on 15 July 1911 and studied at Kidderminster School of Art and Farnborough School of Photography. He began drawing for magazines and newspapers in 1932, contributing to *Blighty*, *Weekend*, *RAF Review*, *Daily Mirror*, *Daily Sketch*, *Everybody's*, *Leader*, *London Opinion* and others. During World War II he served with the RAF as artist-photographer (1937-50) and was best known for creating the character 'Chad' (sometimes mistakenly ascribed to Jack Greenall). First drawn in 1937 while he was stationed at RAF Cardington in Bedfordshire, the character was originally used on posters for RAF social events. He was later used to remind RAF personnel to return borrowed tools etc and to highlight shortages. Chad was immensely popular during World War II and was featured looking over a wall in a series 'Wot! No...?' After the war he also appeared in strip cartoons such as 'Chad by Chat' and 'Mr Chad' until the

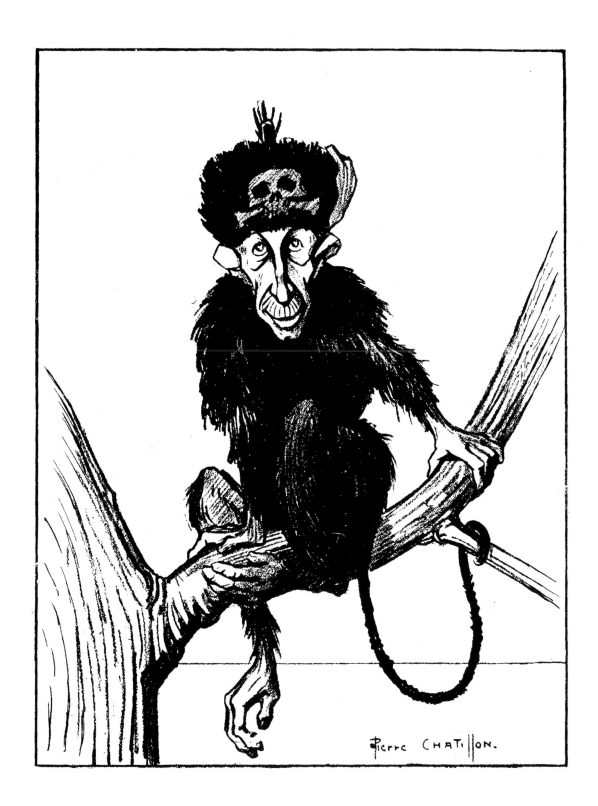

THE HERO OF VERDUN
Pierre Chatillon, 1916

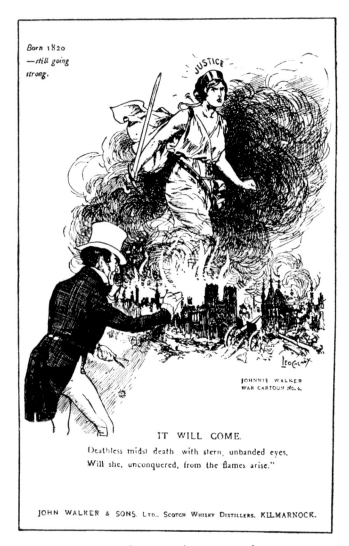

Born 1820
—still going
strong.

JUSTICE

JOHNNIE WALKER
WAR CARTOON No. 6.

IT WILL COME.

Deathless midst death with stern, unbanded eyes,
Will she, unconquered, from the flames arise."

JOHN WALKER & SONS. LTD., SCOTCH WHISKY DISTILLERS. KILMARNOCK.

Leo Cheney, Advertisement for
Johnnie Walker Whisky, 1915

1970s. Chatterton also wrote and illustrated (in black and white) a collection of adventure stories about the French Foreign Legion, *Tattered Tricolor* (1937).

CH'EN I-FAN (CHEN YIFAN) 'JACK CHEN' (1908-95)

Born in China, Jack Chen was a self-taught artist and began to draw cartoons for the Chinese press in 1926. He then moved to Moscow where he studied at the Polygraphic Faculty of Vkhutemas (Higher Art and Technical Workshops) for three years (1927-30), the first Chinese artist to do so. Here he was a near-contemporary of the three cartoonists who became the famous 'KUKRYNIKSI' group. While a student, his photo of Lenin's widow,

Krupskaya, was used on the front page of *Pravda* (it was later made into a montage poster by the cartoonist DENI). After graduating Chen joined the newly launched paper, *Moscow News*, staffed by English and American journalists, and later became its chief cartoonist and art editor while also drawing book and magazine illustrations and posters. He eventually left the paper and became a freelance artist and critic. Arriving in Britain in the 1930s he worked for *Tribune*, *Daily Worker* and others. During World War II he drew the last cartoon published by the latter paper before it was closed down for nineteen months by the government. This cartoon ('Their Gallant Allies', 20 January 1941) shows Churchill inspecting a line-up that consists of figures labelled: 'Dictator Salazar', 'Dictator Metaxas', 'Fascist Staremberg' and 'Dictator (Indian) Princes' amongst others, with Polish Prime Minister Sikorski holding a flag that reads 'War on USSR, Peace with Italy'. Also during World War II Chen produced fine charcoal portraits and illustrations for *Seven* magazine, wrote on art for *The Studio* and *Art & Industry* and produced two books: *Japan and the Pacific Theatre of War* (1942) and *Soviet Art and Artists* (1944). He died in 1995.

CHEN, JACK – see Ch'en I-fan

CHENEY, LEOPOLD ALFRED 'LEO' (1878-1928)

Leo Cheney was born in Accrington, Lancashire, and while working as a bank clerk in the town became the first-ever pupil of Percy Bradshaw's cartoon correspondence course. His first cartoons appeared in *Boys' Own Paper*, *Bystander* and other publications and he sold his first sporting illustrations to the *Manchester Evening News* in 1907. He later became staff sports cartoonist and caricaturist on the paper and then for *Passing Show* in London, contributing a third of the cartoons in the wartime anthology *The Worries of Wilhelm: A Collection of Humorous and Satirical War Cartoons from the Pages of 'The Passing Show'* (1916). He also drew as 'Leo' for the *Daily Chronicle*. One of his notable World War I cartoons was 'The Gnashing Room in a Berlin Hate Club' (*Bystander*, 14 April 1915). Creator of the most famous version of the

'Johnnie Walker' character for John Walker & Sons' Whisky, he also drew wartime variants of this during World War I in the series 'Johnnie Walker War Cartoons'. He later deputised as political cartoonist during POY's absence from the *Daily Mail* (1920-21). Leo Cheney died in Sussex on 29 September 1928.

COLMO, EUGENIO 'GOLIA' (1885-1967)

Golia was born in Turin, Italy, on 29 October 1885, the son of Francesco Colmo, a notary. After studying law he began contributing cartoons to *Due di Picche* and *Torino Ride* in Turin and *Ma Chi E?* in Naples. He also contributed to the Turin satirical journal *Pasquino* (of which he was editor 1904-06). Between 1912 and 1914 he contributed to *Adolescenza*, *La Donna*, *Prisma*, *Guerin Sportivo* and other publications and in 1914 founded (with Caimi, editor of *La Donna*) and Pitigrilli (editor of *Le Grandi Firme*) the satirical weekly *Numero* which would soon afterwards absorb *Ma Chi E?* For this mag-

azine he produced some powerful anti-German cartoons during World War I. In addition he designed a number of wartime cartoon postcards such as 'L'Ingordo' (The Glutton) showing the Kaiser trying to eat the globe. When *Numero* folded in 1922 Golia turned to ceramics (including 'Goodbye to Peace', a colour ceramic bowl, in 1937) and also worked as an illustrator for Mondadori publishers and others. In 1941 he suffered a series of personal crises including the suicide of his wife and the bombing of his studio. After a period in Alba he returned to Turin in 1944 where he became editor of *Vetrine della Gazzetta del Popolo* and also worked as a teacher. He died in Turin on 15 September 1967.

COLOMB, ALPHONSE HECTOR 'B. MOLOCH' (1848-1909)

Born in Paris, Colomb began drawing cartoons for *Belphégore* in 1868 but first came to notice for his caricature work during the Franco-Prussian War (he was

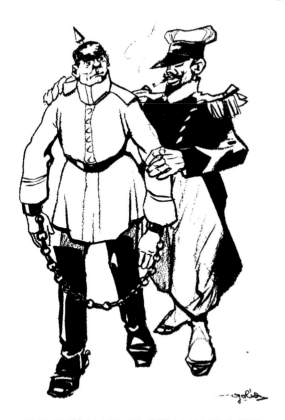

THE ENTRANCE OF GERMAN TROOPS
INTO PARIS
Eugenio Colmo (Golia), *Numero* (Turin),
23 August 1914

BISMARCK PREPARES TO WRITE HIS MEMOIRS
Alphonse Colomb (B.Moloch), c.1890

later an active supporter of the Commune). He contributed political caricatures to *L'Eclipse* (1869-90), *Le Grelot* (1878-80), *Le Sifflet* (1872-8), *Le Pêle-Mêle* (1897-1905), *Le Rire* (1899-1905), *La Silhouette* (including covers), *Le Chambard Socialiste* (including covers), *La Caricature*, *Le Fronde* (including covers), *Le Trombinoscope* (including covers) and *Le Chat Noir* amongst others. He also drew a series of caricatures ('Images Supérieures', 1901-4) for Pellerin, publishers of Les Images d'Epinal (a long-running series of coloured pictorial posters produced in Epinal), and produced anti-British cartoons for *La Silhouette* during the Boer War. He died in Paris on 5 May 1909.

COLVIN, NEVILLE MAURICE (1918-91)
Neville Colvin was born in Dunedin, New Zealand, on 17 December 1918, the son of an accountant. Intending to become a teacher, he studied for an arts degree at Otago University. However, World War II intervened and he served with the Second New Zealand Expeditionary Force in the Middle East, drawing maps. It was for the army's newspaper *NZEF Times* that he created the popular soldier character 'Fred Clueless' which began his cartoon career (he once described him as 'the most stupid little sod you could imagine'). After the war he joined the *Wellington Evening Post* (1946) as political and sports cartoonist and moved to the UK in 1956 to work for the *Daily Sketch*. He then turned freelance, working for *News Chronicle*, *Daily Telegraph*, *News of the World*, *Daily Express* and *Sunday Express*. He is perhaps best known for drawing the 'Modesty Blaise' continuity strip (a James Bond spoof created by Peter O'Donnell), for the *Evening Standard* for nine years – ending in 1986 when he retired aged sixty-eight. He died in Hampstead, London, in November 1991.

COOP, J. WALLACE 'WAL' (fl.1908-1940s)
Wal Coop lived in Birkenhead and Liverpool and worked at first as a caricaturist on the *Liverpool Courier* (c.1908). For this newspaper he produced a book, *Bulls and Bears* (1908), of eighty-nine pen-and-ink caricatures of the members of the Liverpool Cotton Exchange (Liverpool then being the leading cotton port in the UK), including one of the book's compiler, Seymour Taylor. He was political cartoonist on the *Liver-*

'CULTURE!'
J. Wallace Coop, *Liverpool Courier*, 1914

pool Courier during World War I and in the 1920s and 30s drew regularly for the weekly *Gas World*. He also drew for the *News of the World* in the 1930s and during World War II, signing himself 'Wal' or 'Wal Coop'.

COUGHLIN, WILLIAM GARNET 'BING' MBE (1905-91)
Bing Coughlin was born in Ottawa, Canada, on 7 October 1905. The family moved to Philadelphia in 1923 and Bing studied at the Pennsylvania School of Industrial Art. He began work as an advertising artist in Philadelphia but soon after the outbreak of World War II returned to Canada to join the 4th Princess Louise Dragoon Guards, serving in Sicily and Italy and achieving the rank of sergeant. Whilst in Italy he began drawing 'This Army', a series of cartoons about ordinary Canadian soldiers published in *The Maple Leaf* (the Canadian Army newspaper). His main characters were the infantryman Herbie and an unnamed French Canadian soldier. Two books of the cartoons were published during the war (1944 and 1945) and another collection, *Herbie!*, was published in 1946. After the war he returned to work as a commercial artist in Canada and

Philadelphia. Voted Canadian Man of the Year in 1944 by the troops, he was later awarded an MBE (1946) for his wartime cartoons by the Governor-General of Canada. He died on 4 September 1991 and was buried in Springfield, Pennsylvania.

COUNIHAN, NOEL JACK (1913-86)

Noel Counihan was born in Albert Park, Melbourne, Australia, on 4 October 1913. After studying part-time at the National Gallery of Victoria Art School in Melbourne (1930-31) he joined the Communist Party of Australia, helped found the Workers' Art Guild and began producing illustrations for Communist magazines and designing banners. In 1935 he started drawing weekly caricatures for the *Melbourne Argus*. He also contributed to the *Sydney Bulletin*, *Melbourne Sun News-Pictorial* and *Table Talk* magazine. In addition he drew political cartoons for the Communist newspapers *Worker's Weekly* and *Worker's Voice*. During World War II he also produced anti-fascist cartoons for another Communist paper, the *Melbourne Guardian*. In 1949 he left Australia to travel and work in Europe. He travelled through Poland with William GROPPER and later visited Czechoslovakia, Hungary and the UK. In 1951 he returned to the *Guardian* but gave up cartooning in 1958. In 1946 he published *60 Counihan Cartoons*, a collection of his *Guardian* drawings from 1944 to 1946. He died in Melbourne on 5 July 1986.

COVARRUBIAS, JOSÉ MIGUEL (1904-57)

Miguel Covarrubias was born in Mexico City on 22 November 1904, the son of a politician. Self-taught as an artist, he began work drawing maps for a government bureau while also submitting caricatures to local publications and by the age of eighteen his work was syndicated across Central and South America. He later taught art in Mexican schools and in 1923 went to New York on a government scholarship to study art. However, instead of studying he began contributing caricatures of public figures to *Vanity Fair*, *New Yorker*, *Life*, *Time* and *Fortune*. His first book, *The Prince of Wales and Other Famous Americans*, was published in 1925. During World War II he continued the series of caricatures of Nazi leaders ('The Guilty') begun by his friend Sam BERMAN in *Collier's* magazine while

Berman was working as a propaganda artist in India and Burma for three years. He later became an expert on the ancient peoples of Mexico and taught anthropology at the University of Mexico. Covarrubias died in Mexico City aged fifty-three on 4 February 1957.

CRAWFORD, WILLIAM HULFISH (1913-82)

Bill Crawford was born in Hammond, Indiana, USA on 13 March 1913. His family moved to Germantown, Pennsylvania, when he was a child and an early interest in cartoons led him to subscribe to the W.L.Evans correspondence course in cartooning. He also studied art at the Art Institute of Chicago, took a fine arts degree at Ohio State University (where he edited the comic magazine *Sun Dial*) and attended the Académie de la Grand Chaumier in Paris. He then returned to the USA and after a period as a freelance cartoonist joined the *Washington Post* as a staff artist. He then worked for two years at the *Washington Daily News* and in 1938 moved to the *Newark News*, deputising for Lute PEASE before taking over from him as political cartoonist. A notable World War II cartoon was 'This is it!' (1944) showing Hitler holding on to a crumbling stone swastika as he faces countless bayonets. In 1962 he moved to the Newspaper Enterprise Association and became for a time the USA's most widely syndicated editorial cartoonist, his cartoons appearing in more than 700 daily newspapers. He retired in 1977 and died in Washington DC on 6 January 1982.

CRUIKSHANK, GEORGE (1792-1878)

George Cruikshank was born in Bloomsbury, London, on 27 September 1792 the second son of the Scottish-born caricaturist Isaac CRUIKSHANK. His older brother (Isaac) Robert was also a noted caricaturist. He was taught to draw and etch by his father and the first ever published cartoon attributed to him was a war cartoon, 'Boney Beating Mack' (19 November 1805), printed when he was only thirteen years old. It featured Napoleon Bonaparte beating the Austrian General Mack at the Battle of Ulm. In January 1806 (still only thirteen) he also drew an illustration of Lord Nelson's funeral car for *The Times* (at a time when newspapers did not print pictures). In addition his 'The Return to Office' (1 July 1811) – about the scandal around

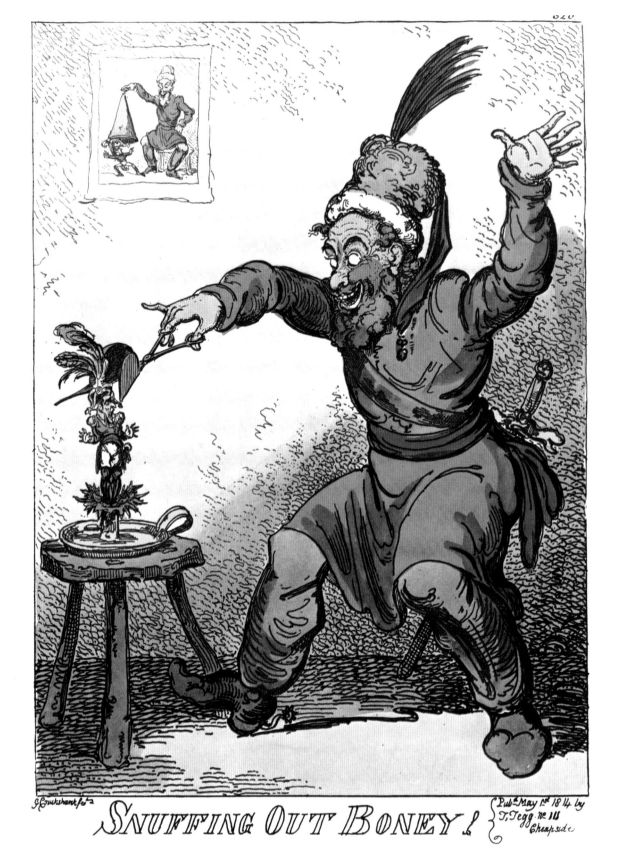

SNUFFING OUT BONEY!
George Cruikshank, 1 May 1814

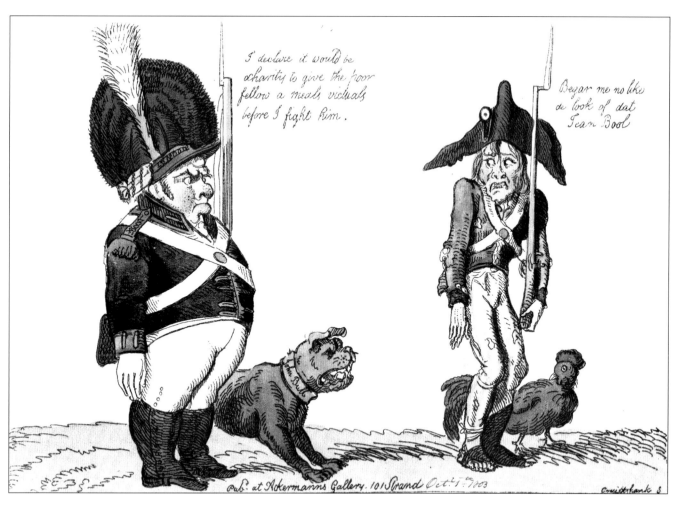

FACING THE ENEMY
Isaac Cruikshank, 1 October 1803

the Duke of York, commander-in-chief of the British Army – was one of the first drawings published in the new monthly magazine, *The Scourge*. With his older rivals James GILLRAY and Thomas ROWLANDSON, Cruikshank drew some of the most famous British caricature images of the Napoleonic Wars. In addition he redrew for the British market a number of wartime cartoons originally designed by the Russian artist Ivan TEREBENEV and illustrated William Combe's *The Life of Napoleon* (1815). Cruikshank was himself a member of the Loyal North Britons, a volunteer regiment made up of Scots in London, and took part in the Grand Review in Hyde Park in 1814 at which the Prince Regent and Tsar Alexander I of Russia were present. He continued drawing during the Crimean War, notably 'Imperial Piety! or the Russian *Te Deum*

for the Successful Slaughter at Sinope' (1853) featuring Tsar Nicholas II praying while kneeling on a pile of corpses. It was published after Russian ships attacked Turkish forces at the Black Sea port of Sinope, drowning 4,000 Turkish sailors. George Cruikshank died in London on 1 February 1878.

CRUIKSHANK, ISAAC (1764-1811)
Isaac Cruikshank was born in Edinburgh, Scotland on 5 October 1764, the son of Andrew Cruikshank (or Crookshanks), a former customs inspector (by then a book and print seller) who had been involved in the Jacobite uprising of 1745. He came to London in 1783 and by 1789 was working as a political caricaturist for the print publisher Samuel Fores. In addition to his own work he etched designs by George WOODWARD

and others. Later rather eclipsed by James GILLRAY, Thomas ROWLANDSON and his own youngest son George CRUIKSHANK, Isaac produced some memorable images of the French Revolution and the Napoleonic Wars, and the first ever British caricature of Napoleon is credited to him ('Buonaparte at Rome Giving Audience in State', 17 March 1797). However, his output declined after 1800 due to his heavy drinking, and he died in London in April 1811. His oldest son, (Isaac) Robert, was also a noted caricaturist.

'CUTHBERT THE WHITE RABBIT' –
see Fearon, Percy Hutton

DA CAMARA, TOMAS LEAL (1876-1948)

Tomas Leal da Camara was born in Pangim, Nova Goa, in Portuguese India on 30 November 1876 the son of Eduardo Inácio da Camara, an army officer. His family moved to Lisbon, Portugal, when he was four years old. After attending the Instituto de Agronomia e Medicina Veterinária he abandoned his studies in 1896 (shortly after the death of his father) and began contributing antimonarchist and anti-clerical cartoons to *O Inferno*, *A Marselhesa* and *A Corja!* However, such was the effect of his drawings that he was forced into exile in Madrid (1898-1901) where he founded (with Francisco Sancha) *Madrid Comico*. He then moved to Paris where he worked for *Le Rire* (1898-1916), *Le Barbare*, *Le Cri de Paris*, *La Marseillaise*, *La Caricature*, *Le Sourire*, *Le Pêle-Mêle*, *L'Indiscret* (1902-3), *Le Journal Pour Tous* (1902-6 including covers) and others. He also became an important contributor to *L'Assiette au Beurre* (1901-12) from the first year of its

PREÇO 2 CENTAVOS

A PASSING SICKNESS
Tomas Leal da Camara, *Miau!*,
25 February 1916

publication and drew many powerful anti-British caricatures in colour for the magazine during the Boer War. Two of its special issues ('Britannique', 28 June 1902 and 'Vive L'Angleterre', 2 May 1903) were entirely devoted to his work. Some of these colour cartoons and caricatures also appeared in the Spanish magazine *Nuevo Mundo*, and as postcards (especially those featuring Kruger and Edward VII). Two years after 'L'Impudique Albion' by Jean VEBER was censored, Da Camara published a cartoon in *L'Assiette au Beurre* (2 May 1903) showing Veber pointing out the offending cartoon to Edward VII at an exhibition of his work. After a brief period in Belgium he returned to Portugal in October 1910 following the Republican revolution and settled in Porto. From 1913 to 1915 he again worked in Paris before returning to Portu-

THE FEAST OF MARS
Honoré Daumier, 1869

gal to teach drawing in Leça da Palmeira. He moved to Lisbon in 1920 and in 1922 travelled to Brazil. On his return to Portugal he drew for *O Seculo* and others, and became co-editor of *Miau!* (for which he also drew many covers) before devoting himself to painting. He settled in Rinchoa in 1930 and died there on 21 July 1948.

D'ACHE, CARAN – see Poiré, Emmanuel

DARLING, JAY NORWOOD 'J.N.DING' (1876-1962)

Ding was born in Norwood, Michigan, on 21 October 1876, the son of Marcellus Warner Darling. After attending Beloit College, Wisconsin, he started work as a reporter for the *Sioux City Journal* (1900-06) in Iowa. He later worked as a sketch artist for the paper before joining the *Des Moines Register and Leader*. He then became editorial cartoonist on the *New York Globe* (1911-13) and in 1913 moved to the *New York Tribune* while also continuing to draw for the *Des Moines Register and Tribune*. Darling signed his cartoons 'J.N.Ding' ('Ding' being a contraction of his surname he adopted while at school). Amongst his World War I cartoons was 'The Rats Are Beginning to Leave' (1918), showing a rat labelled 'Bulgaria' leaving the ship *Teuton Alliance*. He published a number of collections of war cartoons, including *In Peace and War* (c.1916), *Our Sons at Camp Dodge* (1917) and *Aces and Kings* (1918). In 1919 he drew a pastiche of the famous 'Better 'Ole' cartoon by Bruce BAIRNSFATHER to satirise President Wilson's difficult position in trying to sell the League of Nations idea to the US Congress. Having won a Pulitzer Prize in 1924 he won a second one in 1943 for his wartime cartoon 'What a Place for a Waste Paper Salvage Campaign' (11 September 1942). In addition to his cartoons he was also a significant conservationist and won awards for his work promoting wildlife protection. He retired in 1949 and died in Sioux City, Iowa, on 12 February 1962.

DAUMIER, HONORÉ (1808-79)

Honoré Daumier was born in Marseilles on 26 February 1808, the son of Jean-Baptiste Louis Daumier, a glazier. His family moved to Paris when he was aged seven. He started work in a bailiff's office in the city at the age of thirteen and then worked as a bookseller before taking up drawing and lithography. He studied at the Académie Suisse (1823) and his first drawings appeared in *La Silhouette* (1830) and *La Caricature* (1830-40). He later contributed to *Le Charivari* (1833-75), *L'Illustration* (1843-50), *Le Petit Journal Pour Rire* (1861-79), *Le Journal Amusant* (1862-79), *Le Monde Illustré* (1862-78) and others. His caricature 'Gargantua' (*La Caricature*, 29 December 1831) of King Louis-Philippe as Rabelais' fictional giant Gargantua, swallowing public money and defecating favours for his cronies, so enraged the French government that he was imprisoned for six months in 1832-3. After 1835, when total censorship was imposed on the caricaturing of political figures, he turned to social satire, lampooning doctors, lawyers, judges, the army and others. However, during the Crimean War he drew powerful attacks on Tsar Nicholas II and the Russians, notably two colour prints 'The Northern Colossus' (c.1854, showing the Tsar as a deflated balloon descending onto French bayonets) and 'Damn!..It was really stupid of me to want to take on the whole of Europe' (c.1854, with the Tsar struggling to hold back the globe which is rolling over him). Shortly before the beginning of the Franco-Prussian War he also drew 'The European Balance of Power' (*Le Charivari* 3 April 1867), described by the art historian Ernst Gombrich as a 'masterpiece', with a terrified Europa balancing on a smoking bomb. His poignant 'Joyously Singing, Our Brave Troops Move to the Front' was also published nearly eighty years before the US cartoonist Bill MAULDIN won the Pulitzer Prize for a World War II drawing on a similar theme. Increasingly blind in his later years he died in Valmondois on 11 February 1879.

D'AURIAN, JEAN-EMMANUEL 'P.E. PÉRUSAT' 'J.D'A.' (1870-1925)

Jean D'Aurian was born Pierre Emmanuel Marie Pérusat in Bordeaux on 12 December 1870, the son of Pierre Emilien Pérusat, a liquor seller. The family later moved to Paris and at the age of nineteen Jean volunteered to join the French Army, serving in the 16th Infantry regiment for three years. His first drawings (as 'P.E.Pérusat') ap-

THE ENGLISH CLAW
Jean-Emmanuel D'Aurian, 1899

FASCISM EQUALS CONQUERING PEACE AND SERFDOM FOR THE PEOPLE.
THE RED ARMY EQUALS AN AMENDMENT TO THE SITUATION.
Victor Denisov (Deni), Soviet poster, 1943

peared in *Marotte* (1895) and *L'Eclipse* (1896) and he began working as 'Jean D'Aurian' in 1898, contributing at first to *La Petite Caricature* (1898), *Le Petit Bleu* (1898), *Le Rire* (1898-1910) and *Le Pêle-Mêle* (1898-1924). During the Boer War he drew anti-British cartoons and two of these were published as cover illustrations for *La Caricature*. In the first (17 November 1900) President Kruger is shown being protected from Queen Victoria by Queen Wilhelmina of the Netherlands. The second (12 April 1902) has Cecil Rhodes as the 'Napoleon of the Cape', being woken from sleep on bags of gold by the figure of Death who points to flames and piles of skulls as British soldiers raze Boer villages outside. Another powerful Boer War

image was 'The English Claw' (1899) which encircles the globe. He also worked for *Le Sourire*, *Le Charivari*, *Le Journal Pour Tous* (1899-1906 and 1914), *Le Journal Amusant* (1899-1912), *Le Frou-Frou* (1900-10), *La Semaine de Suzette* and the *Almanach Nodot* (1907-14) amongst others. In World War I he enlisted as a reservist in the French Army (aged forty-four) and served as a stretcher-bearer at the barracks in Talence, Gironde. He later drew for children's publications. He died in 1925.

DELANNOY, ARISTIDE (1874-1911)

Aristide Delannoy was born in Béthune, near Lille, France, on 30 July 1874, the son of a clockmaker. After studying painting at the École des Beaux-Arts in Lille and then at the École des Beaux-Arts in Paris (1897) he began exhibiting at the Salon des Indépendants (from 1902). Unable to support his family by painting, he turned to cartoons in 1900, contributing to *La Risette*, *Gil Blas*, *La Caricature* (1900-04) and *La Vie Pour Rire* (1900-06). He later also contributed to *L'Assiette au Beurre* (1901-10, including the whole issue 'Asiles et Fous', 23 July 1904), *Le Rire* (1902-11) *Les Temps Nouveaux* (1905-11), *La Guerre Sociale* (1906-11) and *Les Hommes du Jour* (1908-11, for which he provided almost 150 covers). A revolutionary Socialist, he was a friend of GRANDJOUAN. In 1908, during the Moroccan conflict, one of his caricatures for *Les Hommes du Jour*, featuring the French General Albert d'Amade as a butcher, resulted in him being fined 3,000Fr and sentenced to a year in jail. All income from *Assiette au Beurre*'s special 'Artists' issue (8 May 1909) was given to benefit his family. Released after four months on health grounds, he died in Paris of tuberculosis less than two years later, aged thirty-seven, on 5 May 1911.

DENI – see Denisov, Viktor Nikolaevich

DENIM – see Joss, Frederick

DENISOV, VIKTOR NIKOLAEVICH 'DENI' (1893-1946)

Born in Moscow, Russia, on 24 February 1893, Deni's first drawings were published in *Budilnik* when he was aged seventeen. He moved to St Petersburg in 1913 and studied art under Nikolay Ulyanov. At about the same time he began contributing cartoons to various magazines including *Bich* (of which he became art director), *Satirikon* and others. He became one of the major agitprop poster artists of the Bolshevik period (1917-21) and in about 1919 joined the newly founded state publishing house Litizdat, producing nearly fifty posters during the Russian Civil War. In 1921 he joined *Pravda* as its main daily political cartoonist and

the following year designed the famous and much imitated poster 'Comrade Lenin Cleans the World of Filth', featuring a giant Lenin on the globe sweeping away bankers, royalty and clergy. During World War II he also produced some very striking anti-Nazi posters, including the two-panel 'Fascism Equals Conquering Peace, and Serfdom for the People – The Red Amy Equals an Amendment to the Situation' (1943) with a smug Hitler in the first panel and a battered one in the second. He died in Moscow on 3 August 1946.

DENIZARD – see Orens, Charles Denizard

DE NOÉ, CHARLES AMÉDÉE 'CHAM' (1818-79)

Cham was born in Paris, France, on 26 January 1818, the son of Louis, Comte de Noé, a friend of King Louis-Philippe. Having failed the entrance exam for the École Polytechnique in Paris he worked for the

'AHA, MY FINE FELLOW – THIS TIME YOU'LL HAVE A THORNY MEAL!'
Amedée de Noé (Cham), *Le Charivari*, July 1870

GERMAN OCCUPATION
Stanislaw Dobrzynski, *Sein Kampf* (Jerusalem, 1944)

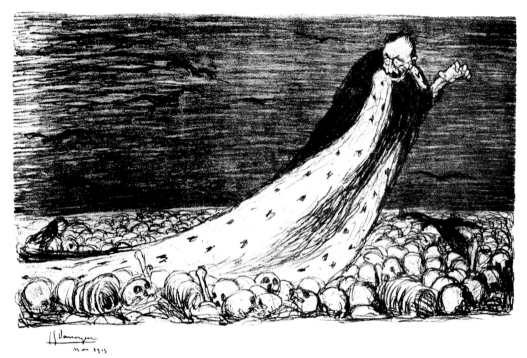

THE MAN RESPONSIBLE
Jean-Gabriel Domergue, 1915

Ministry of Finance before becoming a full-time cartoonist in 1839. As his surname means 'Noah' in French he took as his pseudonym the name of Noah's eldest son Shem (Cham in French, which is also a combination of Charles and Amédé). He began contributing to *Le Charivari* in 1835 and remained with the paper for more than forty years until his death. He also contributed to *L'Illustration* (1843-65), *Musée des Familles* (1849-59), *Petit Journal Pour Rire* (1861-79), *Le Journal Amusant* (1862-71), *Le Monde Illustré* (1866-79), *L'Univers Illustré* (1868-75), *L'Esprit Follet* (1869-72) and others. In addition he produced a number of anthologies of his work. His anti-Prussian drawings during the Franco-Prussian War were particularly powerful (notably Bismarck about to devour a tiny French soldier, *Le Charivari*, July 1870) and as an aristocrat he was one of the very few caricaturists to support the Emperor Napoleon III (he was bitterly opposed to the Commune). A number of his drawings about the Siege of Paris (e.g. 'Queue for Rats' Meat') were published in a book *Album du Siège* (1871). As his sister was married to Russell Henry Manners (later admiral of the fleet), he was a frequent visitor to

Britain and a number of his drawings were also published in British magazines such as *Punch*, *The Man in the Moon*, *Puppet Show* and *Illustrated London News*. He was awarded the Légion d'Honneur. Cham died in Paris on 6 September 1879.

DING J.N. – see Darling, Jay Norwood

DOBRZYNSKI, STANISLAW (1897-1949)
Stanislaw Dobrzynski was a Polish cartoonist who was particularly active during World War II. A contributor to *Szpilki* and other publications, some of his anti-German cartoons were also published in Jerusalem in a book, *Sein Kampf* (1944).

DOMERGUE, JEAN-GABRIEL (1889-1962)
Jean-Gabriel Domergue was born in Bordeaux, France, on 4 March 1889, the son of Gabriel Domergue, a novelist who was also editor of *La Liberté* and *L'Echo de Paris*. After studying at the École Nationale Supérieure des Beaux-Arts he began contributing to *La Baïonnette* (1915), *Je Sais Tout* (1917), *La Gazette de Bon Ton* (1920-22), *Fantasio* and others. One of his

THE DEVIL FOR SMALL CHILDREN

Gustave Doré, *Histoire Pittoresque, Dramatique et Caricaturale de la Sainte Russie* (1854)

best known prints was 'Le Responsable' (The Man Responsible, 1915), featuring the Kaiser amongst skulls etc. He later became celebrated for his posters and designed the poster for the first ever Cannes Film Festival scheduled to open on 1 September 1939 (which never took place because of the German invasion of Poland and France's declaration of war). He received the Légion d'Honneur in 1933. Domergue was curator of the Musée Jacquemart-André (1955-1962) and died in Paris in 1962.

DORÉ, GUSTAVE (1832-83)

Gustave Doré was born in Strasbourg, France, on 6 January 1832, the son of a civil engineer. A self-taught artist, he first visited Paris in 1847 at the age of fifteen and soon after began drawing for *Le Journal Pour Rire*, producing a weekly drawing from 1848 to 1853. His cover for its second issue 'Abd-el-Kadir, le Lion du Jour' (February 1848) featured the Algerian nationalist resistance leader who had finally surrendered to the French in 1847. He also contributed to *L'Illustration* (1851-64), *Le Journal Pour Tous* (1855-62), *Le Monde Illustré* (1857-66), *Le Tour Du Monde* (1860-72) and others. Best known as a book illustrator, Doré was also a pioneer of the comic strip, notably in his *Histoire Pittoresque, Dramatique et Caricaturale de la Sainte Russie* (1854) which also contains a number of large political cartoons about the Crimean War. This anti-Russian book of 500 engravings appeared just as peace negotiations were underway and to avoid any upset the government of Napoleon III bought up the entire edition in 1856, intending to destroy it. Doré died in Paris on 23 January 1883.

DORVILLE, NOËL (1871-1938)

Noël Dorville was born in Mercurey, France, the son of a sub-prefect of the French Empire. He studied in Chalon and Paris and his first drawings were published in *La Caricature* (1895-1901). He also contributed to

CHAMBERLAIN GOES TO WAR
Noël Dorville, 1899

Le Rire (1898-1919), *Le Journal Amusant* (1899-1907), *L'Assiette au Beurre* (1901-2), *La Revue des Causes Célèbres* (1918-20), *L'Echo de Paris*, *Illustrated London News* and others. In addition, in January 1900 he founded the short-lived journal *Le Clou*, whose contributors included Ricardo FLORES, Jules-Félix GRANDJOUAN and Charles-Lucien LÉANDRE. Some of his Boer War cartoons were republished as Dutch postcards. During World War I he was attached to the French topographical service and in 1918 joined the camouflage unit run by the cartoonist Guirand de Scévola (1871-1950). He received the Légion d'Honneur in 1923. He died in Cosne-sur-Loire in 1938. His son Jean (1901-86) and grandson Gérard (1933-76) were also cartoonists.

L'Assiette
au
Beurre

N° 75. — 6 Septembre 190?
50 centimes

Guillaume II

Der Kaiser

Dessins de
D'OSTOYA

WILLIAM II – THE KAISER
Georges D'Ostoya-Sochinsky, *L'Assiette au Beurre*, 6 September 1902

D'OSTOYA-SOCHINSKY, BARON GEORGES 'D'OST' (1878-1937)

Born in Okoclavech, Poland, the son of a Polish aristocrat, D'Ostoya came to Paris aged sixteen. His first cartoons were published in *Le Sourire* and *Le Journal Pour Tous* (1899-1903) and he later contributed to *Le Pêle-Mêle* (1900-24), *Le Rire* (1900-26), *Le Cri de Paris* (1905-28), *Le Matin* (1908-14), *La Guerre Sociale* (1914) and *La Baïonnette* (1915) amongst others. With Laurent Tailhade he illustrated an entire issue of *L'Assiette au Beurre* devoted to Wilhelm II ('Der Kaiser', 6 September 1902),

which also featured his cover of the German Emperor. During World War I he also drew covers for *Ruy Blas* and others and produced two collections of his work: *La Ruée Germanique sur la Pologne* (1915) and *L'Invasion Barbares* (1916). He died in 1937.

DOYLE, GERALD ALOYSIUS (1898-1986)

The son of a postal worker, Jerry Doyle grew up in Philadelphia. At the age of sixteen he started work as a messenger boy on the *Philadelphia Inquirer*, then became a paste-up artist on the *Philadelphia Public Ledger* and eventually rose to be assistant art director of the *Philadelphia Record*. In 1926 he joined the US Merchant Marine and after nineteen months returned to become cartoonist on the *Philadelphia Record*, remaining with the paper until it closed in 1947. A self-taught artist, he also contributed to *Life*, *Time*, *Saturday Evening Post*, *Collier's*, *New York Post* and others. His drawing 'I Saved the Reich' (*Philadelphia Record*, 20 August 1934), a pastiche of Emmanuel Frémiet's famous 1887 sculpture of a giant gorilla with a woman under its arm (but with Hitler as the gorilla) is very similar to a later cartoon, 'John Bull's War Aim' (*Punch*, 18 October 1939), by Bernard PARTRIDGE. One of his best known wartime cartoons was 'Peace Only Through Unconditional Surrender' (*Philadelphia Record*, 27 January 1943) with US President Roosevelt showing a picture of Hitler to Churchill, De Gaulle and French General Giraud. In the painting Roosevelt has extended Hitler's arms held up in surrender to form the letter V for victory. In 1942 he won the National Headliners Award and his cartoon on the death of F.D.Roosevelt

was reprinted in the *New York Times* on 15 April 1945. A selection of his drawings from 1932 to 1943 were published in a book, *According to Doyle: A Cartoon History of World War II* (1943). He later worked for the *Philadelphia Daily News*. Jerry Doyle died on 26 April 1986.

DRANER – see Renard, Jules Jean Georges

DUFFY, EDMUND (1899-1962)

Ed Duffy was born in Jersey City, New Jersey, on 1 March 1899 the son of John T.Duffy, a policeman. While studying at the Art Students' League in New York (1914-19) – where one of his teachers was Boardman ROBINSON – he had his first work (a page of Armistice Day drawings) published in the *New York Tribune Sunday Magazine* in 1918. He later contributed to the *New York Evening Post* and *Scribner's Magazine*. In 1920 he went to Paris to study art and while in Europe contributed to the *Evening News* in London and sent cartoons back to the USA for the *New York Herald*. On his return he worked for *Collier's* and *Century* and was on the staff of the *Brooklyn Eagle* (1922) and the *New York Leader* (1924). In 1924 he moved to the *Baltimore Sun* and remained with the paper for twenty-four years, drawing powerful war cartoons such as 'Civilisation Comes to Africa' showing Mussolini bayoneting Ethiopia. He won the Pulitzer Prize three times (1931, 1934 and 1940). The 1940 prizewinning cartoon, 'The Outstretched Hand' (*Baltimore Sun*, 7 October 1939) published shortly after Germany's invasion of Poland, depicted Hitler holding out a bloody right hand to 'Minorities' cowering amongst burning ruins while in his left he holds papers marked 'No More Territorial Demands', 'Treaty' and 'Broken Promises'. Duffy moved to the *Saturday Evening Post* in 1949 and remained with the paper until 1957. He died in Manhattan, New York, on 12 September 1962.

DUNNE, LAWRENCE FRANCIS (1898-1937)

Frank Dunne was born in Boorowa, New South Wales, and, despite being colour blind, began work as a process engraver producing newspaper blocks. In World War I he served in the First Field Ambulance unit of the Australian Imperial Forces (1915-19) and began drawing cartoons. After the war he worked as an illustrator on the *Sydney Truth* before moving to *Smith's Weekly* in 1928. After the death of Cecil HARTT in 1930 he took over the drawing of the 'Digger' series 'The Unofficial History of the AIF'. A collection of his work, *Digger Days: Laughing Through the Great War*, was published in 1931. He died in Sydney on 23 December 1937, aged thirty-nine.

DYSON, WILLIAM HENRY (1880-1938)

Will Dyson was born in Ballarat, Australia, on 3 September 1880, the younger brother of Edward Dyson, novelist, writer and *Sydney Bulletin* journalist, and Ambrose Dyson, cartoonist of the *Sydney Bulletin* and *Adelaide Critic*. A self-taught artist, his first cartoons were published in the *Sydney Bulletin* and *Lone Hand* when he was seventeen. In 1903 he took over from his brother Ambrose on the *Adelaide Critic*, producing Australia's first cartoons printed in colour, and later worked for *Gadfly* (1906) and *Clarion* (1908). He moved to London in 1909 and the following year married Ruby Lindsay, the sister of the cartoonist Norman LINDSAY (Ruby herself was a successful illustrator who later drew covers for *The Suffragette*). He worked at first for *New Age* and later (from 23 September 1912) was the first-ever cartoonist on the Labour Party paper, the *Daily Herald*. He also contributed to the *Weekly Dispatch*, *World* (colour caricatures in the *Vanity Fair* style signed 'Emu'), *Daily Chronicle* and others. During World War I he also drew for *The Nation* and *Daily Sketch* and produced a series of anti-Kaiser drawings which were later published as a book, *Kultur Cartoons* (1915). On 1 January 1915 the *Daily Mail* reprinted one of these, 'Wonders of Science' (showing monkeys wearing Prussian helmets bombing a city), over the entire back page, occupying more space than any cartoon in a British newspaper up to that time. The same year he was sent to the Front as official war artist to the Australian Imperial Forces and was twice wounded. Other wartime collections included *Conscript 'Em* (1915), *Will Dyson's War Cartoons* (1916) and a book of his war artist sketches, *Australia at War* (1918). After the war he produced one of his best-known drawings: 'Peace and Future Cannon Fodder' (*Daily Herald*, 13 May 1919). It showed Lloyd George, Orlando of Italy, Clemenceau of France and President Wilson of the USA emerging

CROSS AND CRESCENT – TURKEY, 1912
'And the Meek Shall Inherit the Earth.'
Will Dyson, 1912

from the Versailles Peace Conference. Clemenceau ('The Tiger') turns to look in the direction of a naked infant labelled '1940 Class' crying behind a pillar and says 'Curious! I seem to hear a child weeping!' Speaking at the conference Marshal Foch, supreme commander of the Allied forces, had said 'This is not peace, it is an armistice for twenty years.' Returning to Australia in 1925, Dyson was staff cartoonist on the *Melbourne Herald*, and also worked for *Melbourne Punch* and *Table Talk*. He later went back to England to produce front-page cartoons for the *Daily Herald* in August 1931, and a cartoon he drew in June 1935 led to the paper being banned in Italy. His last cartoon, about the bombing of Barcelona during the Spanish Civil

War, was published the day he died, in London, on 21 January 1938. His nephew Edward Ambrose Dyson (1908-52), son of his brother Ambrose, was also a cartoonist for the *Melbourne Guardian* and others.

EFFEL, JEAN – see Lejeune, François

EFIMOV, BORIS EFIMOVICH (1900-2008)

Boris Efimov was born Boris Fridlyand in Kiev, Russia, on 28 September 1900, the son of Yefim Moiseyevich Fridlyand, a shoemaker. His elder brother was the journalist Mikhail Koltsov. The family moved to Bialystok soon after his birth but with the outbreak of World War I returned to Kiev where Boris studied law. A self-taught artist, his first published caricature appeared in a Kiev newspaper in 1919 and he began designing Agitprop posters in 1920-1. In 1922 he moved to Moscow after his brother, by then an editor at *Pravda*, offered him a job drawing cartoons for the paper. He also contributed to *Ogonyok* (a magazine founded by his brother), *Izvestia* and *Krokodil*. His first book of political cartoons (*Politischesliye Karikatury*, 1924) had a foreword by Leon Trotsky. During World War II he produced many colour and black-and-white propaganda drawings and posters featuring savage caricatures of the Nazi leaders. Some of these were distributed in the UK to support the Soviet War Relief Fund, notably 'What is an "Aryan"? He is HANDSOME as Goebbels' (1941) showing Goebbels as Mickey Mouse with a swastika tail. A book of his wartime drawings, *Hitler and His Gang*, was published

Boris Efimov, Soviet poster, 1941

in 1943. After the war he became chief editor of Agitprop and continued to draw for *Pravda* until the 1980s. He was appointed chief artist of *Izvestia* on 28 September 2007, his 107th birthday. He died in Moscow on 1 October 2008.

ELIAS I BRACONS, FELIU 'APA' (1878-1948)

Born in Barcelona, Spain, in June 1878, Apa had his first cartoons published while still a teenager. After studying at Hoyos Painting Academy and Cercle Artistic de Sant Lluc in Barcelona he was soon contributing regularly to *L'Esquella de la Torraxta*, *La Campana de Gràcia* and other publications. In 1904 he set up the magazine *Papitu* and later drew for *El Poble Català*, *Picarol*, *La Publicitat*, *Mirador*, *¡Cu-Cut!* and others. In addition he worked as an art critic under the name 'Joan Sacs'. In 1910 he moved to Paris where he contributed to French journals such as *Le Témoin*, *L'Assiette au Beurre* and *Paris-Midi*. During World War I he produced many savage anti-German cartoons for *Iberia* which were published as a book, *Kamer-*

GENERAL FROST SHAVING LITTLE BONEY
William Elmes, 1 December 1812

aden (1917). He later taught art history at the Escola Superior dels Belis Oficis in Barcelona but fled to Paris after the Spanish Civil War. He was awarded the Légion d'Honneur. Apa died in Barcelona in 1948. His brother Lluis Elias was also a cartoonist.

ELKINS, 'E.' (fl.1930s-40s)
Elkins was a French cartoonist whose drawings first appeared in *Le Rempart* in 1933. He later contributed to *Le Rire* (1934-40), *Paris-Midi* (1937-9), *Le Droit de Vivre* (1937-40), *Vu* (1939-4), *Marianne*, *Vendémiaire*, *Messidor* and others. He also drew for overseas publications such as *Le Peuple* (Brussels), *Evening Standard* and *Pearson's Magazine*. He often signed his work simply with a lower-case E followed by a point.

CRISIS AT THE BUTCHER'S SHOP – THE NEW SAUSAGE
Feliu Elias i Bracons (Apa), *Iberia* (Barcelona), 1 January 1916

Harald Engman, *Den Forbudte Maler*
(Copenhagen, 1944)

Elkins, *Evening Standard*, September 1933

ELMES, WILLIAM (fl.1811-20)

Based in London, Elmes produced a number of anti-French cartoons for Thomas Tegg during the Napoleonic Wars, including a few on the Grand Army's retreat from Moscow such as 'General Frost Shaving Little Boney' (1 December 1812), 'The Valley of the Shadow of Death' (18 December 1812), 'Cossack Sports' and 'The Cossack Extinguisher' (10 November 1813). He also produced anti-American drawings during the New York blockade, such as 'The Yankee Torpedo' (1 November 1813).

EMMWOOD – see Musgrave-Wood, John Bertram

ENGMAN, HARALD (1903-68)

Born in Denmark, Engman was a self-taught artist. With the Nazi invasion of Denmark he fled to neutral Sweden in 1943 where he drew for *Danskeren* (the Free Danish journal in Sweden) and published a collection of his drawings, *Den Forbudte Maler* (The Forbidden Painter, 1945). He also worked as a painter. He died in 1968.

FAIVRE, JULES-ABEL (1867-1945)

Abel Faivre was born in Lyons, France, on 30 March 1867, the son of a professor of science. He studied under J.B.Poncet in Lyons and at the École des Beaux-Arts in Paris (1886-9) and had his first cartoons published in *Le Journal Pour Tous* in 1893. He also contributed to *Le Rire* (1895-1928), *Le Journal* (1899-1941), *Almanach Vermot* (1902-24), *Le Cri de Paris* (1902-17), *Le Figaro* (1907-20), *Candide*, *L'Echo de Paris* (1915-19), *Cyrano* (including covers), *L'Assiette au Beurre* (including a whole issue on doctors, 22 March 1902) and others. A number of his savage satirical cartoons were reproduced as postcards during the Boer War and in World War I he also designed a memorable series of French Victory Loan colour posters, notably 'On Les Aura!' ('We Will Get Them!', 1916) using General Pétain's slogan from the Battle of Verdun. This poster inspired many others including an Italian version (1918) and the US World War II poster 'We have just begun to fight!' (1943), a quotation from John Paul Jones during the American War of Independence. Two collections of Faivre's World War I cartoons were published: *56 Dessins de Guerre* (1915) and *Jours de Guerre 1915-1919* (1920). He was awarded the Légion d'Honneur in 1906. Abel Faivre died in Paris on 14 August 1945.

FAUSTIN – see Betbeder, Faustin

F.C.G. – see Gould, Sir Francis Carruthers

FEARON, PERCY HUTTON 'POY' (1874-1948)

Percy Fearon was born in Shanghai, China, on 6 September 1874, the son of Robert Inglis Fearon, an English merchant. The family moved to New York in 1876 where he studied at the Art Students' League and Chase School of Art in New York. (His pseudonym originated from the American pronunciation of his name ['Poycee'] while he was in the USA.) After the death of his father in 1897 he came to the UK and studied under Hubert Herkomer in Bushey, Hertfordshire. He then worked as principal cartoonist on *Judy* magazine (1898-1904) for which he produced a number of Boer War cartoons. He later moved to Manchester where he became the first ever daily staff political cartoonist on the *Manchester Evening Chronicle* (1905-7) before moving to the *Daily Dispatch* (1907-13) and *Sunday Chronicle* (1907-13). He then returned to London to work on the *Evening News* (1913-35, many of his cartoons being reprinted in its sister morning paper, the *Daily Mail*) and *Weekly Dispatch*. During World War I he served in the City of London National Guard Volunteer Corps (1914-19), attaining the rank of corporal and drawing for its journal *National Guard*. In 1935 he was invited to draw exclusively for the *Daily Mail* (1935-8) and remained with the paper until he retired. Among his most famous creations were John Citizen and Dilly and Dally. However, those with a particular wartime link were Cuthbert the White Rabbit (representing both conscientious objectors and fit men exempted from war service in World War I), and Dora (personifying the Defence of the Realm Act, 1914). Cuthbert first appeared in 'Sketch Map of the Funk Holes of London' (*Evening News*, 27 October 1916) and was so successful that he appeared on the music-hall stage, was produced as a children's toy and even entered the *Oxford English Dictionary* as 'a government employee or officer shirking military service'. A number of his World War I cartoons were published as *Poy's War Cartoons* (1915). He also designed wartime posters, including 'Intern the Germans' (c.1914). Poy died in Putney, London, on 5 November 1948.

FENWICK, IAN (1910-44)

Ian Fenwick was the son of Captain F.H.Fenwick of Market Overton, Rutland. He spent a year at Cam-

THE HUSSAR WILLIAM II

Abel Faivre, *Le Rire Rouge*, 1915

'I am proud, Hermann, to appoint you
Balloon Marshall of the Reich Barrage!'
Ian Fenwick, n.d.

bridge University before going to Berlin to study art. In 1937 he became a 2nd Lieutenant in the Leicestershire Yeomanry and during the 1930s and '40s contributed to the *Bystander*, *Humorist*, *London Opinion*, *Men Only*, *Strand* (notably the 'Ranks and Regiments' series, July 1943-April 1944), *Bulldozer*, *News Chronicle*, *Sunday Dispatch* and the *Tatler*. In World War II he served at first in the King's Royal Rifle Corps and in February 1944 joined the 1st Special Air Service Regiment, later commanding D Squadron in occupied France with the rank of major and being mentioned in dispatches. His wartime cartoon character 'Trubshaw', who features in the collection *Enter Trubshaw* (1944), was reputedly based on Michael Trubshawe, a colourful and eccentric army officer who served during the war in the Highland Light Infantry with Fenwick's childhood friend, the actor David Niven. (Trubshawe was later Niven's

best man and became an actor himself, appearing in *The Guns of Navarone* and other films.) Fenwick also illustrated Jonah Barrington's *Complete Biography of Lord Haw-Haw of Zeesen* (1939). He was killed in Normandy, France, on 7 August 1944 aged thirty-four.

FERRER, JOSEP COSTA 'PICAROL' (1876-1971)
Picarol was born in Ibiza, Spain, on 7 June 1876. In 1888 his family moved to Palma da Mallorca, Majorca, where he studied architecture at the School of Fine Arts. In 1896 he moved to Barcelona where he began drawing cartoons for ¡Cu-Cut!, *La Tomasa*, *La Rambla* and others. He became particularly well known for his contributions to the humorous weeklies *L'Esquella de la Torraxta* and *La Campana de Gracia*. His World War I series 'Kultur Antologia Barbara de Los Tiempos' (A Barbarous Anthology of Modern Times) was published in *La*

DELUSIONS OF GRANDEUR
Josep Costa Ferrer (Picarol), *L'Esquella de la Torratxa* (Barcelona),
17 March 1916

Campana de Gracia and later as a book in 1915. He also contributed to overseas publications such as *L'Asino* (Rome) and *Frivolidad* (Mexico). In 1928 he settled in Majorca, opened an art gallery there (Galeria Costa) and wrote, edited and published tourist guides (Guias Costa) and art books while also drawing illustrations for local papers. He died in Palma da Mallorca, Majorca, on 9 December 1971.

FIPS – see Rupprecht, Philipp

FITZPATRICK, Daniel Robert 'Fitz'
(1891-1969)
Daniel Fitzpatrick was born in Superior, Wisconsin, on 5 March 1891, the son of Patrick Fitzpatrick. After studying at the Chicago Art Institute he joined the *Chicago Daily News* in 1911 as a staff artist (and deputy to Luther BRADLEY) using the pseudonym 'Fitz'. In 1913, at the age of twenty-two, he moved to the *St Louis Post-Dispatch* where he succeeded Robert MINOR as chief editorial cartoonist, by now signing his car-

toons 'Fitzpatrick'. He remained with the paper for forty-five years, through two world wars, before retiring in 1958. He also worked for *Collier's* and *Life*. Widely reprinted, his work earnt him two Pulitzer Prizes (1926 and 1955). Fitzpatrick was one of the first US cartoonists to draw Hitler, who first appeared in 'The Source' (*St Louis Post-Dispatch*, 19 October 1930) where he is seen emerging from a rolled-up copy of the Versailles Treaty. He also drew cartoons on the Spanish Civil War, such as 'Spectators at the Ringside' (*St Louis Post-Dispatch*, 9 August 1936) but is best known for his wartime and pre-war anti-Nazi cartoons. Notable amongst these is 'What Next?' (*St Louis Post-Dispatch*, 25 September 1938) showing Hitler on top of a giant swastika steamroller. A number of his wartime cartoons appeared in his books *Cartoons* (1947) and *Editorial Cartoons, 1913-45* (1965). He died on 18 May 1969.

FLAGG, JAMES MONTGOMERY (1877-1960)

James Montgomery Flagg was born in Pelham Manor, Westchester County, New York, on 18 June 1877. Brought up in Brooklyn and Yorkville he sold his first cartoon to *St Nicholas* magazine aged twelve and was contributing to *Life* and *Judge* at the age of fourteen. He later attended the Art Students' League in New York and the Herkomer School in England and spent two years studying art in Paris. He is best known for his World War I recruiting poster 'I [Uncle Sam] Want YOU for US Army!', based on the original British design featuring Lord Kitchener by Alfred LEETE. It first appeared as a cover for *Leslie's Illustrated Weekly Newspaper* (6 July 1916) and Flagg himself was the model for Uncle Sam. Four million copies of the poster were printed in World War I and 350,000 more in World War II. Another well-known wartime poster was 'Together We Win' (1918, depicting a soldier, a sailor and a factory worker) and a series for War Savings Stamps. In addition he drew covers for the US government's World War I journal *Bulletin for Cartoonists*. He published a number of collections of his work and an autobiography, *Roses and Buckshot* (1946). He died in New York on 27 May 1960.

FLATTER, JOSEPH OTTO (1894-1988)

Joseph Flatter was born in Brigittenau, Vienna, on 26 May 1894, the son of Sigmund Flatter, a distiller of schnapps who also ran a bar. He was a student at the Royal Academy of Fine Art in Vienna when World War I broke out and served in the Austrian Imperial Army. After the war he earned a living as a portrait painter and art lecturer. He came to England in 1934 to research English art for a lecture tour of Czechoslovakia but in 1936, aware of the growing power of the Nazis, decided to stay. In 1940 he was arrested and interned on the Isle of Wight, despite being classified as a 'harmless alien'. However, after he had spent three months as camp cook the Ministry of Information – at the suggestion of David LOW and others – procured his release to work on anti-Nazi cartoons for its overseas department. He also drew for *Die Zeitung* (a German paper published in London), *Sunday Dispatch* and the *Sketch* as well as for the Belgian Refugee Government in London and a Free French newspaper. In addition he produced a series of illustrations satirising Hitler's *Mein Kampf*, which were exhibited around the UK. A notable example is 'The Herrenvolk's Dream' with figures labelled 'Africa', 'Europe' and 'America' carrying a German family on a giant clam-shell while 'China' holds a swastika fan above their heads. In 1946 he was sent by the MOI (with the temporary rank of captain in the British Army) to Nuremberg to draw the defendants in the Nazi war crimes trials. He died in London on 16 July 1988.

FLORÈS, RICARDO (1878-1918)

Ricardo Florès was born on 19 October 1878 in Alençon, France, the son of a Peruvian father. He began work in the office of a military engravers in Alençon in 1894 but in 1896 moved to Paris to study at the École des Beaux-Arts. His first cartoons were published in *Le Rire* (1897-1918) and he also contributed to *Le Sourire* (1900-18), *L'Assiette au Beurre* (1901-11, including a number of entire issues), *Le Cri de Paris* (1906-16), *Fantasio* (1907-14), *Le Journal* (1910-17), *La Baïonnette* and others. In World War I he served in the 103rd Infantry Regiment of the French Army. He published two books of war cartoons: *Boches!*

BEYOND DOUAUMONT
'Poor Michael, this is not the day to look for a victory bulletin.'
Ricardo Florès, *Le Journal*, 26 October 1916

Deutschland Unter Alles (1914) and *Encore des Boches* (n.d.). He died of a war wound on 20 October 1918 in a military hospital in Rennes, France.

FORAIN, LOUIS-HENRI
[known as JEAN-LOUIS] (1852-1931)
Forain was born in Reims, France, on 23 October 1852, the son of a house-painter. His family moved to Paris when he was eight years old. After studying briefly at the École des Beaux-Arts in Paris (1867-8) and under the sculptor Carpeaux (1869-70) he worked for a short time in the studio of André GILL. He began work as a cartoonist in 1876, his first drawings appearing in *Le Scapin* (1876), *L'Eclipse* (1876) and *La Cravache Parisienne* (1876-7). He later contributed to *Le Figaro* (1885-99 and 1915-25), *L'Echo de Paris* (1892-1903), *La Vie Parisienne*, *Le Rire* (1894-1904), *Le Frou-Frou* (1900-22), *Le Gaulois* (1904-21), *Le Journal Amusant* (1886-99), *L'Assiette au Beurre*, *Le Chat Noir*, *Gil Blas*, *L'Opinion*, *Oui* and *Le Courrier Français* (1887-1907) amongst other publications. More than 3,000 of his social satires were later published as a series of books. In 1889 he founded his own short-lived journal, *Le Fifre*, and in 1898, with his friend Caran D'ACHE, set up the weekly *Pssst...!* (1898-9) as a vehicle for anti-Dreyfus satire. During World War I he worked as a camouflage artist while continuing to draw powerful, often grim cartoons, many of them about trench warfare and the lot of the French *poilu*. A particularly well known one was 'L'Inquiétude' (Anxiety, *L'Opinion*, 9 January 1915) featuring two *poilus* in conversation in a trench: 'If only they can hold out!' 'Who?' 'The civilians!' Another, 'La Borne' (The Milestone, *Figaro*, 22 March 1916) showing German dead at a milestone marked 'Verdun', was used as aerial propaganda dropped over the German trenches. A

ANXIETY
'If only they can hold out!' 'Who?' 'The civilians!'
Louis-Henri Forain, *L'Opinion*, 9 January 1915

collection of his war drawings, *De la Marne au Rhin: Dessins des Années de Guerre 1914-1919*, was published in 1920. He was awarded the Légion d'Honneur in 1928. Forain died in Paris on 11 July 1931.

FOUGASSE – see Bird, Cyril Kenneth

'FRED CLUELESS' – see Colvin, Neville Maurice

FRIELL, JAMES 'GABRIEL' (1912-97)
James Friell was born in Glasgow on 13 March 1912, the son of James Friell, an actor. Leaving school at fourteen, he worked at first in a solicitor's office and taught himself to be a cartoonist, freelancing for the *Glasgow Evening Times* (1930-39). He then studied commercial art at Glasgow School of Art (1930) and began work in the advertising department of Kodak. He came to London in 1932, working as an advertising artist and contributing drawings to *World's Press News* and others. In February 1936 he joined the *Daily Worker* as political cartoonist (as 'Gabriel') where he was billed as 'Fleet Street's greatest discovery since David LOW'. A month later, satirising Hitler's announcement after the occupation of the Rhineland, he drew ' "I Come as a Herald of Peace" – Herr Hitler' (*Daily Worker*, 20 March 1936) featuring a

saintly Hitler (with gasmask and sword) hiding Goering, Goebbels and massive Nazi military forces. (Two days later a contrasting, pro-Hitler, cartoon was drawn by Arthur JOHNSON for the cover of the weekly German magazine *Kladderadatsch*.) In World War II he served in the Royal Artillery (1940-46) and helped set up *Soldier* magazine in 1944, working as cartoonist, art editor, layout man and printer liaison. He also contributed to *Seven* (including colour covers) and the combined operations magazine *Bulldozer* (including covers), signing himself 'Jas F.', 'Gnr Friell' or 'Jas Friell'. Three collections of his cartoons (including his war cartoons) were published: *Gabriel Cartoons* (1938), [with Dyad] *Daily Worker Cartoons* (1944) and *Gabriel's 1946 Review* (1946). He also drew the cover (and most of the cartoons) for *13 Years of Anti-Fascist Struggle* (1943) to mark the *Daily Worker's* anniversary. He rejoined the *Daily Worker* in 1946 but left when the Soviet Union invaded Hungary in 1956 and joined the *Evening Standard* (1957-62), drawing as 'Friell'. He then worked freelance before joining *New Civil Engineer* as its first cartoonist (1972-88), drawing as 'Field'. James Friell retired in 1988 aged seventy-five and died in Ealing, London, on 4 February 1997.

FURNISS, HARRY (1854-1925)
Harry Furniss was born in Wexford, Ireland, on 26 March 1854, the son of James Furniss, a civil engineer from Yorkshire. He studied at the Royal Hibernian Schools and the Hibernian Academy and his first published cartoon appeared in *Zozimus* on 31 August 1870. His first job was as a clerk to a wood-engraver, and in 1873 he moved to England, working at first for *London Society* and then as an illustrator and graphic reporter for the *Illustrated London News* (from 1876) and *Illustrated Sporting & Dramatic News*. He also contributed to *Black & White*, *Graphic*, *Daily News*, *Pall Mall Magazine*, *Sketch*, *Vanity Fair* and others. His first

ALL-ROUND POLITICIANS
No.1 – The G.O.M. Variety Entertainer
Harry Furniss, *Punch*, 21 February 1891

cartoons for *Punch* were published on 30 October 1880 and for the next three decades (until 1894) he contributed more than 2,600 drawings to the magazine. He left in 1894 and set up the weekly *Lika Joko*, which sold 140,000 copies on its first day. Then in 1895 he merged *Lika Joko* with *Pall Mall Budget* to form the short-lived *New Budget*. During the Boer War Furniss drew whole-page political cartoons for *The King* (founded on 6 January 1900) and produced a series of postcards attacking Chamberlain and others. He later worked for the Edison Film Company in the USA (1912) and himself wrote and produced animated films, such as *War Cartoons* (1914) and *Peace and Pencillings* (1914). He also published numerous books and gave illustrated lectures including 'Peace with Humour' and 'The Frightfulness of Humour'. Harry Furniss died in Hastings, Sussex, on 14 January 1925.

G

GABRIEL – see Friell, James

GALANTARA, GABRIELE 'RATA-LANGA' 'R.L.' (1865-1937)

Born in Bologna, Italy, Galantara began work as a cartoonist in the city, contributing to *Bononia Ridet* and *La Rana*. He moved to Rome in 1890 and in 1892 founded (with Guido Podrecca) the satirical Socialist weekly *L'Asino*, to which he contributed cartoons (including covers) using the pseudonym 'Rata-Langa' (an anagram of his surname). He also drew for *Avanti!*, and foreign satirical magazines such as *Der Wahre Jacob* (notably drawings on the Russian Revolution of 1905), *Les Corbeaux*, *Le Canard Sauvage* and *L'Assiette au Beurre* (1905-7, including an entire issue on 'The Vatican' in 1905). Galantara and Giuseppe SCALARINI were Italy's leading cartoonists of their generation. During the Boer War he produced anti-British cartoons and his drawing 'England Transvaal' (15 October 1899) was reproduced in a series of Dutch postcards. During World War I, he drew some powerful anti-German cartoons, including 'Wilhelm in Four Acts' (*L'Asino*, 11 October 1914), featuring the progressive decay of the Kaiser. However, the arrival of Fascism in Italy led to the suppression of press freedom and his work declined after the war. Galantara died in Rome in 1937.

GARVENS, OSCAR (1874-1951)

Oscar Garvens was a German sculptor and painter who regularly contributed cartoons to the Berlin weekly

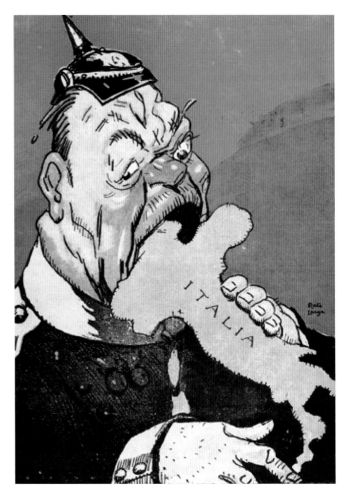

IF THE BRUTE STILL HAD ITS TEETH
Gabriele Galantara (Rata-Langa), *L'Asino*, c.1916

Kladderadatsch. One of his most reproduced anti-Nazi drawings was 'Memorial to the "Sculptors of Germany"' (*Kladderadatsch*, 1933) in which Hitler is seen crushing a 'decadent' sculpture by a Jewish artist and remodelling it into a pseudo-classical male nude. He later became pro-Nazi and also produced posters such as 'Monstre, Tu Nous Fais' (Monster, You Make Us Like This) showing Churchill and a starving family. He died in 1951.

GAS – see Stevens, G.A.

GASSIER, HENRI-PAUL (1883-1951)

Henri-Paul Gassier was born in Paris, the son of a dramatist. His first drawings were published in *Le Geste* in 1902. He later contributed to *La Guerre Sociale*

(1906-15), *L'Humanité* (1908-26), *Les Hommes de Jour* (1908-39), *L'Egalité* (1913-23), *Le Merle Blanc*, *Le Crapouillet* (including covers), *La Gazette* (including covers), *Le Carnet de la Semaine*, *Le Petit Parisien* (1914-40), *Journal Contre la Guerre*, *Le Canard Enchaîné* (1915-19, including the cover drawing attacking censorship for its first ever issue, 10 September 1915), *Le Populaire* (1918-34), *Paris-Soir* (1923-39), *Le Journal* (1925-39), *La Lumière* (1933-40) and others. He also founded two short-lived journals, *La Chaudière* (1912-13) and *Pif-Paf* (1932). Gassier died in Rocquemont, France, in 1951.

GÉRARD, JEAN IGNACE ISIDORE
'J.J.GRANDVILLE' (1803-47)

Grandville was born in Nancy, France, on 15 September 1803, the son of a miniature painter. After studying art in Paris he worked at first as a costume designer for L'Opera Comique. His first cartoons were published in *La Silhouette* (1829) and he also contributed to *La Caricature* (1830-39), *Le Charivari* (1832-35), *Magasin Pittoresque* (1834-47) and others, frequently attacking King Louis-Philippe. Later an inspiration for the Surrealists for his drawings of humans with animal heads – some of which were collected into the books *Les Metamorphoses du Jour* (1829) and *Scènes de la Vie Publique et Privée des Animaux* (1842) – he also drew some powerful war cartoons. Amongst these were 'Order Reigns in Warsaw' (*La Caricature*, 1831) showing a Cossack standing in a bloody battlefield after the Warsaw uprising against Russian rule. He died in Vanves, France, on 17 March 1847.

GHILCHIK, DAVID LOUIS (1892-1972)

David Ghilchik was born in Botosani, Romania, and moved to England when he was five, eventually settling in Manchester. At the age of sixteen he won a scholarship to study at Manchester School of Art under Adolphe Valette (L.S.Lowry was a contemporary), and while still a student succeeded the political cartoonist Sid Treeby on the Manchester-based *Labour Leader* (then the official Labour Party newspaper before the *Daily Herald*) when Treeby returned to Australia in 1908. His first cartoon for the paper was used as a full front page. He also drew political cartoons for the Man-chester-based Socialist weekly, *Laughter Grim and Gay*, before moving to London to study at the Slade under Henry Tonks and then in Paris, Florence and Venice on a travelling scholarship. He then worked as a commercial artist. In World War I he served first as a driver/mechanic in the British Army Service Corps and later in the Intelligence Corps in Italy. His first cartoon for *Punch* was published while he was on active service in France and he later contributed regularly to the magazine (1921-39). He also drew for the *Humorist*, *Bystander*, *Time & Tide*, *Blighty*, *Passing Show*, *News Chronicle*, *Radio Times* (caricatures) and *Men Only*. During World War II he was political cartoonist on the *Daily Sketch*, succeeding Clive UPTTON. A founder member of the Society of Wood Engravers (1920), he was also president of the London Sketch Club (1942). David Ghilchik died in London on 24 November 1972.

GIBSON, CHARLES DANA (1867-1944)

Charles Dana Gibson was born in Roxbury, Massachusetts, on 14 September 1867. He studied at the Art Students' League in New York (1884-6) and had his first cartoon published in *Life* on 25 March 1886. He later worked as a political cartoonist for *Tid-Bits* and also contributed to *Time* and *Puck*. In 1888 he travelled to Britain and France before returning to the USA where he began to draw stylish US society women (later dubbed 'The Gibson Girl') for *Collier's* magazine. In 1905 he again departed for Europe to study and paint, returning in 1910. During World War I he drew anti-Kaiser cartoons for *Life*, notably 'Hanging the Kaiser – A Favourite Sport' (1918) showing Uncle Sam about to string up Wilhelm II to a tree. One of his cartoons, '*Mother*: "Here he is, Sir" ' (*Life*, 19 April 1917), showing a mother presenting her son to Uncle Sam, featured Gibson's own son Langhorne who left Yale to enlist in the US Navy. It was later used as a US Navy recruiting poster. Gibson was also appointed head of the wartime Division of Pictorial Publicity for the US government. In 1920 he became owner and editor of *Life*. He died in New York on 23 December 1944.

'G.I.JOE' – see Breger, Dave

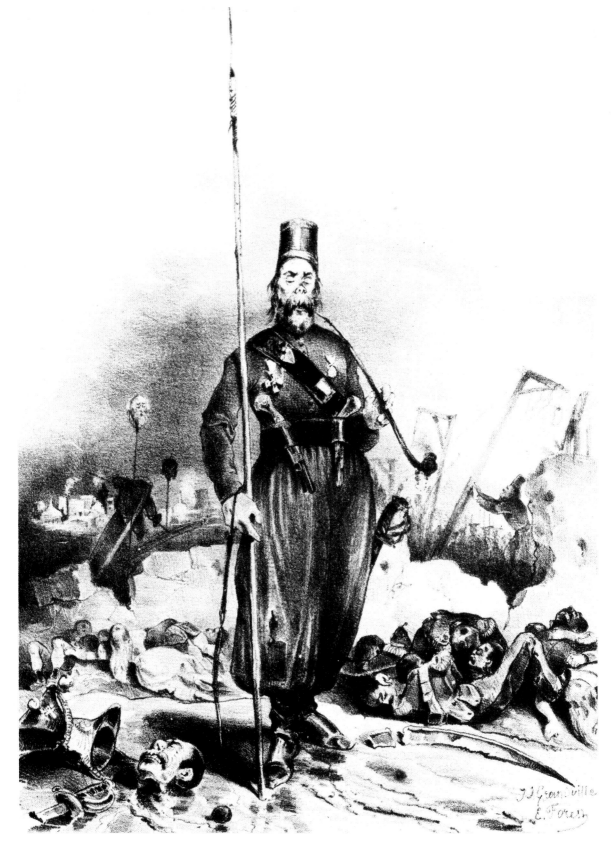

ORDER REIGNS IN WARSAW

Jean Ignace Isidore Gérard (Grandville), *La Caricature* (Paris), April 1831

GILES, CARL RONALD OBE (1916-95)

Carl Giles was born on 29 September 1916 in Islington, London, the son of Albert Giles, a tobacconist, and grandson of Alfred 'Farmer' Giles, a jockey who had ridden for Edward VII. As a child his nickname 'Karlo' (after the actor Boris Karloff, because of his short hair) became abbreviated to Carl, which stuck. He left school at the age of fourteen, working first as an office boy and then as an animator in Wardour Street, London. Moving to Elstree he joined Alexander Korda's studios (1930-35) and was one of the principal animators of Korda's *The Fox Hunt* (artist Anthony Gross), the first British animated colour cartoon with sound. He then worked as an animator in Ipswich but on the death of his brother returned to London to work for the weekly *Reynold's News* (1937-43), producing editorial cartoons and a strip 'Young Ernie'. On the outbreak of war he was classified as unfit for service and so continued drawing for *Reynold's News* while also contributing (from May 1941) to the Communist pocket magazine *Our Time* (including covers), *The Journalist* (1942-4), *AEU Journal*, *Men Only* and others. He also drew colour covers for Evelyn Thomas's series of popular joke books such as *Humours of ARP* (1941) and *Laugh With the Home Guard* (1941). In October 1943, tempted by greater pay, he joined the *Sunday Express* as editorial cartoonist and later also became deputy to Sidney STRUBE on the *Daily Express* and the paper's first ever cartoonist war correspondent. He was with the Second Army in France, Belgium, Holland and Germany and was at Belsen when it was liberated and drew sketches and wrote reports. During the war he also produced animated films for the Ministry of Information (such as *The Grenade*, 1944) and his cartoons were reproduced as posters for the Railway Executive Committee and others. One of the founder members of the British Cartoonists' Association in 1966 (he was later its president), he was awarded an OBE in 1959. Though best known for his postwar *Express* cartoons featuring the 'family', early

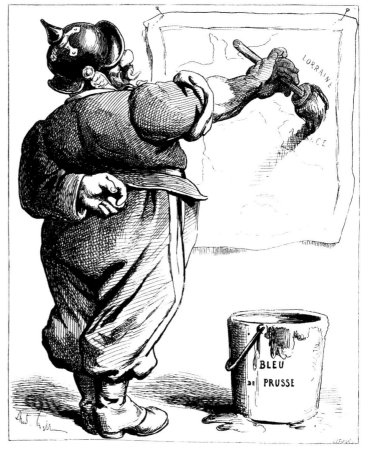

André Gill, *L'Eclipse*, 19 October 1873

versions of his famous Grandma character can be seen in some of his wartime work. A collection of his wartime *Express* cartoons (the first of many annuals) was published in 1946. Carl Giles left the *Express* in October 1989 and died in Ipswich, Suffolk, on 27 August 1995.

GILL, ANDRÉ 'FLOCK' (1840-85)

Louis-Alexandre Gosset de Guines was born in Paris on 7 October 1840, the illegitimate son of the Comte de Guines. While a student at the École des Beaux-Arts he began contributing to *Le Journal Amusant* in 1859 aged nineteen using the pseudonym 'André Gill' in homage

THE HAND-WRITING UPON THE WALL
James Gillray, 24 August 1803

to James GILLRAY. He later also contributed to *Le Charivari* (from 1860), *Le Petit Journal Pour Rire* (1861-85) and others but first came to fame with his series of caricatures 'The Man of the Day' for *La Lune* (1866-8), including Bismarck as a huge cat trying to trap the French mouse (7 April 1867). However, Emperor Napoleon III took exception to being portrayed as the fictional ruffian Rocambole and *La Lune* was banned in January 1868. It re-emerged shortly afterwards as *L'Eclipse* with Gill again its chief caricaturist (1868-76). For the cover on 19 October 1873 he drew Kaiser Wilhelm I painting Alsace-Lorraine Prussian blue after annexing it following the French defeat in the Franco-Prussian War. During the Commune period he was conservateur of the Musée du Luxembourg and reorganised its collections. He also drew for the Socialist newspaper *La Rue* and (as 'Flock') for *Le Grelot*. When government censorship clamped down on press freedom he drew 'L'Enterrement de la Caricature' (The Funeral of Caricature, *L'Eclipse*, 30 November 1873). Gill later set up his own

magazine, *La Lune Rousse* (1876-9). At the age of forty-one he began to suffer from mental illness and died on 1 May 1885 in Charenton asylum for the insane in Paris.

GILLRAY, JAMES (1756-1815)
James Gillray was born in Chelsea, London, on 13 August 1756, the son of a former soldier who had lost an arm in Flanders while serving under the Duke of Cumberland during the War of the Austrian Succession. After serving an apprenticeship to an engraver he entered the Royal Academy Schools in 1778 to study engraving under Bartolozzi. Though he had produced his first caricatures in 1775 he began work as an engraver of portraits and illustrations. However, from 1786 onwards he concentrated on political caricatures, notably for the London printseller Mrs Hannah Humphrey. He quickly became the leading caricaturist of his day and was particularly successful in his work during the French Revolution and the Napoleonic Wars, beginning with prints such as 'French Liberty and British Slavery'

(1792) and 'The Zenith of French Glory' (1793). His 'The Plumb-Pudding in Danger' (26 February 1805), showing British Prime Minister William Pitt and Napoleon carving up the globe, is one of the best known political cartoons of all time and has been much parodied. Gillray had first-hand experience of warfare himself as he was present in Flanders during the campaign of 1793-5, having been invited by the painter Philippe de Loutherbourg RA (1740-1812) to draw portraits of the Allied commanders for his painting *The Grand Attack at Valenciennes* (1793-4). Thus Gillray became the first cartoonist ever to be an official war artist – he even drew a cartoon 'The Military Caricaturist' (6 December 1799). He also created the character of 'Little Boney', who first appeared in 'German Nonchalence [*sic*], or the Vexation of Little Boney' (1 January 1803). Napoleon himself was especially angered by his prints 'The Handwriting on the Wall' (24 August 1803) and 'The Grand Coronation Procession of Napoleon the 1st, Emperor of France' (1 January 1805). Gillray also drew an anti-war strip 'John Bull's Progress' (1793). His health began to decline in 1807 and by 1810 he was mentally ill. He died in London, on 1 June 1815.

GILMOUR, JOHN HENRY (1892-1951)

Jack Gilmour was born in Christchurch, New Zealand, and began work at the *Canterbury Times* in 1911, succeeding David LOW. During World War I he was a captain in the army and Provost Marshal of the Canterbury Military District, which involved him in guarding Count von Luckner (the legendary captain of the German raider *Seeadler*) on Ripapa Island in Lyttelton Harbour. He later also worked for *Truth* (1924-5), *New Zealand Times* (1926), *New Zealand Worker* (1927), *Christchurch Sun* and *Free Lance*. In the early 1930s he went to London where he worked for the *Evening Standard* and in 1936 also drew for the *Blackshirt*, the journal of the British Union of Fascists. He later returned to New Zealand and published the *Cartoon Commentator* in Christchurch.

GITTINS, HAROLD (fl.1930s-after 1950)

Harold Gittins came from Manchester and studied at the Manchester School of Art. In World War I he served

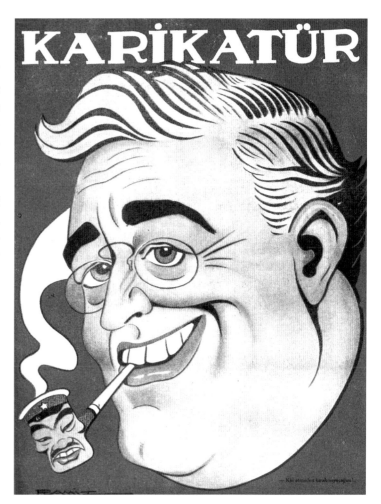

Ramiz Gökçe, *Karikatür* (Istanbul), 7 October 1943

in the South Lancashire Regiment and then the Royal Flying Corps, where he was allegedly shot down by the 'Red Baron', Manfred von Richthofen (though the official records do not list him), and later attended the German ace's funeral. He drew sports cartoons for the *Evening News* for many years and pocket cartoons for the paper during World War II. In addition he contributed to *Blighty* and others. A number of his wartime drawings were reproduced in a book, *400 Famous Cartoons by Five Famous Cartoonists: Neb, Lee, Moon, Gittins, Illingworth* (1944), and he also illustrated *An A.A.Brigade at War!* (1944).

GÖKÇE, RAMIZ (1900-53)

Ramiz was born in Istanbul, Turkey, and had his first cartoons published in *Seytan* in 1918. He later contributed to *Akbaba, Cumhuriyet Gazetesi* and others. Among his cartoons for *Karikatür* was a colour cover for

the issue of 7 October 1943, published shortly after a major retreat by Japanese forces in the Solomon Islands. It featured US President F.D.Roosevelt smoking a pipe in the form of Japanese military leader General Tojo. His books included the World War II cartoon collections *Bu Harbin Karikatür Albumü 1* (1944), *Bu Harbin Karikatür Albumü 2* (1945) and *Kadinlar Albumü* (1945). He died in Istanbul on 5 January 1953.

GOLIA – see Colmo, Eugenio

GOULD, SIR FRANCIS CARRUTHERS 'F.C.G.' (1844-1925)

F.C.Gould was born in Barnstaple, Devon, on 2 December 1844, the son of Richard Davie Gould, an architect. He worked at first in a bank and then as a broker in the London Stock Exchange (1864-88). A largely self-taught artist, his first cartoon was published in *Truth* in 1879 and he continued to draw for the journal until 1895. He also contributed to the *Pall Mall Gazette* from 1887 and drew a regular weekly cartoon for the *Pall Mall Budget* from 1888. He left the Stock Exchange in 1890 to join the *Pall Mall Gazette* as the first ever staff political cartoonist on a British daily newspaper. When the paper changed ownership he moved to the newly launched *Westminster Gazette* (1893), became its assistant editor in 1896 and remained with the paper until he retired in 1914. He also drew for the weekly *Westminster Budget* and in 1894 founded his own monthly journal, *Picture Politics* (published by the *Westminster Gazette*) which ran for twenty years. His drawings were syndicated to the *Manchester Guardian* and elsewhere and he also contributed to *Vanity Fair*, *Star*, *Strand* and others, and designed political postcards for E.Wrench (e.g. the 'Westminster Cartoon Series' from his *Westminster Gazette* cartoons). During the Boer War he produced many successful images, particularly of Kruger and the monocled statesman Joseph Chamberlain, but was never malicious in his work, claiming that 'I etch with vinegar, not vitriol'. Six volumes of his collected cartoons from the *Westminster Gazette* were published (*The Westminster Cartoons*). Volume IV has 'A Pictorial History of Political Events Connected with South Africa 1899-1900' while Volume V covers the Khaki

election. Chapter 4 of the 1902 volume of his cartoon collection *Froissart's Modern Chronicles* deals with 'The War in Africa' and Chapter 5 covers 'The Ending of the War'. He also drew colour caricatures of Boer War figures for Harold Begbie's books *The Political Struwwelpeter* (1899) and *The Struwwelpeter Alphabet* (1900), and *The Westminster Alice* (1902) by H.H.Munro (Saki). In addition he produced caricature figurines of Chamberlain and Kruger (1899), a Kruger jug and money box (1900) and Lloyd George as a Welsh terrier (1913). A committed Liberal himself he was knighted (the first daily cartoonist to be thus honoured) after the Liberal election victory in 1906. During World War I he continued to draw occasional cartoons and designed a series of Toby Jug caricatures of 'Prominent Personages of the Great War' including Woodrow Wilson, Foch, Lloyd George, Haig, Beatty, Jellicoe, French and Joffre. He was also commissioned in the London Irish Rifles for fifteen years as a volunteer, retiring with the rank of major. Sir Francis Carruthers Gould died in Porlock, Somerset, on 1 January 1925. His son, Alec Carruthers Gould RBA RWA (1870-1948), also drew cartoons and caricatures.

GOURSAT, GEORGES 'SEM' (1863-1934)

Sem was born in Périgueux, France, on 23 November 1863, the son of a grocer. While working in his father's shop he had his first drawings published in *L'Entracte Périgourdin* (1886-7) and *Le Périgueux Illustré*. He moved to Paris in 1900 where he began to caricature high society, contributing to *Le Rire* (1897-1912), *Le Journal* (1903-28), *La Vie Parisienne* (1905-11), *Le Figaro* (1905-17), *Les Annales* (1905-31), *Fantasio* (1906-18), *L'Illustration* (1906-19), *Excelsior* (1911-17) and others while also publishing annual sketchbooks beginning with *Le Turf* (1900). During World War I he also contributed cartoons to *Le Poilu* (1917) and *La Baïonnette* (1915-19), including the cover for the 1 August 1916 special issue on 'Pacifists' featuring a top-hatted man trying to catch artillery shells in a butterfly net. In addition he designed posters for the French war loan such as 'Pour le Triomphe Souscriver à L'Emprunt Nationale' (1916), wartime postcards and, after his visits to battlegrounds and military hos-

THE German Emperor is **G**,
He rules mankind by Heaven's decree.
It is a most inspiring sight
To see him robed in all his might,
With frothing tankard raised on high,
Exclaiming :—" Hoch ! (hic), Hoch ! I'm dry,"
While Burghers whisper as he's shouting,
" Odd that our William's dry when spouting !"

THE TOP G

Francis Carruthers Gould in Harold Begbie, *The Struwwelpeter Alphabet* (1900)

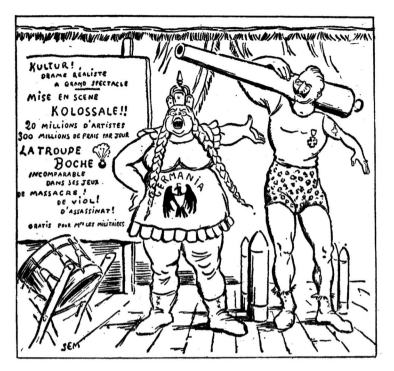

GRAND THEATRE OF THE FOLIES-WILHELM
Georges Goursat (Sem), *Le Journal*, 28 February 1915

pitals, wrote and illustrated a book, *Un Pékin sur le Front* (A Civilian at the Front, 1917). He later designed the menu and champagne labels for Maxim's restaurant. He was awarded the Légion d'Honneur in 1923. Sem died in Paris on 27 November 1934. His younger brother Victor Goursat was also a cartoonist working for *La Rampe* (1915-18), *Bagatelles* (1918-19) and others.

GRANDJOUAN, JULES-FÉLIX (1875-1968)

Jules-Félix Grandjouan was born on 22 December 1875 in Nantes, France, and had his first drawings published in *Le Clou* and *L'Ouest-Republicain* in 1895 while studying law in the city. He abandoned his studies in 1897 to concentrate on art and in 1899 wrote and illustrated *Nantes la Gris* (Nantes the Grey City) and later (with his cousin, the cartoonist 'Jel' [Jean-Emile Laboureur, 1877-1943]) illustrated the periodical *Nantes Amusant*. He moved to Paris in 1900 and drew for *Le Rire* (1900-18), including a double-page Boer War cartoon 'Au Transvaal: Happy Christmas' (29 December 1900). He later became the most frequently published artist in *L'Assiette au Beurre* (1902-12) – for which he also produced forty-six special numbers and designed the most

covers – and contributed to *Le Canard Sauvage*, *Le Cri de Paris* (1901-05), *L'Humanité* (1908-27), *La Baïonnette* (1915-18) and others. His caricatures also included Russian revolutionaries such as Trotsky and Zinoviev. A friend of DELANNOY, Grandjouan was anti-militarist and a militant syndicalist and anarchist. To avoid an eighteen-month prison sentence for his drawings he fled France in 1911 but returned the following year after an amnesty. He then began contributing drawings to *La Révolution* and *La Voix du Peuple* and designing posters for the French Communist Party until he was expelled from the Party in 1930. He died in Nantes on 12 November 1968.

GRANDVILLE, J.J. – see Gérard, Jean Ignace Isidore

GREENE, NELSON BEACH (1869-1955)

Nelson Greene was born in Little Falls, New York State, on 7 November 1869, the son of Horace Greene, owner of the *Mohawk Valley Register*. After studying at the Art Students' League in New York, he worked as a cartoonist and illustrator for *Puck* and others. One of his most reprinted war cartoons was 'The Hand of God' (*Puck*, 1914) showing the divine hand descending on the Kaiser as he watches the destruction of Reims cathedral by the German Army. He later moved back to Fort Plain and became editor of the *Fort Plain Standard* (1922-39). He also wrote a number of books about the Mohawk Valley. He died on 11 November 1955.

GROPPER, WILLIAM (1897-1977)

William Gropper was born in New York on 3 December 1897. After studying art at the National Academy of Design and the New York School of Fine & Applied Arts his first cartoons were published in the *New York Tribune* in 1919. A committed Socialist, he visited the Soviet Union a number of times and drew posters and illustrations for the Communist movement. In 1924 he began drawing a daily cartoon for the Yiddish newspaper *Freiheit* and also began contributing to *The Liberator*, *New Masses* and *New Yorker*. In 1935 one of his

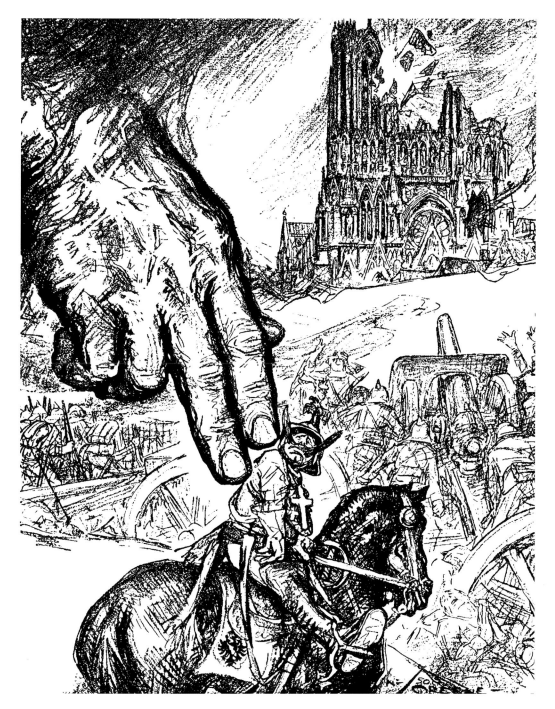

THE HAND OF GOD
Nelson Greene, *Puck* (New York), 1914

Vanity Fair cartoons about Japanese aggression in China resulted in the magazine being banned from Japan (the Japanese government's pressure on its advertisers led to *Vanity Fair*'s collapse shortly afterwards). Captioned 'Japan's Emperor Gets the Nobel Peace Prize' the cartoon showed Hirohito pulling a gun carriage on which the rolled-up Nobel citation has been transformed into the barrel of a cannon. Gropper died on 8 January 1977.

GROSZ, GEORGE (1893-1959)
George Grosz was born Georg Ehrenfried in Berlin, Germany, on 26 July 1893 the son of a Berlin innkeeper.

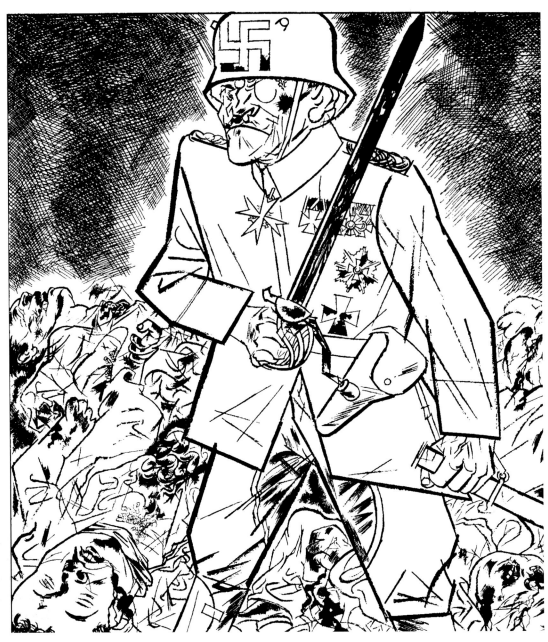

THE WHITE GENERAL
George Grosz, *Die Pleite*, November 1923

From 1910, while studying at the Dresden Academy (1909-12), he began contributing cartoons to *Berliner Tageblatt*, *Ulk*, *Lustige Blätter* and others. He continued his art studies in Berlin (1912) and Paris (1913) before serving in the German Army in World War I. Invalided out in 1915, he had work published the same year in the anti-war magazine *Die Aktion* and in *Die Neue Jugend* edited by Wieland Herzfelde. In 1916 Herzfelde and his artist brother John Heartfield set up the left-wing publishing company Malik Verlag which published the first two collections of Grosz's work in 1917. When the brothers founded the journal *Die Pleite* in March 1919, he drew a satirical cover cartoon attacking Friedrich Ebert, president of the Weimar Republic for its first issue. However, most of his work featured anonymous types such as crippled war veterans, fat war

profiteers, ugly prostitutes etc. One of his notable World War I drawings was 'Fit For Active Service' (1918) showing a doctor pronouncing a skeleton fit for the army. He also contributed to *Querschnitt* (from 1924), the Communist weekly *Der Knüppel* and *Simplicissimus*. One of his drawings, 'Shut Up and Do Your Duty' (also known as 'Christ with a Gasmask'), from his collection *Hintergrund* (1928) led to a blasphemy trial. He later turned his attack on the Nazis and after some of his works were burnt as 'degenerate art' he was forced to flee to the USA in 1932. Here he joined the staff of the Art Students' League in New York (1933-53) and contributed to *Vanity Fair, Esquire* and *Harper's Bazaar*. He became a US citizen in 1938 but returned to Berlin in 1959, dying there on 6 July that year.

GULBRANSSON, OLAF LEONARD (1873-1958)

Olaf Gulbransson was born in Christiania (now Oslo), Norway, on 26 May 1873, the son of Edvald Gulbrandsen, technical manager of the newspaper *Verdens Gang*. He studied at the Royal College of Art & Drawing in Oslo (1885-92) and began contributing to *Tyrihans* (1893-1902), *Transviksposten* and *Karikaturen*. He changed his name to Gulbransson in 1895. In 1900 he studied briefly at the Académie Colarossi in Paris but then returned to Oslo and published his first book, *24 Caricatures of Famous Norwegian Artists and Bohemians* (1901). He moved to Munich in 1902 to work for *Simplicissimus* at the invitation of its founder, Albert Langen (who was married to the daughter of the Norwegian poet Björnson – Gulbransson himself later married Björnson's granddaughter). Apart from a period back in Oslo in 1923-7 (drawing for *Tidens Tegn*) he remained in Germany working for *Simplicissimus* for more than four decades – through both world wars – until it ceased publication in 1944. (He had become a co-owner of the magazine in 1906.) In 1929 he also became professor of drawing and painting at the Munich Academy of Fine Arts. He died on 18 September 1958 at his home, Schererhof, on Lake Tegern in Bavaria.

GURNEY, ALEXANDER GEORGE (1902-55)

Alex Gurney was born in Morice Town, Devon, on 15 March 1902, the son of William George Gurney, a captain's steward in the Royal Navy. On the death of his father in 1903 his mother (an Australian) returned with Alex to Hobart, Tasmania. While serving a seven-year apprenticeship with the Tasmanian Hydro-Electric Commission he studied art part-time at the Hobart Technical School. His first cartoons appeared in the *Sydney Bulletin, Melbourne Punch* and *Smith's Weekly* c.1918. After publishing a collection of his drawings, *Tasmanians Today: Caricatures and Cartoons* (1926), he worked successively for the *Melbourne Sunday Post, Sydney Sunday Times, The World*, and the *Daily Guardian* before moving to the *Adelaide News* in 1931. In 1933 he joined the *Melbourne Herald* and in 1939 created his wartime 'Digger' characters Bluey and Curley for *Picture-News* magazine. They also appeared in Australian Army newspapers such as *Guinea Gold* and in 1940 Gurney transferred the strip to the *Melbourne Sun News-Pictorial* from where it was syndicated throughout Australia, New Zealand and Canada. The adventures of the two private soldiers (Bluey was the older one), serving with Australian forces in North Africa and the South Pacific, were very popular with Allied troops. Gurney also served as a war correspondent and visited numerous army camps in search of material (while in New Guinea he contracted malaria). The strip survived into peace time and after Gurney's death was continued by Norman Rice and then Les Dixon. A collection of the drawings, *Gurney and Bluey and Curley: Alex Gurney, His Greatest Cartoons*, was published in 1986. Alex Gurney died in Elwood, Melbourne, on 4 December 1955.

HAHN, ALBERT (1877-1918)

Albert Hahn was born in Groningen, Netherlands, on 17 March 1877. After studying at the Academie Minerva in Groningen (1890-96) and then at the two main art schools in Amsterdam (1896-1901), he worked at first as a commercial artist. He joined the staff of *Het Volk* in Amsterdam in 1902, quickly becoming the main

TWENTIETH-CENTURY MONUMENTAL STYLE
Albert Hahn, *De Notenkraker*, 26 September 1914

artist of its Sunday supplement. He also contributed to journals such as *De Ware Jacob* and *De Hollandsche Revue* and became the main artist on *De Notenkraker*. During World War I, like his fellow countryman Louis RAEMAEKERS, he drew powerful anti-German cartoons, despite Holland's neutrality. One of his best known drawings of this period was 'Twentieth-Century Monumental Style' (*De Notenkraker*, 26 September 1914). Drawn after the shelling of Reims Cathedral by the Germans, it showed its façade rebuilt out of shells, cannon and German helmets with a death's-head instead of a central window. Some of his cartoons were published in a book *Prenten van Albert Hahn: De Oorlog*. Hahn had suffered ill health since childhood and died in Amsterdam aged forty-one on 3 August 1918, shortly before the war ended. His son Albert Hahn Junior drew anti-Nazi cartoons for *De Notenkraker* (including covers).

HAMILTON, GRANT E. (1862-1926)

Grant Hamilton was born in Youngstown, Ohio, on 16 August 1862, the son of a furnaceman. He worked at first as a furnaceman in Youngstown but after he had some drawings published in the *New York Daily Graphic* was invited to join its art department and moved to New York. He began to contribute to *Judge* in 1881 and worked as assistant to Bernard Gillam, who also taught him lithography. Hamilton later became the main political cartoonist on *Judge* and its art editor, producing some powerful images during the Boer War. One cover cartoon from this period ('We Told You So', 24 February 1900) featured a topsy-turvy image of John Bull and a Boer fighting with one caption reading: 'It is just as *Judge* predicted – John Bull is on top, giving the Boer a good licking.' When the magazine was turned the other way up, the opposite caption could be read. Hamilton also drew for *Puck* in 1904 and was art editor of *Leslie's Weekly*. One of his best known cartoons is his colour cover drawing which appeared during the Spanish-American War, 'The Spanish Brute Adds Mutilation to Murder' (*Judge*, 9 July 1898). He died in Los Angeles on 17 April 1926.

HANSI – see Waltz, Jean-Jacques

THE SPANISH BRUTE ADDS MUTILATION TO MURDER
Grant E. Hamilton, *Judge*, 9 July 1898

HARTT, Cecil Laurence (1884-1930)

Cecil Hartt was born on 16 July 1884 in Prahran, near Melbourne, Australia, the son of James Hartt. Self-taught apart from some art lessons he received from *Melbourne Punch* cartoonist Alek Sass, he worked free-lance at first, drawing cartoons for *Comment* and *Clarion* from about 1908. After getting a drawing published in the *Sydney Bulletin* he moved to Sydney in 1909, and also began contributing to the *Comic Australian* and *Australian Worker*. By the outbreak of World War I he was regularly contributing to the *Bulletin*. During the war Hartt served in the 18th Battalion, Australian Imperial Forces, and was badly wounded twice at Gallipoli. Sent to London to recuperate in 1916, he had drawings published in the *Bystander*, *Passing Show*, *London Opinion* and others. *Humorosities* (1917), a collection of his 'Digger' soldier war cartoons published in London, was a surprise bestseller (60,000 copies were sold) and led to him being presented to King George V. After the war he returned to Australia and joined the newly launched *Smith's Weekly* in 1919 as its staff artist. Here (with Frank DUNNE) he continued to draw Digger cartoons about ex-servicemen for its page 'The Unofficial History of the AIF'. Two more anthologies, *Diggerettes* (1919) and *More Diggerettes* (1920) were published in Sydney. Cecil Hartt was found dead from a head wound (his shotgun beside him) on a mountain near Moruya, New South Wales, on 21 May 1930.

HASELDEN, William Kerridge (1872-1953)

Born on 3 December 1872 in Seville, Spain, the son of Adolphe Henry Haselden, an English civil engineer, W.K.Haselden was self-taught as an artist. He left school at sixteen and worked as an underwriter at Lloyd's for thirteen years while freelancing cartoons for *The Sovereign*, *St James's Gazette* and *Tatler*. He joined the *Daily Mirror* (1904-40) as editorial cartoonist and also produced regular theatre sketches for *Punch* (1906-36). Regarded as the father of the British newspaper strip cartoon, Haselden is also celebrated as the creator of 'The Sad Experiences of Big and Little Willie', lampooning Kaiser Wilhelm of Germany and his son during World War I, which the Kaiser himself later admitted to have been 'damnably effective'. The feature first appeared on 2 October 1914 and a book of these cartoons, *The Sad Experiences of Big and Little Willie During the First 6 Months of the Great War*, was published in 1915. Haselden's annuals, *Daily Mirror Reflections* (including the World War I *Daily Mirror Reflections in War Time*) appeared from 1908 to 1937 and also included other characters such as Miss Joy Flapperton, and Burlington Bertie. Another character was Colonel Dug-Out who appeared on the cover of the 1918 volume of *Daily Mirror Reflections in War Time* which contained 'The War Story of Colonel Dug-Out' in twenty-three episodes as well as seven episodes of 'Trials of the Wounded Tommy' and other war-related cartoon series. He was offered a knighthood by Stanley Baldwin but turned it down as he 'didn't want all the fuss'. Haselden died on 25 December 1953.

HASSALL, John (1868-1948)

John Hassall was born in Walmer, Kent, on 21 May 1868, the son of Lieutenant Christopher Clark Hassall, an officer in the Royal Navy. His father died when Hassall was eight and his stepfather was General Sir William Purvis Wright KCB. Having failed to be accepted by the Royal Military Academy, Sandhurst, he moved to Manitoba, Canada, where he worked as a farmer for three years. When his first published drawing 'A Surprise Party' appeared in the *Daily Graphic* on 26 February 1890, he returned to the UK. He then studied in Antwerp and Paris. His first humorous drawing appeared in the *Sketch* on 7 March 1894 and he first exhibited at the Royal Academy the same year. He then worked for the Belfast poster printers David Allen for seven years, producing many theatrical posters as well as advertisements. Perhaps his most famous poster design was 'Skegness is *So* Bracing' (1908), featuring the Jolly Fisherman skipping along the beach. In addition, he illustrated books (including designing the covers of the 'Punch Library of Humour') and contributed illustrations and cartoons to the *Captain* (including the original cover design), *Star*, *Idler*, *Illustrated Bits*, *Judy*, *London Opinion*, *Moonshine*, *New Budget*, *Pall Mall*, *Pick-Me-Up*, *Tatler* and others. In 1905 he set up the New Art School & School of Poster Design (later known as the John Hassall School), with his old Antwerp tutor

John Hassall, from Walter Emanuel and John Hassall,
Keep Smiling: More News by Liarless for German Homes (1914)

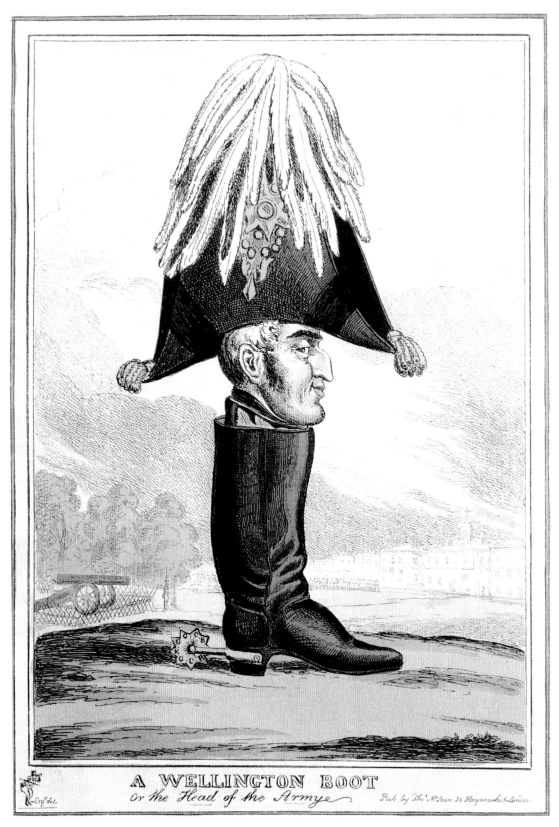

A WELLINGTON BOOT
Or the Head of the Army

Pub. by Thos. McLean 26 Haymarket London

A WELLINGTON BOOT, OR THE <u>HEAD</u> OF THE <u>ARMY</u>
William Heath (Paul Pry), 1827

Charles van Havermaet, in Earls Court, London, pupils including Bruce BAIRNSFATHER, Bert THOMAS and H.M.BATEMAN. In addition he designed pottery and drew some of the earliest postcards (from 1899) for Tuck, Faulkner and others. During the Boer War he drew for *The Graphic* and *The King*, produced a number of postcards, published a children's book, *An Active Army Alphabet* (1899), and designed the cover for the official programme for the National Bazaar in Aid of Sufferers by the War (1900). In World War I he served as a special constable (1916-18), guarding the gates of Buckingham Palace amongst other duties. He also published three wartime books: *Keep Smiling! More News by Liarless for German Homes* (with Walter Lewis Emanuel, 1914), *Ye Berlyn Tapestrie: Wilhelm's Invasion of Flanders* (1915) and *The Hassall ABC* (1918). After the war he designed covers for *The Ex-Service Man* magazine. A friend of Baden-Powell, he designed the first cover for *Scouting for Boys* and the movement's Imperial Jubilee flag (1920) and illustrated Baden-Powell's *Now, Then!* (1927). Elected RI in 1901, he was awarded a Civil List pension for 'services to posters' in 1939. He continued designing posters in World War II (his last being 'Save Poland') and also produced a wartime children's book *The Defence ABC Painting Book*. He was one of the founder members of the London Sketch Club (president 1903). John Hassall died in Kensington, London, on 8 March 1948. His daughter Joan Hassall became a celebrated wood-engraver.

HEATH, WILLIAM 'PAUL PRY' (1795-1840)

Born in Northumberland, William Heath described himself as a former Captain of Dragoons and a 'portrait and military painter'. His first caricatures were published in 1809. However he began work as an illustrator of such books as *Historical Military and Naval Anecdotes* (1815), *The Martial Achievements of Great Britain and Her Allies* (1815) and *The Life of a Soldier* (1823), as well as William Combe's *The Wars of Wellington* (1819). He was also editor and illustrator of Europe's first caricature magazine, the *Glasgow Looking Glass* (soon renamed *The Northern Looking Glass*, 1825-6) and later edited McLean's *Looking Glass or Caricature Annual* (1830). In 1827 he adopted the pseudonym 'Paul Pry' (after the 'nosey parker' character in John Poole's popular 1825

farce of that name) and produced a number of popular prints signed with this name and/or a miniature drawing of the top-hatted character. However, he dropped the pseudonym in 1829 because it had been plagiarised. As well as his series of prints, *Military Progress*, showing the downfall of an army officer, amongst the best known of Heath's works are those on the Duke of Wellington. These include 'Portrait of a Noble Duke' (1829), with his head made out of military objects (cf. the Corpse Head of Napoleon by Johann Michael VOLTZ), and 'A Wellington Boot, or the Head of the Army' (1827), featuring Wellington's head emerging from a huge Wellington boot. He died in Hampstead, London, on 7 April 1840 aged forty-five.

HEINE, THOMAS THEODOR (1867-1948)

Heine was born in Leipzig, Germany, on 28 February 1867, the son of a chemist and manufacturer of rubber products. He studied art at Düsseldorf Academy and settled in Munich where he worked as a landscape painter, book illustrator and commercial artist while also contributing cartoons to *Fliegende Blätter* and (from 1896) *Die Jugend*. He also designed book jackets for Albert Langen's publishing company and when Langen launched *Simplicissimus* magazine in 1896 he became its first staff artist and created the magazine's motif of a red bulldog with a broken chain. He signed his work 'TTH' with the letters stacked vertically. After Langen's death in 1909 the subtitle for the magazine read: 'Founded by Albert Langen and Th. Th. Heine.' A regular cover artist for the magazine (he drew more than any other single artist) he later became its editor. Heine was jailed for six months in 1898 for his anti-Kaiser cover drawing for the Palestine special (the magazine was banned as a result). During the Boxer Rebellion in China he drew 'The Empress of China's Dream' with a huge armoured knight pouring blood over Asia and he also produced a number of anti-British cartoons during the Boer War, notably 'England's Dream in South Africa' (1899) with Queen Victoria plucking ostriches (this was also reprinted as a colour postcard). In World War I he attacked the USA's neutrality in the cover drawing 'Neutral America' (9 February 1915). Outspoken against the Nazis he produced many drawings lampooning them and as

THE EMPRESS OF CHINA'S DREAM
Thomas Theodor Heine, *Simplicissimus* (Munich), 1900

IN OCCUPIED TERRITORY
'Smile or I'll shoot you!'
René Georges Hermann-Paul, *La Guerre Sociale*, n.d.

a result was forced to leave *Simplicissimus*. He left Germany itself in 1933 when the Nazis came to power and after travelling to Prague, Oslo and elsewhere he finally settled in Stockholm, Sweden, in 1942. Here he drew for *Göteborgs Handels- och Sjöfartstidning* and eventually took Swedish nationality. One of his later cartoons was 'German Autumn' (1944) with the figure of Death shaking swastikas from the trees. He died in Stockholm on 26 January 1948.

'HELPFUL HINTS' – see Wallgren, Abian Anders

'HERBIE' – see Coughlin, William Garnet

HENRIOT – see Maigrot, Henri

HERBLOCK – see Block, Herbert Lawrence

HERMANN-PAUL, RENÉ GEORGES 'H.P.' (1864-1940)
Hermann-Paul was born in Paris on 27 December 1864,

the son of a doctor. He studied at the Écoles des Arts Décoratifs and at the Académie Julian. He began contributing to *La Revue Méridionale* in 1892 and in November the same year founded the short-lived weekly *La Faridondaine* (1892-3). He later worked for *Le Courrier Français* (1894-1907), *Le Rire* (1894-1933), *Le Cri de Paris* (1897-1922), *L'Echo de Paris* (1897-1926), *Le Petit Bleu* (1898-1914), *Le Figaro* (1899-1907), *Le Sourire* (1899-1913), *Le Sifflet*, *La Petite Gironde* (1902-14), *La Baïonnette* (1915-18), *La Victoire* (1916-24), *Les Humoristes* (including covers), *Candide* (1924-39), *Je Suis Partout* (1930-40) and others. He also drew for *L'Assiette au Beurre* from its first issue (4 April 1901), including the special war issue 'La Guerre' (4 July 1901). During the Boer War he produced a number of anti-British cartoons and he also drew powerful cartoons during World War I for the daily *La Guerre Sociale* and others. He was later a professor at the Écoles des Beaux-Arts in Paris. He died in Saintes-Maries-de-la-Mer on 23 June 1940.

THE MILITARY COMMITTEE
David Hess/James Gillray, 1796

HESS, DAVID (1770-1843)

David Hess was born in Zurich, Switzerland, on 29 November 1770 and was an army officer in a Swiss regiment that served the Dutch government in Holland from 1787 to 1795. However, the coming of the French Revolution and the Napoleonic Wars led to the defeat of the Netherlands, the establishment of a French puppet government, and the disbandment of Hess's regiment without pay. This led Hess to produce his famous series of prints *Hollandia Regenerata* (etched by James GILLRAY and published in London in 1796) which attacked the various organising committees of the new puppet regime. Hess died in Zurich on 11 April 1843.

HILL, LEONARD RAVEN (1867-1942)

Leonard Raven Hill was born in Bath, Somerset, on 10 March 1867, the son of William Hill, a law stationer. While studying at the Lambeth School of Art from 1882 (fellow students included F.H. TOWNSEND) he contributed joke cartoons to *Judy* signed 'Leonard Hill' (1885). He then studied at the Académie Julian in Paris (1885-7) and exhibited at the Paris Salon aged twenty. On his return to Britain he worked at first as a painter, exhibiting at the Royal Academy (1889). However, he had more success contributing joke cartoons, theatrical caricatures and illustrations to *Black & White*, *Daily Chronicle*, *Daily Graphic*, *Pall Mall Gazette*, *Reveille*, *Sketch*, *Strand* and others. He was art editor of *Pick-Me-Up* (1890), and then became founder and joint editor of the short-lived weeklies *Butterfly* (1893) and *Unicorn* (1895). His first drawing for *Punch* appeared on 28 December 1895 and he continued to work for the magazine for nearly forty years. In 1910 he succeeded Bernard PARTRIDGE as Second Cartoonist, until failing eyesight forced him to retire in 1935. A member of the 2nd Volunteer Battalion of the Wiltshire Regiment, a number of his cartoons featured volunteer soldiers. Shortly after the Boer War he wrote and illustrated a book, *Our Battalion: Being Some Slight Impressions of His Majesty's Auxiliary Forces, in Camp and Elsewhere* (1902), and illustrated Israel Zangwill's Jewish soldier story 'S. Cohen & Son or Anglicisation' (*Pall Mall Magazine*, 1902). He also produced a number of memorable World War I cartoons, notably 'The Return of the Raider' (*Punch*, 3 February 1915, featuring the Kaiser and a battered Admiral Tirpitz), 'The Old Man of the Sea' (*Punch*, 21 July 1915, the Kaiser carrying Tirpitz on his shoulders – see also Frank BELLEW) and 'Held!' (*Punch*, 31 May 1916, a German boar with its snout caught in a trap marked 'Verdun'). Some of

his *Punch* cartoons were reproduced as postcards and he also drew a World War I postcard series 'Out for Victory'. Amongst his colour World War I posters were 'To Arms!' (1914, reproducing a *Punch* cartoon) and 'Not Much!' featuring a bloody-handed Kaiser saying to John Bull: 'Won't you shake hands?' and being answered: 'Not till you've cleaned yourself.' Leonard Raven Hill died in Ryde, Isle of Wight, on 31 January 1942.

HILL, ROLAND PRETTY 'RIP' (1866-1949)

Born in Astwood Bank, Feckenham, Worcestershire, Rip lived most of his life in London. He is best known as a sports cartoonist and in his *Wisden* obituary is credited with being 'the first line artist to concentrate on cricket'. He drew cricket caricatures for the *Evening News*, *Weekly Dispatch* and the *Cricketer* and designed two sets of caricature cigarette cards (on cricketers and footballers) issued by John Player & Sons in 1926. He also produced illustrations and cartoons for the *Windsor Magazine*, *Truth*, *Strand*, *Captain* and others. However, during the Boer War he also drew political cartoons for *Black & White* (1899), *Sketch* and the *Daily Mail* amongst others. Indeed, one of the pre-publication dummy issues of the *Daily Mail* (launched in 1896) had a large front-page cartoon by him ('Will Little Trilby Come?', 16 April 1896) featuring President Kruger as Du Maurier's character Trilby and Joseph Chamberlain as Svengali trying to hypnotise Kruger into singing 'Rule Britannia'. He also drew the first political cartoon published in the *Daily Mail*, 'The Mystic East: The Busy West' (3 March 1896) featuring Prime Minister Lord Salisbury greeting Li Hung Chang, Viceroy of China (and known as 'the Bismarck of Asia') on his arrival in Britain. Roland Pretty Hill died in Fulham, London on 29 December 1949 aged eighty-three.

HOFFMEISTER, ADOLF (1902-73)

Adolf Hoffmeister was born in Prague, Bohemia (then part of the Habsburg Empire) on 15 August 1902. A talented writer (he had his first book published when

WILL LITTLE TRILBY COME?
Roland Pretty Hill (Rip), *Daily Mail*, 16 April 1896

he was only seventeen), he studied law at Charles University, Prague, in 1925 and began work as a writer and cartoonist for various Czech publications. Vehemently anti-Nazi, when Hitler came to power he attacked him in savage cartoons and was forced into exile in France. When the Germans invaded in 1940 he was put into a concentration camp. However, he escaped to Casablanca where he was interned by the Vichy regime, fled to Spain where he was imprisoned by Franco's government, and finally escaped (via Havana) to the USA in 1941 where he continued to draw anti-Nazi cartoons. He published a book about his experiences, *The Animals Are in Cages* (1941, UK version *The Unwilling Tourist*), and is held by some to have been the inspiration for the character Victor Laszlo played by Paul Henreid in the film *Casablanca* (1942). Among his wartime cartoons is an equation in which a cigar (Churchill), a cigarette holder (Roosevelt) and a pipe (Stalin) are equal to V (Victory). Some of his wartime work was also reproduced in a book, *Jesters in Earnest* (1944), along with drawings by Walter TRIER, Z.K., STEPHEN and Antonin PELC. He was later Czech ambassador to France (1948-51). Adolf Hoffmeister died in Rickach, Czechoslovakia, on 24 July 1973.

A PLACE IN THE SUN
'There is no flying hence or tarrying here,
I 'gin to be aweary of the Sun' – *Macbeth*
Frank Holland, *John Bull*, 15 August 1914

HOLLAND, FRANK (fl.1895-after 1922)

Editor of the weekly comic and story paper *The Gleam*, Frank Holland drew comic strips in the 1890s and early 1900s for *Comic Home Journal*, *Illustrated Chips*, *Comic Cuts*, *Funny Wonder*, *Big Budget* and others. In addition he drew 'The Terrible Twins' (Willy and Wally Wanks) for the front page of *The Halfpenny Comic* from

1898, including a number of adventures set in South Africa during the Boer War. He later worked for *Fun*, *Black & White* and the *Daily Express* (political cartoons) and c.1912–19 was political cartoonist on the controversial magazine *John Bull*, edited by Horatio Bottomley (who was later imprisoned). He was also political cartoonist on the weekly *Reynold's News* (c.1911-22), and drew a number of anti-German cartoons during World War I. In addition his 'lightning sketch' versions of some of his *John Bull* cartoons featured in a number of wartime Pathé films. These included *Climbing the Greasy Pole* (1916), showing the Kaiser trying to climb the pole to 'World Power' while the sun of 'The Allies' shines down, and *The Tumble-Down Nest* (n.d.) with the Kaiser under the rubble of 'The Hohenzollern Arms' pub and the caption 'His Little Grey Home in the West'.

HÖÖK, STIG – see Blix, Ragnvald

HOOPER, WILLIAM JOHN 'RAFF' (1916-96)

Bill Hooper was born in London on 21 August 1916. He worked as a laboratory assistant in a medical clinic in Windsor before volunteering for RAF aircrew in 1939, later joining 54 Squadron, Fighter Command HQ and Intelligence. Self-taught as an artist, he is best known as 'Raff' (the name comes from his dog while in the RAF), the creator of Pilot Officer Percy Prune. The name 'Prune' was a term for new recruits and PO Prune was a persistently inept pilot who first appeared (unnamed) in *Forget Me Nots for Fighters* (c. 1940), a book produced after the Battle of Britain

which showed the lessons learned by fighter pilots. The character was then christened and appeared regularly in *TEE EMM* (for *Training Manual*), an aircrew training magazine edited by *Punch* writer Anthony Armstrong from 1 April 1941 until its last issue in March 1946. Other creations were Aircraftsman Plonk (Prune's mechanic), Prune's girlfriend WAAF Winsum and his mascot dog Binder. Prune variants included a bearded Fleet Air Arm version (Sub-Lt Swingit), the Free French Air Force Aspirant Praline (created for the *Bulletin des Forces*) and a French resistance variant. Like the Two Types by JON, Prune and his colleagues were not based on real people, but by mistake his name got into the Air Ministry phone book, his portrait was hung in the National Gallery and the Luftwaffe awarded him an Iron Cross. A collection of mannikins of the Prune characters made by Hooper is held at the RAF Museum, London, and he published a number of books including (as '977950') *Forget Me Nots for Fighters* (c. 1940), (as 'Raff') *Behind the Spitfires* (1941), (with Anthony Armstrong) *Plonk's Party of ATC* (1942), *Prune's Progress* (1942), *Nice Types* (1943), *More Nice Types* (1944), *Whiskers Will Not be Worn* (1945), *Goodbye Nice Types!* (1946), (as Bill Hooper) *The Passing of Pilot Officer Prune* (1975) and *Pilot Officer Prune's Picture Parade* (1991). In addition he illustrated Anthony Armstrong's *Sappers at War* (1949). After the war Hooper was political cartoonist on the *Sunday Chronicle* and for fifteen years worked as a presenter and animator for BBC TV. Bill Hooper died in Rustington, Sussex, on 14 October 1996.

'HUBERT' – see Wingert, Richard C.

HYNES, EDWARD SYLVESTER (1897-1982)
Edward Hynes was born in Burren, Co. Clare, Ireland, the son of a surgeon, and was brought up in Nottingham. He was a cadet on HMS *Worcester* before serving as a navigator in the Merchant Navy for ten years. He then studied medicine at Sheffield University for three years. After World War I he returned to the sea but finally abandoned this career in favour of cartoons. Some of his early caricatures appeared in *Town Topics* (1923) but he is best known for his colour caricature covers for *Men Only* (July 1937-June 1956), es-

pecially his wartime figures of military and naval types. He also contributed to the *Daily Sketch*, *Lilliput*, *Gentlewoman*, *Evening News*, *Strand*, *Humorist*, *Razzle* (including covers), *Sunday Express*, *Bystander*, *London Calling*, *Night & Day* and *London Opinion*, *Illustrated Sporting & Dramatic News* (theatre caricatures). In addition he produced a book, *Cocktail Cavalcade* (1937). Hynes retired to Burren, Co. Clare, Ireland, where he painted in oils and produced charcoal sketches. He died at Bayfield House, Newquay, Burren, on 12 May 1982.

IBELS, HENRI-GABRIEL (1867-1936)
H.G. Ibels was born in Paris, on 30 November 1867. A student at the Académie Julian in Paris he was a friend of Toulouse-Lautrec, Bonnard and others and with Toulouse-Lautrec produced a joint collection of lithographs, *Le Café-Concert* (1893). His first cartoons appeared in *Le Messager Français* (1890) and in 1893 he founded the short-lived journal *L'Escarmouche* (1893-4, contributors including HERMANN-PAUL, VALLOTON and WILLETTE). In 1898 he set up the pro-Dreyfus *Le Sifflet*, in direct response to the anti-Dreyfus *Pssst...!* founded by Jean-Louis FORAIN and Caran D'ACHE). He also drew for a number of other publications, such as *Le Journal* (1892-1929), *Le Carnet de la Semaine*, *Le Cri de Paris* (1899-1909), *Le Rire* (1906-28), *La Grande Guerre* (1914-15), *La Baïonnette* (1915), *La Victoire* (1916) and *L'Assiette au Beurre* (1901-10, to which he contributed from its first issue on 4 April 1901). He received the Légion d'Honneur in 1913 and produced many savage anti-German cartoons in World

KAiser - Bonnot

ATTILA!
Henri-Gabriel Ibels, *La Guerre Sociale*,
29 September 1914

War I. One of the most notable of these was 'Attila!' which appeared on the front page of *La Guerre Sociale* in 1914 and showed Kaiser Wilhelm as a knife-wielding thug (it was later redrawn as 'Kaiser-Bonnot', after the Parisian motor bandit, and widely reprinted). After the war he concentrated on painting, lithography and teaching. He died in Paris in February 1936. His half-sister Louise Ibels (1891-after 1953) was also a cartoonist who contributed to *La Baïonnette* in World War I (1917) and other publications.

ILLINGWORTH, LESLIE GILBERT (1902-79)

Leslie Illingworth was born in Barry, Glamorgan, Wales, on 2 September 1902, the son of Richard Illingworth, later chief clerk in the engineers' department of the Barry Railway & Docks Company. His uncle, Frank William Illingworth (1888-1972), was also a cartoonist who drew the well-known World War I cartoon 'Do I know if the Rooshuns has really come through England?' (*Punch*, 23 September 1914). While at Barry County School (with Ronald NIEBOUR) he won a scholarship to Cardiff Art School, aged fifteen, and began drawing for the *Western Mail* while still a student. In 1920 he won a scholarship to the Royal College of Art in London (contemporaries included Barbara Hepworth, Henry Moore, Eric Ravilious, Edward Bawden and John Gilroy). Offered the job of political cartoonist on the *Western Mail* when J.M.STANIFORTH died, he returned to Wales in 1921. He studied briefly at the Slade School of Art in London (1924) while continuing to work for the *Western Mail* but left the paper in 1927. He then studied in Paris at the Académie Julian and again at the Slade (1928-9) and worked as a freelance illustrator, cartoonist and advertising artist contributing to *Nash's*, *Passing Show*, *Strand Magazine*, *London Opinion*, *Answers*, *Tit-Bits* and others. His first contribution to *Punch* was in 1931, and he drew a number of full-page cartoons for the magazine during World War II. (He became the magazine's Second Cartoonist in 1945 and later took over from E.H.SHEPARD as Cartoonist, 1949-68.) In October 1939 he succeeded POY as political cartoonist of the *Daily Mail*. Illingworth drew more than 1,000 wartime cartoons for the paper, some of which were later republished in the wartime anthology, *400 Famous Cartoons by Five Famous*

DAVID AND GOLIATH
Paul Iribe, *Le Mot*, 28 November 1914

Cartoonists: Neb, Lee, Moon, Gittins, Illingworth (1944). (A later collection, *Illingworth's War in Cartoons: 100 of His Greatest Daily Mail Drawings, 1939-1945* was published in 2009.) During the war he also served in the Home Guard and produced work for the Ministry of Defence, Ministry of Information and Ministry of Labour. Illingworth was one of very few Allied cartoonists to have seen the leading Nazis close up (at a ski resort in Germany in the 1930s) and cuttings of *Daily Mail* cartoons by him (and NEB) were discovered in Hitler's bunker after the war, classified and filed by Goebbels. He later worked for the *News of the World* and in 1963

drew a cover for *Time* magazine. One of the founder members of the British Cartoonists' Association in 1966, he was its first president. Leslie Illingworth died in Hastings, Sussex, on 20 December 1979.

IRIBE, PAUL (1883-1935)

Paul Iribe was born on 18 June 1883 in Angoulême, France, the son of an engineer of public works and editor of *Le Temps*. He studied at the École des Beaux-Arts in Paris and began drawing for *Le Rire* (1901-30) and *Le Journal de Paris* (1901-2). In 1906 he founded the weekly *Le Témoin* (contributors included

APA, D'OSTOYA, FORAIN, HERMANN-PAUL, ROUBILLE and VALLOTON). In 1914 he co-founded (with Jean Cocteau) *Le Mot* for which he also drew the first cover, 'David and Goliath' (28 November 1914) featuring a Frenchman with a small gun versus a German with a huge howitzer. *Le Témoin* folded in 1910 but Iribe later resurrected it briefly (1933-5). He also contributed to *Le Sourire* (1901-11), *Le Frou-Frou* (1901-13), *Le Cri de Paris* (1901-14), *L'Assiette au Beurre*, *Le Journal* (1903-19), *Les Temps Nouveaux* (1905-14), *La Baïonnette* (1915-18) and others. In the 1920s he worked as an art director for Paramount Studios in Hollywood, USA. In the 1930s he contributed to *Gringoire*, and in 1933 he drew 'Barlons Vranzais' showing a huge Hitler holding out a French edition of his book *Mein Kampf* in his bloody right hand. He also published a book *Parlons Français* (1934). He was awarded the Légion d'Honneur in 1933. The same year he became engaged to Coco Chanel but they never married as he died of heart failure on her tennis court in Menton, France, on 21 September 1935.

'JANE' – see Pett, William Norman

JOHNSON, ARTHUR (1874-1954)

Arthur Johnson was born in Cincinnati, USA, the son of Charles F. Johnson, a US journalist (and owner/editor of the *Cincinnati Volksblatt*), and his German wife. He studied at Cincinnati Art Academy and the family moved to Germany in 1889 (when Arthur was fifteen) when his father was appointed US consul to Hamburg.

Here he studied at the Berlin Academy of Art and was awarded the Prix de Rome from the Prussian Academy. After travelling in Italy he returned to Berlin to work as a painter. He began work for *Kladderadatsch* in 1906 and shortly after the assassination of the Archduke Franz Ferdinand of Austria-Hungary drew a prophetic cartoon ('Infelix Austria! – What Next?', 1914) showing the figure of Death writing a question mark on a wall. Johnson produced a number of anti-British cartoons for the magazine in World War I, including some lampooning George V's German descent ('The Rape of the Germans in England', 1914). At first anti-Nazi he later supported them, and after Hitler's occupation of the Rhineland, drew a front-cover cartoon, 'The Seeds of Peace, Not Dragons' Teeth' (*Kladderadatsch*, 22 March 1936), featuring Hitler sowing seeds in front of the angel of peace blowing a trumpet (see, by contrast, the cartoon on the same topic by James FRIELL). During World War II he also drew many anti-Allied cartoons and remained with *Kladderadatsch* until it closed in 1944. He died in Berlin in 1954.

JON – see Jones, William John Philpin, and Musgrave-Wood, John Bertram

JONES, WILLIAM JOHN PHILPIN 'JON' 'PHILPIN' MBE (1913-92)

JON was born on 17 August 1913 in Llandrindod Wells, Wales, the son of John Jones, a bookmaker. He had his first cartoon published in the *Radnor Express* in 1928 and after studying at the Birmingham School of Art (1932) won a scholarship to the RCA in London. However, he did not complete the course, returning to Wales to work as a cartoonist on the *Western Mail*. In 1937 he joined Godbolds advertising agency in London and in World War II served at first in the Welch Regiment. Attached to Princess Patricia's Canadian Light Infantry during the Sicily landings in 1943, he was assistant military landing officer at Salerno and Anzio. He later joined the British Newspaper Unit under Hugh (later Lord) Cudlipp and contributed cartoons to *Eighth Army News*, *Union Jack*, *Crusader* ('Philpin' weekly political cartoons) and *Soldier*, which were later syndicated elsewhere. He is best known for the 'Two Types' feature which first appeared in *Eighth Army*

News as 'Page Two Smile' in July 1944 and as 'The Two Types' on 16 August 1944. The Two Types were a roguish pair of moustachioed Desert Rat officers who were never named. One was dark-haired and wore a cap while the other was blonde and wore a beret. Though only some 300 Two Types cartoons appeared between 1943 and 1946, more than a million copies of the two wartime collections of the drawings – *The Two Types* (1945) and *JON's Two Types in Italy* (1945) – were published. They also appeared on the cover of a special twelve-page Christmas 1944 issue of *Union Jack*. (These and others were republished as *JON's Complete Two Types* in 1991.) Their effect on Allied morale was tremendous (General Sir Bernard Freyberg VC said they were 'worth a division of troops') and earned JON an MBE from Winston Churchill. However, one drawing caused uproar with twenty-six Italian newspapers running editorials condemning JON and he was even challenged to a duel by an Italian count. It showed the Two Types confronting an Italian POW and one of them says: 'Si, si, si, we knew your sister in Naples' (evidently 'knew' had been translated in the biblical sense). After the war JON worked for the *Sunday Pictorial* (1946-52), *Kemsley Newspapers* (1952-5), *News Chronicle* (1955-60) and *Daily Mail* (1960-81). He retired from the *Daily Mail* in 1981 but continued to draw for the *Mail on Sunday* until 1988 and for the *South Wales Argus* and *Abergavenny Chronicle* until 1990. JON died in Newport, Wales, on 28 June 1992.

JORDAAN, LEENDERT JURRIAAN (1885-1980)

Born in Amsterdam on 30 December 1885, 'Leo' Jordaan studied at the Rijksacademie voor Beeldende Kunsten in Amsterdam. His first cartoons appeared in *De Ware Jacob* (1904-10), *De Notenkraker* (1909-27), *Het Leven* and *Geillustreerd*. In World War I he drew a number of anti-German cartoons for *De Amsterdammer* (from 1915) and others, notably 'The Peace of Versailles – The Child Enters' (*De Notenkraker* 1919) with US President Wilson as an old lady presenting a monstrous winged monster which holds a strangled dove and an olive branch (see also Will DYSON). A great admirer of the work of Albert HAHN he eventually succeeded him as the main artist of *De Notenkraker* and in 1931 succeeded Johan BRAAKENSIEK as the main artist of

De Amsterdammer (known as *De Groene Amsterdammer* after 1925). From 1934 his cartoons appeared on the front page of *De Groene Amsterdammer* and his 1939 cover drawing 'The Time Bomb' (featuring Hitler, Goebbels and Goering) led to problems with the police. In World War II he produced some striking anti-Nazi colour images for *De Groene Amsterdammer* until May 1940 when the Nazis invaded Holland. A number of his wartime cartoons appeared in a book *Nachtmerrie over Nederland* (Nightmare over Holland, 1945). After the war Jordaan returned to *De Groene Amsterdammer* and also drew for *Het Parool* and *Vrij Nederland*. Jordaan was also a prominent film critic, writing for *Het Leven*, *Geillustreerd* (from 1912), *De Groene Amsterdammer* (from 1927), *Haagsche Post* and *Vrij Nederland*, and from 1931 to 1961 presented the weekly 'Filmpraatje' ('Movie Chat') for AVRO Radio. He retired in 1961 and died in Zelhem, Netherlands, on 21 April 1980.

JOSS, FREDERICK 'DENIM' (c.1909-67)

Fred Joss was born Fritz Josefowitsch in Vienna and studied art at the city's Kunstgewerbeschule. He then travelled around Europe and by the age of nineteen was working as a cartoonist in Rio de Janeiro, Brazil. He later returned to Vienna and drew for an evening newspaper, moving to Britain in 1933. He joined the *Star* as political cartoonist in 1934 and stayed with the paper for twenty-one years. In 1938 he drew forty illustrations for *Blackmail or War?* by Genevieve Tabouis and himself wrote a controversial satirical novel, *Amateurs in Arms*, about arms racketeers in the Spanish Civil War, using the pseudonym 'F.J.Joseph'. During World War II he served as a gunner (achieving the rank of sergeant) and also drew pocket cartoons for the *Star* under the name of 'Denim'. Two collections of these drawings were published: *200 Cartoons by Denim* (1946) and *Another 200 Cartoons* (1946). He left the *Star* in 1955 and travelled to the Far East, writing and illustrating articles for various publications and reporting on the Korean War for the British press. He married his second wife in Korea and eventually settled in Hong Kong. He died there after falling from the roof of the Hilton Hotel on 22 April 1967.

'Whatever became of your adjutant?'
'The fellow turned out terribly...left the army!
Became a grubby little journalist!'
Henri-Gustave Jossot, 1896

A PROMENADE – GRANDMA GOES TO WAR
G.Julio, *La Reforme* (Brussels), 15 October 1899

JOSSOT, HENRI-GUSTAVE 'ABDUL KARIM JOSSOT' (1866-1951)

Jossot was born in Dijon, France, on 16 April 1866. His first drawings were published in *Le Sans-Souci* in 1886 and he later contributed to *Le Rire* (1894-7), *Le Cri de Paris* (1899-1922), *La Caricature*, *Cocorico*, *La Raison* and others. He is best known for his many drawings for *L'Assiette au Beurre* from its first issue (4 April 1901), including twenty special issues. He also designed posters and postcards, illustrated books and was a notable painter and writer. He moved to Sidi Bou Said (Bou Saada), Tunisia, in 1911 where he converted to Islam in 1913, taking the Muslim name Abdul Karim. He died there on 7 April 1951.

JULIO, G. (fl.1890s-1900s)

G.Julio was a Belgian cartoonist who contributed to the Brussels journal *La Reforme* during the Boer War. A number of these cartoons were also reproduced as a series of anti-British postcards, 'Cartes Postales Artistiques par Julio', which were printed in French, Dutch and German versions. A notable example was 'A Promenade – Grandma Goes to War' (15 October 1899), featuring Queen Victoria and John Bull on a gunboat pulled by the Lion and the Unicorn.

JÜTTNER, FRANZ ALBERT 'F.J.' (1865-1926)

Franz Jüttner was born in Lindenstadt, Germany, on 23 April 1865. He worked at first for the Kreisbüro (local district registration office) in Birnbaum. During the Boer War he contributed anti-British cartoons to *Lustige Blätter* and *Das Goldene Büchlein*. He also drew cartoons (some in colour) for a number of series of Boer War postcards published by Dr Eysler & Co. (publisher of *Lustige Blätter*) including 'Gruss vom Kriegsschauplatz' (Greetings from the Theatre of War) and 'Transvaalkarten'. During World War I he continued to draw cartoons for *Lustige Blätter* and others but suffered a nervous breakdown in 1917 and moved to Wolfenbüttel where he later died.

VICTORY!
Franz Jüttner, *Lustige Blätter*, 30 December 1914

K

KA – see Arnold, Karl

KEM – see Marengo, Kimon Evan

KIRBY, ROLLIN (1875-1952)

Rollin Kirby was born in Galva, Illinois, on 4 September 1875, the son of George Washington Kirby. Brought up in Hastings, Nebraska, he left home aged nineteen to study at the Art Students' League in New York. He then studied for two years in Paris at the Académie Julian and elsewhere before returning to New York as a painter. He then worked as a freelance illustrator and cartoonist, contributing to *Collier's*, *McClure's*, *Harper's*, *Life* and others. In 1911 he became editorial cartoonist on the *New York Evening Mail* and then moved briefly to the *New York Sun* in 1913 before settling at the *New York World* (later the *New York World-Telegram*) later the same year. He drew some powerful patriotic cartoons in World War I including 'That's My Fight, Too!' (*New York World*, 1917) with Uncle Sam heading for the 'Battle of Picardy'. The first cartoonist ever to win the Pulitzer Prize ('On the Road to Moscow', 1922) he was also the first to win three (1922, 1925 and 1929). He moved to the *New York Post* in 1939 and retired in 1942 but still drew occasionally for *Look* and the *New York Times Magazine*. One of his books, *Political Cartoons 1930-42* (1942) contains a number of his war cartoons. He died in New York on 8 May 1952.

Hidezo Kondo, *Manga*, October 1940

KONDO, HIDEZO (1908-79)

Hidezo Kondo was born in Koshoku, Nagano Prefecture, Japan, on 15 February 1908, the son of a haberdasher. He came to Tokyo aged fifteen and worked at first as a salesman in a department store. After studying with the illustrator Ippei Okamoto he began drawing cartoons for *Tokyo Puck* and in 1929 joined the staff of *Manga Man* which was closed down by the Japanese government in 1931. In 1933 he began drawing freelance for the leading Tokyo daily, *Tomiuri Shimbun*, and produced his first book, *This is Nonsense*, in 1934. In 1939 he moved to the newly founded *Manga*, drawing cartoons and colour caricature covers. After Japan entered World War II in December 1941 he drew increasingly vicious cartoons attacking the Allies, depicting President Roosevelt as a green-faced, Dracula-fanged, grasping monster on the cover of *Manga* in 1943. He was later sent to Borneo where he was a military correspondent and also drew propaganda cartoons for distribution on the battlefront. After the war he re-

vived *Manga* (1948) and also contributed to *Mimpo* and *Van* before joining *Yomiuri Shimbun* as staff political cartoonist. He died in Tokyo in 1979.

KRYLOV, PORFIRY NIKITICH – see Kukryniksi

KUKRYNIKSI

The *nom de plume* used by three Soviet cartoonists: Mikhail Vasilevich Kupryanov (Teyuschi, 1903-91), Porfiry Nikitich Krylov (Tula, 1902-90) and Nikolai Aleksandrovich Sokolov (Moscow, 1903-2000). They met while studying at the Vkhutemas Art and Technical School in Moscow (where a fellow student was Jack CHEN) and began working together producing cartoons for a student newspaper. After graduation they first used their group pseudonym for drawings in *Komsomolskaya*, *Red Star*, *Izvestia* and *Krokodil* and began working regularly for *Pravda* in 1933. ('Kukryniksi' derives from KUpryanov, KRYlov and NIKolai Sokolov.) They drew anti-Franco cartoons during the Spanish Civil War and were particularly well-known for the many savage anti-Nazi cartoons they produced in World War II. These included more than 200 posters beginning in 1941 with 'We Shall Mercilessly Shatter and Obliterate the Enemy' (24 June 1941) published two days after the German invasion of the USSR. It depicts a Red Army soldier bayoneting Hitler as he tears through the 1939 Russo-German Non-Aggression Pact holding a pistol.

KUPKA, FRANTIŠEK (1871-1957)

František (or Franz) Kupka was born in Opocno, Bohemia, on 23 September 1871. After studying art in Prague and Vienna he worked for a time in Scandinavia and eventually settled in Paris in 1894. His first

Kukryniksi, 1944

THE ALLIES' CULTURE MISSION
František Kupka, 1901

cartoons were published in *Cocorico* (1900-01), *Le Frou Frou* (1901) and *Le Sourire*. He also contributed to *Le Rire* (1903-8), *Les Temps Nouveaux* and others. During the Boer War he produced some powerful anti-British

cartoons for *Canard Sauvage*, and an entire issue of *L'Assiette au Beurre* ('L'Argent', 11 January 1902) was devoted to his work. (A contributor to *L'Assiette au Beurre* from its first issue on 4 April 1901, he also drew two other special issues, one of which was on 'Peace'.) One of his cover drawings for *L'Illustration* (15 December 1900), depicting Kruger and Queen Wilhelmina of the Netherlands, was reproduced as a postcard. In World War I he served in the French Foreign Legion and later became a noted painter. He died in Puteaux, near Paris, France, on 21 June 1957.

KUPRYANOV, MIKHAIL VASILEVICH – see Kukryniksi

Georges Raoul Eugène Labadie (Pilotell), c.1871

LABADIE, Georges Raoul Eugène 'Pilotell' (1845-1918)

Pilotell was born on 17 February 1845 in Poitiers, France, the son of the deputy mayor of Poitiers. In 1866 he founded *Le Gamin de Paris* and the following year founded the equally short-lived *La Feuille*. He also contributed to *L'Eclipse* (1868-9), *Paris-Caprice*, *Le Monde Pour Rire* (1869-70), *La Lune* and others. During the Commune he worked at the Prefecture of Police and was director of fine arts. He also drew a series of prints, 'Croquis Révolutionnaires par Pilotell', for the publisher Gaillant which included 'Le Dieu des Armées se Chargeant par la Culasse' featuring Bismarck loading a cannon in the form of Kaiser Wilhelm I. In addition he drew two series for Deforet & Cesar. These were 'Les Représentants en Représentation' (c.1871), featuring Victor Hugo et al., and 'Actualités'(No. 2 in the series has Kaiser Wilhelm I ordering a skeleton to march). On 8 February 1871 he founded another short-lived journal, *La Caricature Politique*. He fled to Geneva after the fall of the Commune (to escape a death sentence) and then Italy where he founded *Milan-Caprice* in 1874. He moved to London in 1875 and there later published a collection of twenty-one prints, *Avant, Pendant et Après la Commune* (1879). He died in London on 29 June 1918.

LADA, Josef (1887-1957)

Josef Lada was born in Hrusice, Czechoslovakia, on 17 December 1887, the son of a cobbler. At the age of

Josef Lada from Jaroslav Hasek, *The Adventures of the Good Soldier Schwejk During the World War* (1923)

fourteen he went to Prague as an apprentice book-binder and gilder for four years (1902-06) while also taking evening classes in drawing at the Prague School of Commercial Art (1905-7). He had his first cartoons published in *Maj* (1905). In 1908 he began contributing to overseas magazines such as *Musquete* (Austria) and *Pasquino* (Italy) and in 1911 published his first book, *My ABC*. He subsequently worked as a book illustrator (in all he illustrated more than 300 books). He wrote the popular children's book *Mikeš* (Mikesh the Cat) in 1934 but is best known for his (nearly 600) illustrations for his friend Jaroslav Hasek's World War I novel about the Austro-Hungarian Army (which included many Czechs), *The Adventures of the Good Soldier Schwejk During the World War* (1923). He died in Prague on 14 December 1957.

LAIDLER, Gavin Graham 'Pont' (1908-40)

Graham Laidler was born on 4 July 1908 in Jesmond, Newcastle-upon-Tyne, the only son of George Gavin Laidler, the proprietor of a firm of painters and decorators. Soon after qualifying as an architect at the Architectural Association's School of Architecture in London he contracted tuberculosis, and after a major operation in 1932 was unable to pursue an architectural career. While still a student his first cartoon strip appeared in *Woman's Pictorial* (1930-37), and he had

his first cartoon accepted by *Punch* in August 1932. The first drawing in his celebrated series 'The British Character' ('Adaptability to Foreign Conditions') appeared in the magazine on 4 April 1934, signed 'Pont' (the pseudonym arose from a family joke concerning 'Pontifex Maximus'). His wartime *Punch* series included 'Popular Misconceptions' and 'Wartime Weaknesses'. A number of his wartime drawings were reproduced in books, such as *The British Carry On* (1940), *Pont* (1942) and *Most of Us Are Absurd* (1946). He died in Uxbridge, Middlesex, on 23 November 1940.

LANCASTER, Sir Osbert CBE (1908-86)

Osbert Lancaster was born in Notting Hill, London, on 4 August 1908, the son of Robert Lancaster, a businessman who was killed at the Battle of the Somme in 1916. After studying at the Byam Shaw School of Art (1925-6) he took English at Lincoln College, Oxford (1926-30) – where one of his fellow students was Winston Churchill's son, Randolph – and contributed caricatures and humorous articles to *Cherwell*. He then studied art at Oxford's Ruskin School (1929-30) and stage design under Vladimir Polunin (formerly Diaghilev's designer) at the Slade in London (1931-2). At first he worked as a freelance illustrator and poster designer before becoming an assistant editor on the *Architectural Review* (1934-9). In 1938 he began contributing to the *Daily Express* and shortly afterwards John Rayner, features editor of the paper, invited him to draw single-column cartoons on the European model. The first one appeared in Tom Driberg's 'William Hickey' gossip column on 1 January 1939, but they later transferred to the front page and it is estimated that he drew some 10,000 in all between 1939 and 1981. During the war they were headed 'Pocket Cartoon', a description Lancaster himself invented, drawing the parallel with 'pocket' battleships in that though small they packed a punch. In World War II he also drew large political cartoons for the *Sunday Express* using the pseudonym 'Bunbury' (an allusion to the imaginary character in Oscar Wilde's play, *The Importance of Being Earnest*, rather than to the eighteenth-century caricaturist). Many of his wartime cartoons were reproduced in books, notably *Pocket Cartoons* (1940), *New Pocket Cartoons* (1941), *Further Pocket Cartoons* (1942), *Assorted Sizes* (1944) and *Cartoons* (1945). Some were also translated for publication in French aerial propaganda newspapers such as *Le Courrier de l'Air* and *Revue de la Presse Libre*. Lancaster also worked for the news departments of the Ministry of Information (1939) and the Foreign Office (1941) and in 1944 was sent to the British Embassy in Athens as Press Attaché (Second Secretary) for two years. After the war he continued to draw cartoons, painted murals, produced books and designed stage sets. Appointed CBE (1953) he was later knighted (1975). Sir Osbert Lancaster died in Chelsea, London, on 27 July 1986.

LANGDON, David OBE (b.1914)

David Langdon was born in London on 24 February 1914, the son of Bennett Langdon. Largely self-taught, he had his first cartoons published in *Punch*, *Lilliput* (from its first volume) and *Time & Tide* in 1937 while he was working in the London County Council Architects Department (1931-9). During World War II he was an executive officer in the London Rescue Service (1939-41), a squadron leader in the RAF (1941-6) and editor of the *Royal Air Force Journal* (1945-6). As well as his wartime cartoons, some of which were republished in his books *Home Front Lines* (1941) and *All Buttoned Up!* (1944), he illustrated Squadron Leader C.H.Ward-Jackson's *It's a Piece of Cake: RAF Slang Made Easy* (1943). In addition he produced advertising cartoons including the well-known wartime 'Billy Brown of London Town' series of posters for London Transport. After the war he continued to draw for *Punch* (1937-92) and the *Sunday Pictorial* and *Sunday Mirror* (1948-90), but also contributed to *Paris-Match*, *Radio Times*, *Saturday Evening Post*, *Aeroplane*, *Royal Air Force Review*, *Collier's*, *Spectator* and the *New Yorker* amongst others. He was awarded an OBE in 1988.

LANOS, Henri (fl.1885-1932)

Henri Lanos was born in Paris and began contributing to *La Vie Moderne* in 1885. He also drew for *La Caricature* (1887-9), *Mon Journal* (1896-1901), *Fantasio* (1915) and *Le Rire* (1915-19). In the Boer War some of his drawings were reproduced in the *Graphic*. During World War I he drew some striking covers for *Le Rire Rouge*, including 'La Voix de Dieu' (The Voice of God,

Henri Lanos, *Le Rire Rouge*, 27 March 1915

6 March 1915) with the hand of God grabbing Zeppelins from the sky and saying 'You kill women and children; I will destroy you all!'

LÉANDRE, Charles-Lucien (1862-1934)

Charles-Lucien Léandre was born in Champsecret, near Alençon, Orne, France on 23 July 1862. After studying at the École des Beaux-Arts in Paris, his first cartoons appeared in *Les Hommes d'Aujourd'hui* (1878-9), *L'Évènement Parisien* (1882), *Le Chat Noir* (1883) and *La Vie Mod-* erne (1884-94) and he later contributed to *Le Gaulois, Le Rire* (1894-1929, including covers), *La Revue de L'Art* (1896-1930), *Le Cornet* (1896-1934), *Le Cri de Paris* (1897-1905), *La Vie Amusante* (including covers), *Le Journal Amusant* (1897-1924), *Lectures Pour Tous* (1900-14), *Le Journal* (1901-22), *La Baïonnette* (1915-19), *L'Assiette au Beurre* (from its first issue on 4 April 1901) and others. He was also co-founder of the journal *Les Quat'z-Arts* (1897-1915). During the Boer War he drew many savage attacks on Queen Victoria and British politicians, espe-

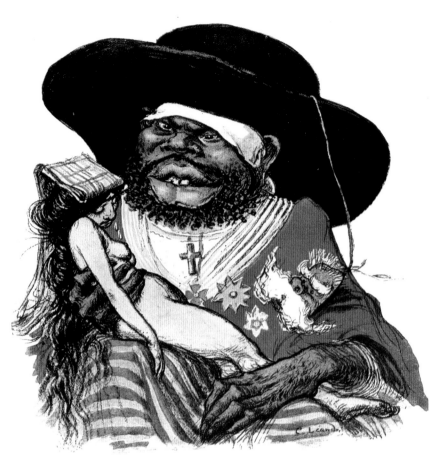

MENELIK II, KING OF ETHIOPIA AND DEFEATER OF ITALY
Charles-Lucien Léandre, *Le Rire* (Paris), 1896

was used as a poster 'Cultura Francesca!' (1918). Awarded the Légion d'Honneur he was the founder and first president of the Société des Dessinateurs Humoristes in 1904. He died in Paris in 1934.

LEBÈGUE, LÉON (1863-1944)

Léon Lebègue was born in Orléans, France. His first drawings were published in *Scapin* in 1880 and he later contributed to *L'Illustré National* (1899-1905, including covers), *Le Gaulois du Dimanche* (1899-1911), *Le Rire* (1894-1908), *Nos Caricatures* and others. He also drew for *L'Illustré Soleil du Dimanche* (1896-1903), a notable Boer War cover being 'Old England à la Rescousse' (17 December 1899) showing Queen Victoria, dressed as a kilted Scottish sergeant mounted on a white unicorn, rescuing a battered-looking British lion with a cannon tied to its tail.

cially Joseph Chamberlain, and these provoked diplomatic protests from the British government. One notable cover drawing for *Le Rire* ('England, the Eternal Champion of Justice, Upholder of the Weak', 7 October 1899), was the magazine's first on the Boer War. Published only a few days before the declaration of war, it shows Victoria, carrying a pack of illegal dum-dum bullets and a smoking gun, sitting on Kruger's head and poking him with a sharp bodkin. His celebrated portrait of Kruger published on the cover of a special issue of *La Vie Illustrée* ('L'Oncle Paul', 16 November 1900) also appeared as a postcard. He continued producing powerful cartoons in World War I, notably 'Le Repaire du Monstre' (The Lair of the Monster, *La Baïonnette*, 22 July 1915) showing Prince Willy in a cave with the figures of Debauchery, Vileness, Cowardice, Cruelty and Death. In October 1915 an exhibition of his World War I anti-German cartoons was held at the Leicester Galleries in London. Later one of his wartime drawings for *Le Rire*

OLD ENGLAND TO THE RESCUE
Léon Lebègue, *L'Illustré Soleil du Dimanche* (Paris), 17 December 1899

LEE, JOSEPH BOOTH (1901-74)

Joe Lee was born on 16 May 1901 in Burley-in-Wharfedale, Yorkshire. While at Leeds Grammar School he learned to draw cartoons via Percy Bradshaw's Press Art School correspondence course. He also attended Leeds School of Art (c.1915-18), where his contemporaries were Henry Moore and Barbara Hepworth, with the intention of becoming an architect. On Christmas Eve 1919 he came to London to take up a scholarship at the RCA but was unable to pay his way. He worked freelance at first (his first cartoon appeared in the *Bystander* in 1920) and joined the *Pall Mall Gazette* (1920) as daily cartoonist and political writer. When that folded eighteen months later he moved to the *Liverpool Daily Courier* as cartoonist and art editor. He then worked for the *Sunday Express* but resigned during the General Strike in 1926 and moved to the *Daily Chronicle* while also contributing to the *Daily Mail*, *Bystander*, *Tatler*, *Sketch*, *London Opinion*, *Punch* and others. On 14 May 1934 he created the popular 'London Laughs' series of joke drawings with a London background for the *Evening News* (1934-66) which for many years was the longest running daily cartoon series in history. It was retitled 'Smiling Through' during World War II and a number of these Home Front drawings were reproduced in a wartime anthology, *400 Famous Cartoons by Five Famous Cartoonists: Neb, Lee, Moon, Gittins, Illingworth* (1944). Nearly 9,000 cartoons later Lee retired to Norwich in July 1966 but continued to produce political cartoons three days a week for the local *Eastern Daily Press* and drew for children's comics. He died on 15 March 1974.

LEECH, JOHN (1817-64)

John Leech was born on Ludgate Hill, London, on 23 August 1817, the son of a coffee-house proprietor. After Charterhouse School (where a contemporary was W.M. Thackeray) he began to study medicine but his father's bankruptcy led to his working as a humorous illustrator. Taught to etch by George CRUIKSHANK

THE FRENCH PORCUPINE
He May Be an Inoffensive Animal But He Don't Look Like It
John Leech, *Punch*, 19 February 1859

he became his deputy artist on *Bentley's Miscellany* in 1840. He began contributing to *Punch* soon after it was founded in 1841 and quickly became its main artist. He also drew the magazine's first ever war-related cartoon after the 1st Opium War ('The Presentation of the Chinese Ambassador', *Punch*, 17 December 1842) which showed the new fat, pigtailed ambassador being presented to Queen Victoria by Prime Minister Sir Robert Peel. On 3 January 1846 he created the character of the Brook Green Volunteer in answer to the British government's call to re-organise the militia. In Leech's series of drawings for *Punch* the reader follows the comic escapades of a single recruit, based in Brook Green, Hammersmith, London. During the Crimean War he drew a number of well-known cartoons including 'General Février Turned Traitor' (10 March 1855), on the death of Tsar Nicholas I, and 'The General Fast (Asleep). Humiliating – Very!' (24 March 1855) attacking British Commander-in-Chief Lord Raglan. He also produced a drawing which could be seen as a precursor to those by Bruce BAIRNSFATHER and Bill MAULDIN featuring two freezing soldiers grumbling about the issue of the new Crimean Medal: 'Well, Jack! Here's good news from home. We're to have a medal.' 'That's very kind. Maybe one of these days we'll have a coat to stick it on?' (17 February 1855). After the Crimean War Leech also drew the celebrated cartoon of the belligerent Napoleon III as 'The French Porcupine' (*Punch*, 17 February 1859) published shortly after the Battle of Solferino between France and Austria. From his mouth come the Emperor's famous words 'L'Empire, c'est la Paix' while the caption reads: 'He May Be an Inoffensive Animal, But He Don't Look Like It' (a similar drawing, but featuring Tsar Nicholas I, had appeared in the *Puppet Show* in June 1854). One of his last cartoons on a war theme was 'New Elgin Marbles' (24 November 1860) featuring Lord Elgin after the defeat of China in the Third Opium War. He died in Kensington, London, on 29 October 1864.

LEES – see Lees Walmesley, Peter

LEES WALMESLEY, PETER 'LEES' (c.1908-42)
Born in Norfolk, the son of the managing director of the Great Yarmouth Gas Company, Lees attended Lord Nelson's old school at North Walsham and studied at Norwich Art School. His first published drawing was of gas appliances on a leaflet for his father's company and he worked at first as an artist for Dorlands Advertising Agency in London (1927-33). He then turned freelance and contributed strips to the *Daily Express*, *Daily Chronicle* and *John Bull* and joke cartoons to *Lilliput*, *Punch*, *Strand*, *Bystander*, *Night & Day* and others. A gunner in the army during World War II, he also drew editorial cartoons for the *Sunday Graphic*.

LEETE, ALFRED AMBROSE CHEW (1882-1933)
Alfred Leete was born on 28 August 1882 in Thorpe Achurch, Northamptonshire, the son of John Leete, a farmer. He left school at the age of twelve to be an office boy in a Bristol surveyor's office and his first

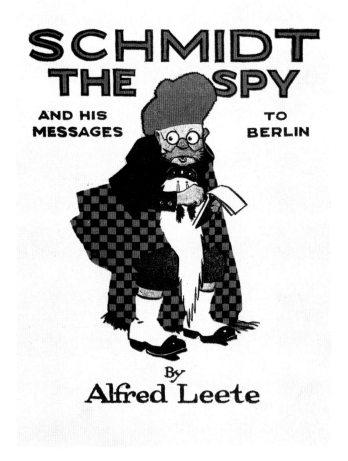

Alfred Leete, *Schmidt the Spy and His Messages to Berlin* (1915)

cartoon was accepted by the *Daily Graphic* when he was sixteen. Self-taught as an artist, he then began to contribute regularly to *Bristol Magpie* and in 1905 moved to London where he worked as a draughtsman in a furniture company and for a lithographer in the City. Here his drawings soon began to appear in *Ally Sloper's Half-Holiday*, *Pall Mall Gazette*, *Pick-Me-Up*, *Bystander*, *Sketch*, *Passing Show* and *Punch* (1905-33). In 1914 he created the popular 'Schmidt the Spy' strip for *London Opinion* which was later published as a book (*Schmidt the Spy and His Messages to Berlin*, 1915), and was turned into a film in April 1916 by Phoenix Films with Lewis Sydney playing Schmidt. He also drew the title page for *The Worries of Wilhelm: A Collection of Humorous and Satirical War Cartoons from the Pages of 'The Passing Show'* (1916, see also Leo CHENEY) and illustrated two wartime volumes by Reginald Arkell: *All the Rumours* (1916) and *The Bosch Book* (1916). In addition he drew the Kaiser signing death warrants of some British cartoonists (*London Opinion*, 26 June 1915). However, perhaps his best-known work is the recruiting poster featuring War Secretary Lord Kitchener pointing with the text 'BRITONS [Kitchener] "Wants YOU". Join Your Country's Army!' The design first appeared as a front cover for *London Opinion* on 5 September 1914 (with the words 'Your Country Needs YOU' under the Kitchener image). It was later copied by James Montgomery FLAGG in the USA, with Uncle Sam replacing Kitchener (and the text 'I Want YOU for U.S. Army'), and inspired many other posters, including those by the Italian Achille Mauzan (1917) and the Russian D.S. MOOR (1919). In 1936 a Spanish version called women to arms in the Spanish Civil War, in World War II Bill Little used the design with Churchill saying 'Deserve Victory!' and there was even a wartime comics version with Desperate Dan saying 'YOU Can Help Britain by Collecting Waste-Paper' (*Dandy*, 1942). Leete also produced posters for the Tank Corps ('Let Professor Tank Teach You a Trade') and others and later enlisted in the Artists' Rifles and served in France. Alfred Leete died in Kensington, London, on 17 June 1933.

LEHMANN, JACQUES 'JACQUES NAM' (1881-1974)

Jacques Nam was born in Paris and after studying at the École des Beaux-Arts exhibited his paintings in Paris and London. His first cartoons appeared in *Le Sourire* (1900-11) and he also contributed to *Le Rire* (1903-16), *Fantasio* (1912-22), *La Vie Parisienne* (1913-16), *La Baïonnette* (1915-19), *L'Echo de Paris* (1916-23) and others. Nam was also a distinguished book illustrator, notably of the works of Colette from *Sept Dialogues de Bêtes* (1912) onwards and Colette wrote texts for his own book *Chats* (Cats, 1935). He was awarded the Légion d'Honneur in 1926. He died in Paris in 1974.

KAPUT!
'I will break my beak!'
Jacques Lehmann (Jacques Nam),
Le Journal (Paris), n.d.

TSAR NICHOLAS
Willy Lehmann-Schramm, *Nebelspalter* (Zurich),
May 1906

BEFORE...AFTER
Alfred Le Petit, *La Charge*, 24 September 1870

LEHMANN-SCHRAMM, WILLY 'WL-S'
(1866-after 1905)
Born in Dresden, Germany, on 4 December 1866, Lehmann-Schramm was working in Zurich from 1892, primarily for *Nebelspalter* but also for *Postillon* and others. He drew cartoons during the Boer War, Spanish-American War and Russian Revolution of 1905.

LEJEUNE, FRANÇOIS 'JEAN EFFEL' (1908-82)
Jean Effel was born in Paris on 12 February 1908, the son of a professor of languages. His first cartoons appeared in *La Lumière* (1930-9) and he also contributed wartime cartoons to *Paris-Soir* (1932-44), *Marianne* (1933-40), *Le Canard Enchaîné* (1933-40, 1944-9), *Messidor* (including covers), *Ric et Rac* (1933-44) and *Candide* (1934-43) amongst many others. His pseudonym is derived from his initials 'F.L.' Among his many books are *Le Colonel de la Roque* (1936, drawings from *Le Canard Enchaîné* and *Marianne*) and *Jours Sans Alboches*

(1945). After the war he was awarded a Croix de Guerre and had great success with *La Création du Monde* (1951, translated into fifteen languages) and other books based on Bible stories. He died in Paris on 10 October 1982.

LEO – see Cheney, Leopold Alfred

LE PETIT, ALFRED (1841-1909)
Alfred le Petit was born on 8 June 1841 in Aumale, France, the son of a clockmaker and jeweller. He studied in Rouen at the Académie de Peinture et de Dessin (1866) and then moved to Paris where he began contributing caricatures to *La Lune* (1866), *Le Journal Amusant* (1867-83) and *L'Eclipse* (1868-77). In January 1870 he set up the satirical anti-Empire magazine *La Charge* (contributors included CHAM, FAUSTIN, MOLOCH, REGAMEY and ROBIDA). However, his caricatures lampooning Emperor Napoleon III led to

THE PLUCKED EAGLE
Alphonse-Jacques Lévy (Saïd), 1870

the magazine being suppressed. After France's defeat in the Franco-Prussian War and the exile of the Emperor, Le Petit attacked both the Government of National Defence and the Commune (notably in his series 'Hommes de la Commune'). After the restoration of order he contributed to *Le Charivari* (1872-86), *La Jeune Garde* (1878-90) and *L'Assiette au Beurre* amongst others. He founded four more short-lived satirical magazines: *Le Pétard* (1877-9), *Sans Culotte* (1878-9), *La Charge* (a revived version, 1888) and *L'Etrille* (1898). During the Boer War he also drew for *Le Grelot* and others. He died in Levallois-Perret on 15 November 1909. His son Alfred-Marie (1876-1953) was also a cartoonist (signing himself 'A. Le Petit Fils') and worked for *Le Rire* (1896-1940), *Le Sourire* (1899-1913) and others.

LÉVY, ALPHONSE JACQUES 'SAÏD' (1843-1918)

Saïd was born in Marmoutier, France, on 8 January 1843. He moved to Paris aged seventeen and after studying under the painter Jean-Léon Gérôme began work as a painter and printmaker, exhibiting at the Paris Salon in 1874. His first cartoons were published in *La Rue* and *Le Bonnet de Coton* in 1867 and he also contributed to *L'Eclipse*, *Le Journal Amusant* (1876-81), *Le Rire* (1895-1902), *L'Illustré National* (1900-02) and others. A notable Franco-Prussian War drawing by him was 'L'Aigle Deplumé!...' (1870) showing Napoleon III as a plucked imperial eagle wearing a Prussian helmet and sitting chained to a parrot's perch between feed pots marked 'Disgrace' and 'Ignominy' after being defeated at the Battle of Sedan. Saïd died in Algiers in February 1918.

LINDSAY, NORMAN ALFRED WILLIAMS (1879-1969)

Norman Lindsay was born in Creswick, Victoria, Australia, on 23 February 1879, the son of Robert Lindsay, an Anglo-Irish surgeon. A self-taught artist, he began work as an illustrator on the crime journal *Hawklett*, sharing a studio in Melbourne with his brother Lionel. He later produced lithographic posters, was art editor of the short-lived *Rambler* magazine and began to draw cartoons for *Melbourne Punch*. In 1901 an exhibition of his illustrations of Boccaccio's *Decameron* in Sydney led to an invitation to join the staff of the weekly *Sydney Bulletin* at the age of twenty-one. Within a year he was drawing a full-page cartoon every week and produced a number on the last stages of the Boer War. He came to London in 1909 but returned to Australia the following year. In World War I he continued to draw powerful newspaper cartoons, a number of which were later published as *Norman Lindsay War Cartoons 1914-1918* (1983). He also produced postcards and a series of six memorable posters (and three leaflets) for the Australian government's last recruiting campaign in 1918 (Australia had no conscription during the war). The first, '?', featuring a Prussian monster grabbing the globe with bloody hands next to a question mark in a circle, caused considerable interest and was followed by 'Quick!', 'God Bless Dear Daddy', 'Will You Fight?', 'The Last Call' and 'Fall In'. However, before the last two were issued an armistice was signed and the campaign was abandoned. At the end of the war he wrote and illustrated the bestselling children's book, *The*

Magic Pudding (1918). He also drew cartoons in World War II. He died in Springwood, near Sydney, on 21 November 1969. His sister Ruby was also a cartoonist and illustrator (notably for *The Suffragette*) and married Will DYSON.

'LITTLE BONEY' – see Gillray, James

LITTLE, THOMAS (1898-1972) Tom Little was born on 27 September 1898, in Tennessee, the son of John Wallace Little. He was brought up in Nashville and after studying art at the Watkins Institute (1912-15) and the Montgomery Bell Academy began work as a reporter on the *Nashville Tennessean* (1916-23) where he was tutored in cartooning by Carey ORR. During World War I he served in the US Army, after which he returned to the *Nashville Tennessean*. In 1923 he moved to New York as a reporter for the *Herald-Tribune*, for which he also drew comic strips. Returning to Nashville in 1924 he became city editor of his old paper and in 1934 began drawing editorial cartoons. From 1937 he concentrated on cartooning and produced some powerful work during World War II. He won the Pulitzer Prize in 1957. Tom Little died on 20 June 1972.

L.M. – see Métivet, Lucien-Marie-François

LORENTZ, ALCIDE JOSEPH (1813-91) Alcide Lorentz was born in Paris on 23 February 1813. His first drawings appeared in *L'Artiste* in 1833 and he also contributed to *La Caricature*, *Le Journal Pour Rire*, *La Lune*, *L'Eclipse* and others. One of his notable prints

THE NORTHERN COLOSSUS
Alcide Joseph Lorentz, July 1854

published by Martinet during the Crimean War was 'Le Colosse du Nord' ('The Northern Colossus', July 1854) featuring a giant statue of Tsar Nicholas I being attacked by tiny Allied troops who swarm over his body, cutting off his fingernails etc. Lorentz died in Paris in 1891.

LOW, SIR DAVID ALEXANDER CECIL (1891-1963)

David Low was born in Dunedin, New Zealand, on 7 April 1891, the son of David Brown Low, a Scottish-born journalist. Self-taught, apart from a correspondence course with a New York school of caricature (c. 1900) and a brief period at Canterbury School of Art, he was influenced at first by English comics such as *Chips*, *Comic Cuts* and *Ally Sloper's Half Holiday*. At the age of eleven he had his first cartoons published in *Big Budget* (a comic strip) and the *Christchurch Spectator* (a topical cartoon). In 1907 he joined the *Sketcher* and in 1908 became the *Christchurch Spectator*'s political cartoonist (his first full-time job), signing his drawings 'Dave Low'. He later moved to the *Canterbury Times* (1910) and the *Sydney Bulletin* (1911-19). At the *Bulletin* he was influenced by Will DYSON and Norman LINDSAY, and he drew a number of cartoons during World War I, such as 'Peace on Earth' (18 April 1918) featuring a huge winged German woman sitting on the globe, holding a sword marked 'Kultur' and blowing a trumpet marked 'Deutschland Uber Alles'. His bestselling *The Billy Book* (1918), lampooning Australian PM Billy Hughes, drew praise from Arnold Bennett and led to his move to England. His first cartoon to be published in Britain (a syndicated *Sydney Bulletin* drawing from 20 October 1914) appeared in the *Manchester Guardian* on 4 January 1915. In London he began work on the Liberal evening paper the *Star* in 1919 (signing his cartoons 'Low') and in 1927 became the first-ever political cartoonist on Lord Beaverbrook's Conservative *Evening Standard*, drawing four cartoons a week. It was at the *Standard* that he produced his powerful anti-Nazi and anti-Fascist cartoons in the 1930s and 40s. 'It Worked at the Reichstag – So Why Not Here?' (18 November 1933) with Hitler burning down the League of Nations, so angered Hitler that all Beaverbrook's newspapers were banned in Germany. 'The Girls He Left Behind Him' (10 May 1935) with the Nazi leaders waving farewell to Mussolini as he departs for Abyssinia, led to the *Standard* being banned in Italy. 'The Harmony Boys' (2 May 1940), featuring General Franco and the Axis partners (Spain was then neutral), led to protests to the Foreign Office from the Spanish government. Some of his war cartoons were also published in

book form, notably *Low's Political Parade* (1936), *Low Again* (1938), [with Q. Howe] *A Cartoon History of Our Times* (1939), *Europe Since Versailles* (1940), *Europe at War* (1941), *Low's War Cartoons* (1941), *Low on the War* (1941), *The World at War* (1941) and *Years of Wrath* (1946). Low also illustrated Peter Fleming's novel *The Flying Visit* (1940), about an imaginary visit by Hitler to Britain. Low had even planned a satirical version of Hitler's *Mein Kampf* in 1942 but Churchill ordered it to be banned. Of Low's many cartoon characters, those with a wartime link included Musso the Pup (originally created while on the *Star*) and the weekly strip 'Hit and Muss', both of which led to complaints from the Italian embassy (the latter strip was replaced by 'Muzzler', combining Hitler and Mussolini). However, the best known was Colonel Blimp who caused problems at home – Churchill even tried to ban the 1943 film, *The Life and Death of Colonel Blimp* (which was loosely based on the character) saying it was 'detrimental to the morale of the army'. (A collection of cartoons and texts featuring the character, *The Complete Colonel Blimp*, was published in 1991.) After the war Low moved to the pro-Labour *Daily Herald* (1950) and in 1953 joined the *Manchester Guardian* as the paper's first staff cartoonist (it had previously only used syndicated cartoons, including his own work). In addition, he contributed to *Picture Post*, *Graphic*, *Life*, *New Statesman* (of which he later became a director), *Illustrated*, *Collier's*, *Nash's Magazine*, *Pall Mall Magazine* and others. He was knighted in 1962. Sir David Low died in London on 19 September 1963.

LUMLEY, SAVILE (1876-1960)

Savile Lumley was born in Marylebone, London, the son of Henry Robert Lumley, a newspaper proprietor. His brothers Lyulph and Osbert were both journalists. In the 1890s Savile Lumley shared a studio in Abbey Road, St John's Wood, with G.L.STAMPA who was then studying at the Royal Academy Schools with Heath ROBINSON and others so it is likely that Lumley was at the RA at the same time (1895-1900). His first cartoons and Boer War illustrations started appearing in *Shurey's Pictorial Budget* and *Sketchy Bits* (another Shurey publication) during this period. He also contributed to *Tatler* and other magazines before World

'DADDY, WHAT DID <u>YOU</u> DO IN THE GREAT WAR?'
Savile Lumley, poster, c.1915

War I. However, he is best known for his famous recruiting poster 'Daddy, What Did <u>You</u> Do in the Great War?' (*c.* 1915). Amongst the many pastiches of this was the anti-appeasement cartoon 'What Are <u>You</u> Going to Do in the Great Peace, Daddy?' by E.H.SHEPARD (*Punch*, 12 October 1938), published shortly after the Munich Agreement ceding parts of Czechoslovakia to Germany. After the war Lumley illustrated books and comics for children and contributed cartoons to the *Humorist* in the 1920s and 30s. He died in 1960.

NO FAMILY RESEMBLANCE
The German Eagle (tearfully): 'As bird to bird, surely you won't desert me?'
The American Eagle: 'Desert you! I'm an eagle, not a vulture!'
Herbert Wood Mackinney (Mac), *Cape Times* (Cape Town), 1914

MAC – see Mackinney, Herbert Wood

MACKINNEY, HERBERT WOOD 'MAC' (1882-1953)
Mac first began drawing cartoons for the *Pretoria News* c.1904 and joined the *Cape Times* in 1906, remaining with the paper until 1923. He drew political cartoons throughout the Boer War and World War I and produced a series of books of his work, *Cartoons of the Great War, 1914-1916* (1916), *Cartoons of the Great War, 1916-1917* (1917) and *Cartoons of the Great War, 1917-1918-1919* (1920). He died in 1953.

MAIGROT, HENRI 'HENRIOT' (1857-1933)
Henriot was born on 13 January 1857 in Toulouse, France. After studying law he had his first drawings published in *L'Echo des Trouvères* in 1877. He also contributed to *Le Charivari* (1879-1904), *Le Journal Amusant* (1882-1925), *L'Illustration* (1883-1931), *Almanach Vermot* (1886-1931) and others. During the Boer War he produced many cartoons for *Le Charivari* (of which

he became a director in 1890), notably for the special issue, *Boers et Anglais*. On 23 January 1915 he founded (and edited) the journal *À la Baïonnette!*, named after the *cri de guerre* of French soldiers charging the enemy. The first issue had a cover by Henriot, 'The Return of the Taube' with its German pilot being asked 'How many children today?' On replying 'Seven, colonel' his superior officer comments 'Is that all?' It was renamed simply *La Baïonnette* on 8 July 1915 and ceased publication in 1922. He was awarded the Légion d'Honneur. Henriot died in Nesles-la-Vallée, France, on 10 August 1933.

MARCUS, EDWIN (1885-1961)
Born in the USA, Ed Marcus drew a whole-page cartoon for the *New York Times* for fifty years from 1908 to 1958

CHAMBERLAIN'S CHRISTMAS SURPRISE
Henri Maigrot (Henriot), *Le Charivari* (Paris), December 1900

and throughout two world wars. A notable drawing in World War I was a pastiche of 'Who Stole the People's Money?', the famous Tweed Ring cartoon by Thomas NAST. In Marcus' version, 'Who caused the War? – 'Twas Him' (*New York Times*, 15 December 1918) the guilty man in the 'Potsdam Ring' is the Kaiser. He also drew for *Life* during the war. In World War II he drew 'Worth Paying For' (1941) about the price of democracy. Later, after the daily bombing of Tokyo (but ironically only the day before the first atomic bomb was dropped on Hiroshima), he drew 'Ah! Those Were the Good Old Days!' (*New York Times*, 5 August 1945) spoken by a besieged Tokyo civilian in reference to the small-scale Doolittle Raid of 1942. He retired in January 1958 (his last cartoon appearing on the 5th) and died in 1961.

MARENGO, KIMON EVAN 'KEM' (1904-88)

Kem was born in Zifta, Egypt, on 22 January 1904, the son of Evangelos Marangos, a Greek cotton merchant. He grew up in Alexandria where he edited and illustrated the political weekly *Maalesh* (1923-31). He later moved to Paris to study at the École Libre des Sciences Politiques and eventually settled in London c.1937. A self-taught artist, his cartoons were published in *Le Petit Parisien*, *Iraq Times*, *John Bull*, *La Bourse Égyptienne*, *Cartoon Comment*, *Men Only*, *New York Times*, *Liberal News*, *Razzle*, *Daily Herald* and *Daily Telegraph*. In 1938 he designed the cartoon menu card for the Foreign Press Association's fiftieth anniversary dinner at which Prime Minister Neville Chamberlain was guest of honour. During World War II he ran the 'KEM Unit' in the Political Information Department of the Foreign Office, producing propaganda cartoons for the Middle East and for French aerial newspapers such as *Le Courrier de L'Air*. In all he produced c.3,000 cartoons during World War II. Many of his anti-Nazi and wartime drawings

also appeared as postcards and posters and some of them were reproduced in books, notably *Toy Titans* (1937), *Adolf and His Donkey Benito* (1940) and *Lines of Attack* (1944). One of his best-known wartime posters was 'The Progress of Russian and German Co-operation' (1939), published shortly after the signing of the Nazi-Soviet Pact, which showed Hitler and Stalin in a three-legged race going nowhere. Its title was originally in Arabic. Kem was a specialist in Middle Eastern languages and in about 1943 he also produced a series of six illuminated colour postcards in imitation of the Persian national epic, the *Shanamah* (Book of Kings), but with Hitler and the leading Nazis in place of the original characters and with Tojo and Mussolini as serpents. In addition he illustrated Lieutenant-Colonel Pierre Tissier's book about the Vichy regime, *I Worked With Laval* (1942). After the war when his pseudonym was copied he was forced to take his case to the House of Lords ('Marengo v. *Daily Sketch* and *Sunday Graphic* Ltd [1948]', set a precedent for civil litigation). He was awarded the Légion d'Honneur and Croix de Guerre. Kem died in London on 4 November 1988.

MARIO – see Armengol, Mariano

MARTINI, ALBERTO (1876-1954)

Alberto Martini was born in Oderzo, Italy, on 24 November 1876, the son of a portrait painter who was a professor of drawing at the Istituto Tecnico in Treviso. A noted painter (his work was seen as a precursor of Surrealism), lithographer and book illustrator, Martini also contributed drawings to *Jugend*, *Dekorative Kunst* and others. In addition he produced fifty-four gruesome cartoon images during World War I (four series of twelve and one series of six). Entitled *La Danza Macabra Europea* (The European Dance of Death) the drawings were published between 1914 and 1916 both as a portfolio of prints and as postcards (some with French and Italian titles). First published when Italy was still neutral, the images were very controversial and were threatened with censorship by the Italian government. However, when Italy joined the war on the Allied side in May 1915 they were seen as useful propaganda tools. Most of the drawings were directed at Kaiser Wilhelm and the Central Powers but the Al-

EUROPEAN SUICIDE
Alberto Martini, *La Danza Macabra Europea*
(Treviso, 1914-16)

lies were also attacked. An example of this is 'Patriottismo' (Patriotism) showing the figure of Death wearing a French Liberty Cap, shouting 'Les Alboches' and sharpening a scythe marked '1870' and '1914' over ground strewn with the spikes from German helmets. Martini moved to Paris in 1928, returned to Italy in 1934 and in about 1940 published a satirical journal, *Perseus*, containing his drawings and cartoons. He died in Milan on 8 November 1954.

MATT – see Sandford, Matthew Austin

MATYUNIN, PAVEL PAVLOVICH 'PEM' (1885-1961)

Pem was born in South Russia on 27 January 1885. Trained as an engineer, his first cartoons appeared in *Novoie Vremnya* and *Vechernee Vremia* in 1905. His World

AN UNLIKELY ALLY
Pavel Pavlovich Matyunin (Pem),
La Guerre et Pême (Petrograd, 1916)

War I drawings for *Loukomorie* and others were collected in a book, *La Guerre et Pême* (The War and Pem, 1916). A good example is 'Laocoon, Antique Sculpture of the 20th Century' (*Loukomorie*, 1916) showing Franz Joseph of Austria, Ferdinand of Bulgaria and Mehmet V of Turkey being tied up by the German snake, whose head bites Franz Joseph. He later worked for *La Pensée Russe* in Paris. He died on 12 July 1961.

MAULDIN, WILLIAM HENRY (1921-2003)

Bill Mauldin was born in Mountain Park, New Mexico, on 29 October 1921, the son of Sidney Albert Mauldin, an apple farmer. At the age of thirteen he took a correspondence course from the Chicago Art Institute and in 1937 studied for a year at the Chicago Academy of Fine Arts. After moving to Phoenix, Arizona, he worked in various jobs while also contributing cartoons to *Arizona Highways* and *The Oklahoman*. In September 1940 he joined the 120th Quartermaster Regiment of the Arizona National Guard (part of the 45th Infantry Division) at Fort Sill, Arizona. When *45th Division News* was founded in 1943 he volunteered to be its cartoonist

and his celebrated characters Willie and Joe appeared in his first drawing for the paper. In 1943 Mauldin sailed with the US Task Force to North Africa and took part in the Sicily landings. By the time the Allies had advanced through Italy and *45th Division News* had moved its base to Naples the Mediterranean edition of the US military newspaper *Stars and Stripes* had begun to reprint his cartoons. Mauldin's 'Up Front' panel, featuring Willie and Joe, two cynical, shabby 'dog-face' GIs became very popular with the US troops and was even syndicated in the USA. Despite being criticised by General George S. Patton who said that the characters looked like 'goddamn bums' and threatened to imprison him, Mauldin won the Pulitzer Prize for his 1944 cartoon ' "Fresh, spirited American troops, flushed with victory, are bringing in thousands of hungry, ragged, battle-weary prisoners..." (News item)'. The drawing showed a single downcast GI escorting three POWs along a rainswept street. It was the first time the award had been made for work on a military paper and at the time Mauldin (aged twenty-three) was its youngest ever winner. Another famous image has Willie saying 'Just gimme a coupla Aspirin, I already got a Purple Heart' (*Stars and Stripes*, December 1943), which has a personal link to Mauldin who was himself awarded a Purple Heart in the war after being wounded at Cassino. Willie and Joe harked back to the characters created by Bruce BAIRNSFATHER in World War I and further still to a Crimean War cartoon by John LEECH. Willie was the taller of the pair, with a big nose and in his thirties, while Joe was in his twenties. However, their identities became muddled later, as Mauldin himself admitted in *Bill Mauldin's Army: Bill Mauldin's Greatest World War II Cartoons* (1983): 'Joe was a smart-assed Choctaw Indian with a hooked nose and Willie was his red-necked straight man...', but later '...for some reason Joe seemed to become more of a Willie and Willie more of a Joe'. A number of Mauldin's war cartoons and drawings were also reproduced in books including *Sicily Sketch Book* (1943), *Mud, Mules and Mountains* (1944), *Star Spangled Banter* (1944), *This Damn Tree Leaks* (1945), *Up Front* (1945, which is reputed to have earnt Mauldin more than half a million dollars in 1945 alone), and *Willie and Joe: The World War II Years* (2008). Willie and Joe continued into peace time, fea-

turing in two Hollywood films, *Up Front* (1951) and *Back at the Front* (1952), and even made a brief appearance in the Korean War. In 1947 Mauldin left cartooning for other pursuits but in 1958, learning that Daniel FITZPATRICK was about to retire, took over his job on the *St Louis Post-Dispatch* (winning another Pulitzer Prize in 1959). He moved to the *Chicago Sun-Times* in 1962 and retired in 1991. Bill Mauldin died in Newport Beach, California, on 22 January 2003.

MAYER, HENRY (1868-1954)

Henry Mayer was born in Worms am Rhein, Germany, the son of a London merchant. He worked at first as a clerk in London and then, after travelling in Mexico, moved to the USA when he was eighteen. His first drawings appeared in *Life* in the 1890s and he also contributed to *Judge*, *Fliegende Blätter*, *The King*, *Punch*, *Black and White*, *Pick-Me-Up*, *Le Rire*, *Figaro Illustré* and others, especially during the Boer War and World War I. He became editor of *Puck* in 1914 and, having begun drawing and directing animated films for Universal Studios in 1913, continued to do so during the war, notably *Topical War Cartoons* (1914), *Topical War Cartoons No.2* (1914) and *War Cartoons by Hy Mayer* (1914). He died in Grossinger, New York State, on 27 September 1954.

McCUTCHEON, JOHN TINNEY (1870-1949)

John McCutcheon was born on 6 May 1870, near South Raub, Indiana, the son of John Barr McCutcheon. After graduating from Purdue University, Illinois, he began drawing for the *Chicago Record* (1889-1901) and *Chicago Record-Herald* (1901-03). His first political cartoon appeared in 1896 and the following year he left on the first of many trips to war zones as cartoonist and war correspondent, including the Spanish-American War and the Boer War. He also illustrated *The Chicago Record's Stories of Filipino Warfare* (1900). In 1903 he moved to the *Chicago Tribune*, remaining with the paper for forty-three years until he retired in 1946. In World War I he was attached to both the Belgian and German armies, was arrested as a spy and was the first newspaperman to fly over the trenches. He won the Pulitzer Prize in 1932 and his books include *War Cartoons Reproduced from the Chicago Tribune* (1942) and *History of World War II in Cartoons* (1942). He died near Chicago on 10 June 1949.

MÉTIVET, LUCIEN-MARIE-FRANÇOIS 'L.M.' (1863-1932)

Lucien Métivet was born in Paris on 19 January 1863. After studying art at the Académie Julian his first cartoons appeared in *Le Journal Amusant* (1886-1913). He began contributing to *Le Rire* in 1894 and produced cartoons for this magazine (and *Le Rire Rouge*) throughout the Boer War and World War I (including covers) until 1923. In addition he drew for *La Vie Parisienne* (1899-1910), *L'Assiette au Beurre*, *Fantasio* (1906-21), *La Baïonnette* (1915-18), *Excelsior* (1917-21), *Le Journal* and others. He died in Versailles, near Paris, in 1932.

MINHINNICK, SIR GORDON EDWARD GEORGE OBE (1902-92)

Gordon Minhinnick was born on 13 June 1902 in Torpoint, Cornwall, the son of Percy Charles Minhinnick, a naval engineer. He was educated at Kelly College, Tavistock, Devon, intending to enter the navy as a cadet. However, the family moved to Auckland, New Zealand, in 1921 and Minhinnick began work as a sheep farmer. Then, after studying at Auckland University College, he worked as an architectural draughtsman (1923-5) while drawing cartoons in his spare time for the Wellington *Free Lance* (his first cartoon was of the US Fleet's visit to the city in 1924). He later joined the weekly's staff (1925-6) before moving to the *Christchurch Sun* and then the *Auckland Sun* (1927-30, for which he also wrote a regular column). However, he is perhaps best known for his work as political/editorial cartoonist of the *New Zealand Herald* (1930-87). During World War II he created the popular character of 'Old Soldier Sam' for the paper. Some of his pre-war anti-Nazi cartoons appeared in a book, *Minhinnick Cartoons* (1938) and he later published *War Cartoons and 'Old Soldier Sam'* (1941) and *More War Cartoons and 'Old Soldier Sam'* (1945). He received an OBE (1950) and a KBE (1976) and though he retired from the *Herald* in 1976 he continued to draw occasionally for the paper. He died on 19 February 1992.

MINOR, ROBERT (1884-1952)

Robert Minor was born in San Antonio, Texas, on 15 July 1884, the son of a schoolteacher who later became a district judge. He was also a relative of Mildred Washington, aunt of George Washington. He worked

4ᵉ Année. — Nº 146. — 18 Avril 1918. Le numéro. — **30** Centimes Abonnements : France : 15 fr. — Étr. : 22 fr.

(L'EDITION FRANÇAISE ILLUSTREE.) *TOUS LES JEUDIS* ·30, rue de Provence, PARIS, Tél. Bergère 39-61.)

MARIANNE ET GERMANIA

Lucien Métivet, *La Baïonnette*, 18 April 1918

at first as a carpenter and sign painter and then became cartoonist on the *San Antonio Gazette* before moving to the *St Louis Post-Dispatch*. He then studied briefly at the École des Beaux-Arts in Paris (1913) before joining the *New York World* (1913) while also contributing to the anarchist magazine *Mother Earth*. However, he was later sacked from the *New York World* for refusing to draw pro-war cartoons. He then worked for *The Masses* and the *New York Call* and in 1915 became European war correspondent for the Newspaper Enterprise Association. Described by Daniel FITZPATRICK as 'the greatest political cartoonist of all time', one of his best known World War I cartoons was 'Army Medical Examiner: "At last a perfect soldier!" ' (*The Masses*, July 1916) depicting a huge, muscular man with no head. He continued working for *The Masses* until it folded in 1917 after five of its editors were indicted under the Espionage Act. He then contributed to the *Liberator* and the *New Masses*. In 1919 he became one of the founders of the US Communist Party and drew regularly for its newspaper, the *Daily Worker*. He died in Croton-on-Hudson, New York, on 26 November 1952.

MJÖLNIR – see Schweitzer, Hans Herbert

MOLOCH – see Colomb, Alphonse Hector

'MONTY AND JOHNNY' – see Callan, Les

MOON, SIDNEY (fl. 1930s-after 1947)
After studying art by correspondence course, Sid Moon began work on the *Cambridge Daily News*. In 1935 he moved to London to draw for the *Daily Worker* and *Weekly/Sunday Dispatch*. He also contributed to *Inky Way Annual*, *Everybody's* and other publications, signing his work either 'SID MOON' or just 'MOON' with an anthropomorphic crescent moon. Some of his wartime cartoons for the *Weekly Dispatch* were reprinted in a book, *400 Famous Cartoons by Five Famous Cartoonists: Neb, Lee, Moon, Gittins, Illingworth* (1944).

MOOR, D.S. – see Orlov, Dmitry Stakhiyevich

MORELAND, ARTHUR (1867-1951)
Arthur Moreland was born on 12 October 1867 in Higher Ardwick, Manchester, the son of a domestic property speculator. A self-taught artist, he worked at first as an office junior on the *Manchester Evening Mail* and then moved to London aged eighteen to become a 'newspaper inspector' overseeing distribution of the evening *Star* to newsagents. Then, after drawing a caricature of Ernest Parke (editor of both the *Star* and its sister paper the *Morning Leader*), he was transferred to the company's art department. He drew his first cartoon for the *Morning Leader* in April 1896 and remained with the paper for eighteen years, producing cartoons throughout the Boer War and World War I. Though himself a lifelong Conservative, Moreland drew the celebrated 'Chinese Labour Cartoon' (1905) which was credited with leading to the large Liberal majority in the 1906 election after Liberal candidates pasted more than three million posters of the cartoon all over the country. The drawing shows the ghosts of two British soldiers killed in the Boer War standing by an open grave and one of them pointing at imported Chinese labourers being escorted in chains by armed guards from their compounds to the gold and diamond mines of South Africa with the caption: 'Look there, Bill, that's what you and I, and 20,000 others, died for.' The Opposition leader Alfred Lyttelton called it 'an infamous document'. (By 1905 more than 50,000 Chinese labourers were working in the mines in South Africa lending support to Joseph Chamberlain's 1900 claim that 'This is a Miners' War'.) However, he was best known for his creation of the popular 'Humours of History' series of cartoons which first appeared in the *Morning Leader* in 1898 and continued via the *Daily News* through some 160 cartoons, many of them later published in book form and as postcards. These also included many light-hearted interpretations of wartime scenes, such as 'Napoleon's Retreat From Waterloo'. Moreland also contributed to *Punch*, *Strand*, *Passing Show*, and others, a notable example being 'Himmel! The All-Highest Has the Truth Spoken – the Worst Is Behind Us' (*Punch*, 13 November 1918) with German troops running away from Allied tanks. He also illustrated T.J.Macnamara's *The History of the Hun* (1917). Arthur Moreland died in Groombridge, Sussex, in August 1951.

HONEST ABE'S RUDDER

Abe: 'I'm being licked tarnation well! Only 'cos my rudder won't act.'
Matt Morgan, *Fun*, 9 May 1863

MORGAN, MATTHEW SOMERVILLE (1839-90)

Matt Morgan was born in London on 27 April 1839, the son of an actor. In 1859 he covered the Austro-Italian War as a 'special artist' for the *Illustrated London News*. His contributions to *Fun* (1862-7) included a number of anti-Lincoln cartoons on the US Civil War, some of which were reprinted in a book *The American War: Cartoons by M.Morgan* (1874). Amongst these was 'Honest Abe's Rudder' (*Fun*, 9 May 1863), drawn after the Union forces failed to capture Charleston. It depicted Lincoln as a dog running away from the town with the ships *Monitor* and *Ironside* tied to his tail. In 1867 he became part-owner and the main cartoonist on the weekly *Tomahawk* magazine. He emigrated to the USA in 1870 where he was employed on *Frank Leslie's Illustrated Newspaper* in New York as a foil to Thomas NAST on the rival *Harper's Weekly*. He left in 1880 and later became art editor of *Collier's Magazine* (1888-90). Matt Morgan died in New York on 2 June 1890.

MORROW, EDWIN ARTHUR (1877-1952)

Edwin Morrow was born in Belfast, Northern Ireland, on 7 February 1877, one of eight sons of George Morrow, a decorator from Belfast. After studying at Belfast School of Art and the South Kensington Schools his work began to appear in *Punch* (1914-40), *Passing Show*, *Bystander*, *Strand Magazine*, *London Opinion* and elsewhere. He was also a member of the London Sketch Club and the Savage Club. One of his notable World War I cartoons was 'In Egypt – Not Yet! Awful Prospect in Egypt If and When the Germans Come'(*Bystander*, 3 February 1915). It showed a giant head of the Kaiser in place of the Sphinx surrounded by German tourists drinking lager. He died in Clapham, Sussex, on 9 December 1952. His brothers George MORROW (1869-1955), Albert (1863-1927), Norman (1879-1917) and Jack (1872-1926) also drew cartoons, while his brother Harry helped found the Ulster Literary Theatre.

MORROW, GEORGE 'GEO. M.' (1869-1955)

George Morrow was born in Belfast on 5 September 1869, one of eight sons of George Morrow, a painter and decorator. Apprenticed at first to a sign-painter, he later studied at the Belfast School of Art, the South Kensington Schools and in Paris. He began work in 1896 as a book illustrator and the same year also began to contribute to *Pick-Me-Up*, *Idler*, *Tatler*, *Bystander*, *Windsor Magazine* and others. His first drawing for

Munro, *Civil & Military Gazette* (Lahore), 16 August 1939

Punch was published on 19 September 1906. He remained with the magazine for nearly fifty years (contributing more than 2,700 cartoons including twenty-two full-page drawings), until 1954 and succeeded Frank REYNOLDS as art editor. He usually signed his drawings 'Geo. M.'. As well as many cartoons published through both world wars, Morrow published a book of his wartime *Punch Almanack* cartoons, *An Alphabet of the War* (1915) and illustrated E.V.Lucas's Struwwelpeter pastiche *Swollen-Headed William: Painful Stories and Funny Pictures After the German!* (1914) and *In Gentlest Germany* (1915). In addition he drew 'Bravo, Austria!' (*Punch*, 12 July 1933) a parody of F.H.TOWNSEND's famous World War I cartoon but with Hitler waving the big stick. George

Morrow died in Thaxted, Essex, on 18 January 1955. His brothers Albert (1863-1927), Edwin MORROW (1877-1952), Norman (1879-1917) and Jack (1872-1926) also drew cartoons, while his brother Harry helped found the Ulster Literary Theatre.

MUNRO (fl.1930s-40s)

Munro was a political cartoonist based in Lahore, then in India, who drew for the *Civil & Military Gazette*, Lahore. His book, *Cartoons by Munro* (1939), featured a foreword by H.D.Craik, governor of the Punjab, and contained many anti-Nazi cartoons. He continued to draw for the *Civil & Military Gazette* throughout World War II.

MUSGRAVE-WOOD, JOHN BERTRAM 'EMMWOOD' (1915-99)

John Musgrave-Wood was born in Leeds, Yorkshire, on 22 February 1915, the son of Gerald Musgrave-Wood, a printer's designer and landscape painter. After working in his father's studio he attended Leeds College of Art. However, he left after eighteen months to serve as a steward on a cruise liner where he began drawing cartoons to entertain passengers and his shipmates. In 1939 he returned to London and taught for a while but after the death of his father that year moved to Cornwall where his mother had set up an antiques business. In September 1939 he joined the Duke of Cornwall's Light Infantry as a PT instructor. He was later commissioned in the Sherwood Foresters and became a commando. While in India in 1941 he volunteered to join Orde Wingate's Chindits, serving in Burma and China and later attained the rank of major in the Burma Rifles. Demobilised in 1946 he produced a book (with fellow Chindit Major Patrick Boyle, later Earl of Cork and Orrery) about his experiences entitled *Jungle, Jungle, Little Chindit* (1946), signing himself 'Jon' (he later changed his pseudonym to 'Emmwood' to avoid confusion with another 'Jon', W.J.Philpin JONES). After the war he drew illustrations and theatre caricatures for *Tatler & Bystander* (1948-54). He also contributed to *Punch* and the *Sunday Express* (from 1953) and drew political cartoons for the *Evening Standard* (1955-7) and *Daily Mail* (1957-75). He died in Vallabrix, France, on 30 August 1999.

NAM, JACQUES – see Lehmann, Jacques

NAST, THOMAS (1840-1902)

Thomas Nast was born in Landau-in-der-Pfalz, near Heidelberg, Bavaria, on 27 September 1840, the son of a trombone player in a military band in the Royal Bavarian Army. His family moved to the USA in 1846 and settled in New York. Nast studied at the National Academy of Design and in 1856, at the age of fifteen, joined *Frank Leslie's Illustrated Newspaper* drawing illustrations and cartoons. In 1859 he moved to the *New York Illustrated News* which sent him to Europe where he worked as an artist-reporter covering Garibaldi's Italian campaigns and also contributed to the *Illustrated London News*. He returned to the USA in 1861 and in 1862 moved to *Harper's Weekly*. During the American Civil War he was a supporter of the Union and his cartoons and drawings were so effective that, though still aged only twenty-four, Abraham Lincoln called him 'our best recruiting sergeant...his emblematic cartoons have never failed to arouse enthusiasm and patriotism'. One of his cover drawings for *Harper's Weekly* (3 January 1863) showed Santa Claus distributing gifts to Union soldiers on the battlefront, and was the first to portray the Christmas figure as a fat bearded man (here dressed in the Stars and Stripes – Nast's own classic version dressed in red and white appeared later). One of his best known war drawings was 'Compromise with the South' (*Harper's Weekly*, 3 September 1864), featuring a weeping Columbia (modelled by Nast's wife). Published shortly after the Democratic National Convention

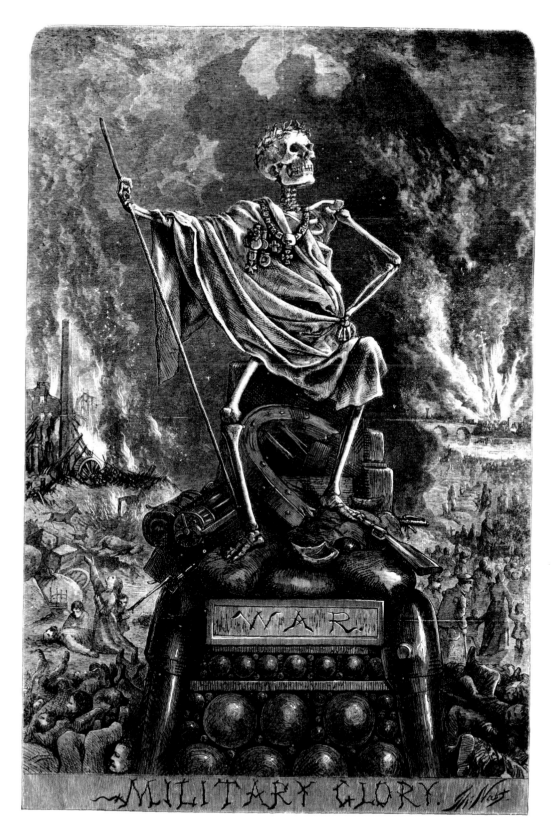

MILITARY GLORY
Thomas Nast, *Harper's Weekly*, 12 November 1870

DEATH
Bernard Naudin, 1905

had accepted a peace platform, it was reproduced in millions as an election poster for the Republican campaign and helped re-elect Lincoln. Later in 1868 when General Ulysses Grant stood for president he said: 'Two things elected me: the sword of Sheridan and the pencil of Thomas Nast.' Nast also drew President Grant for the London *Vanity Fair* (1 June 1872). During the Franco-Prussian War he drew some powerful cartoons and later achieved additional fame for his creation of the Tammany Tiger exposing corrupt politicians at New York's Tammany Hall. Nast left *Harper's* in 1886 to join the *New York Graphic* and he later worked for *Time*, *America*, *Chicago Inter-Ocean* (1892-3), the *New York Gazette* and others and in 1892 he founded his own short-lived paper, *Nast's Weekly*. At the end of his life he was appointed US consul-general to Guayaquil, Ecuador, where he died on 7 November 1902.

NAUDIN, BERNARD (1876-1946)
Bernard Naudin was born in Châteauroux, France, on 11 November 1876, the son of a clockmaker who was also an amateur artist and sculptor. After studying at the École des Beaux-Arts in Paris his first drawings appeared in *Le Cri de Paris* (1903-26). He later contributed to *L'Assiette au Beurre* (1904-9, including whole issues),

Les Temps Nouveaux (1905-14), *Fantasio* (1906-12), *La Grande Guerre* and others, including drawings on the Russo-Japanese War. In World War I he also drew for frontline journals such as *Le Poilu*, *Le Rire aux Eclats* and *L'Horizon*. Some of these drawings were later collected into books: *Dessins pour le Bulletin des Armées de la République* (1916), *Croquis de Campagne* (1915) and *La Guerre, Madame* (1918). In 1917 he and Théophile STEINLEN were appointed official war artists. Naudin died in Noisy-le-Grand, France, on 7 March 1946.

NEB – see Niebour, Ronald

NEUMONT, MAURICE LOUIS HENRI (1868-1930)
Maurice Neumont was born on 22 September 1868 in Paris and studied painting with Jean Léon Gérôme. His first drawings appeared in *La Chronique Parisienne* (1886-7) and *Le Courrier Français* (1889) and he also contributed to *Fin de Siècle* (1897-8), *L'Amour* (1903-04), *Le Sourire*, *Le Rire*, *La Baïonnette* (1915) and *Le Journal* (1915-16) amongst others. He also produced many propaganda posters during World War I, notably 'On Ne Passe Pas! 1914-1918' (1918) warning French civilians not to trust any peace overtures from the Germans

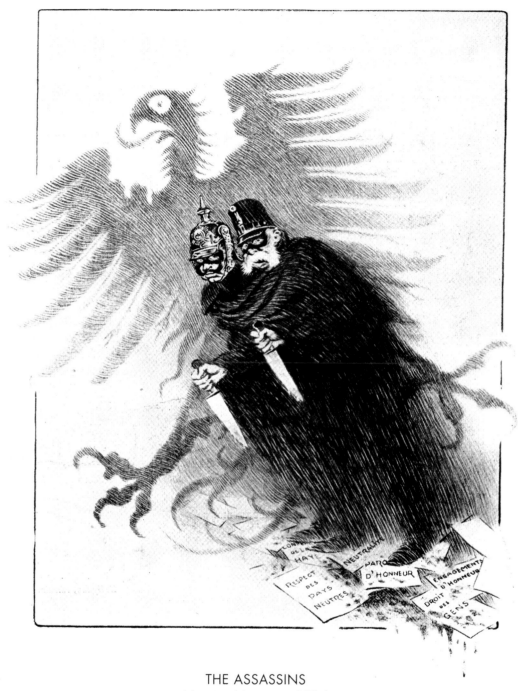

THE ASSASSINS
Maurice Neumont, 1914

after the second French defeat on the Marne in 1918. He was awarded the Légion d'Honneur. Maurice Neumont died in Paris on 10 February 1930.

'NEWCOME, JOHNNY' – see Rowlandson, Thomas

NIEBOUR, RONALD 'NEB' (1903-72)

Ronald Niebour was born in Streatham, London, on 4

April 1903. He was educated at Barry County School, Wales, with Leslie ILLINGWORTH. However, instead of following Illingworth to the local Cardiff Art School he went to sea and spent two years in the Merchant Navy. Encouraged by an uncle who was a superintendent of handicraft teaching he then studied metalwork and woodwork and became a teacher of handicrafts at schools in Birmingham, Weymouth and Kendal for

INSEPARABLE FRIENDS
Bogdan Nowakowski (Bogdan), *Mucha* (Warsaw), 1914

three years. Self-taught as an artist, he returned to Wales and drew football cartoons for the *Barry Dock News* and *Cardiff Evening Express*. He later became sports cartoonist on the *Oxford Mail* and staff artist on the *Birmingham Evening Dispatch & Gazette*. He joined the *Daily Mail* in 1938, working at first as an illustrator but later as a pocket cartoonist. A number of his wartime cartoons were printed in a book, *400 Famous Cartoons by Five Famous Cartoonists: Neb, Lee, Moon, Gittins, Illingworth* (1944). Cartoons by Neb and Illingworth were found in a file in Hitler's chancellery after the war. He

retired on 1 December 1960 and died at his home in Benajaràfe, near Malaga, Spain on 18 July 1972.

NOWAKOWSKI, Bogdan Bartlomiej 'Bogdan' (1887-1945)
A Polish cartoonist, Bogdan worked for *Facet* (including covers) and *Mucha* (Warsaw) in World War I.

NOWODWORSKI, Henryk (1875-1930)
Henryk Nowodworski was a Polish cartoonist who worked for *Sep, Nowy Szczutek* and others. His cover

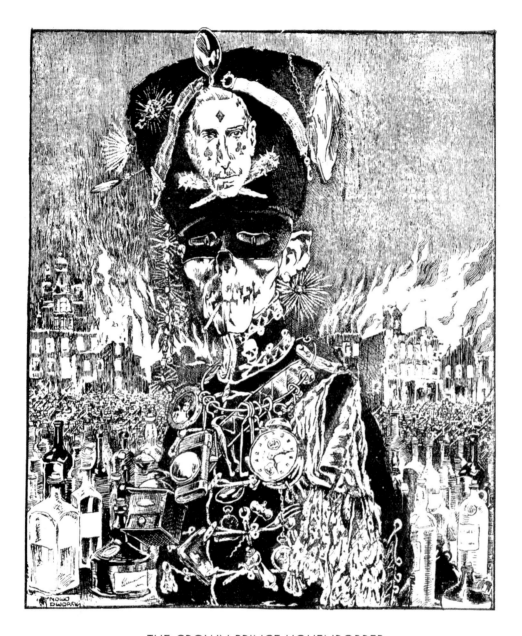

THE CROWN PRINCE HOHENROBBER

The Heir to the German Throne: 'Caesar, Hannibal and Napoleon the heroes of history?
Don't make me laugh! The real hero is I, who in just a few months have succeeded in
burning a hundred works of art and have stolen another hundred.'
Henryk Nowodworski, *Mucha* (Warsaw), February 1915

drawing for the the first issue of *Sep* ('The Germans Have Arrived', 14 September 1906) showed a giant German soldier stepping over a tiny border post and saying: 'Damn! The first step over the border and already we step into filth.' A notable 1910 cartoon from *Nowy Szczutek* is 'Drang Nach Osten' (The Push to the East) which shows the Kaiser driving a chariot pulled by three pigs and followed by a cloud of crows. During World War I he also drew cartoons for *Mucha* and edited *Zolnierz Polski* (Polish Soldier, 1917-18). He often signed his name in capitals in two lines as 'NOWO DWORSKI'. Henryk Nowodworski died in 1930.

'ODDENTIFICATIONS' –
see Wren, Ernest Alfred

OHSER, ERICH 'E.O.PLAUEN' (1903-44)

Erich Ohser was born in Untergettengrün, Germany, on 18 March 1903, the son of Albert Paul Richard Ohser, a customs official. When he was four the family moved to Plauen (from where he later derived his pen name, added to his initials), near Leipzig. Apprenticed as a fitter (1917-20) he then spent five years at the Academy of Graphic Art in Leipzig where he met Erich Kästner (later to write *Emil and the Detectives*, illustrated by Walter TRIER) and illustrated Kästner's first volumes of poetry. He worked at first for *Neue Leipziger Zeitung* and then moved to Berlin where he contributed to *Vorwärts*, *Querschnitt*, *Katakombe*, *Neue Revue* and others. When the Nazis came to power in 1933 he was forbidden to work as a political cartoonist and so drew the 'Vater und Sohn' (Father and Son) wordless strip for the *Berliner Illustrierte Zeitung* (1934-7) using the pseudonym 'e.o.plauen'. It was very successful (even being used in Nazi propaganda campaigns) and three books of the drawings (1935, 1936 and 1938) were published. From 1940 he also drew political war cartoons for *Das Reich*. However, by 1944 he had become increasingly anti-Nazi and was arrested by the Gestapo. He committed suicide (aged forty-one) in Moabit Prison, Berlin, during the night of 5 April 1944, only hours before his trial (which would have sentenced him to death).

O'KEEFE, WILLIAM 'WOK' (fl.1794-1807)

William O'Keefe was an Irish cartoonist who was published by J.Aitken. One of his notable cartoons of the

PREPARED FOR A FRENCH INVASION
William O'Keefe, 1 October 1796

Napoleonic Wars was 'Prepared for a French Invasion' (1 October 1796) in which British Prime Minister William Pitt and George III, accompanied by a gang of old women, are seen preparing to fend off a boatload of French devils, one of whom holds a guillotine.

OLAF G. – see Gulbransson, Olaf

'OLD BILL' – see Bairnsfather, Charles Bruce

'OLD SOLDIER SAM' – see Minhinnick, Sir Gordon Edward George

ONO, SASEO (1905-54)
Saseo Ono was born in Yokohama, Japan, in 1905. After graduating from Ueno Art School in Tokyo he began to contribute to *Tokyo Puck* (including covers) and soon acquired a reputation for drawing glamorous women. In 1941 he joined the Imperial Army and served in Java where he drew many propaganda cartoons both against the Allies and in favour of the Japanese occupation. He also drew for *Manga* (see Hidezo KONDO), a notable cartoon being 'Grieving Statue of Liberty' (*Manga*, January 1942) featuring the top of the head of the Statue of Liberty on which a monster-like President Roosevelt can be seen sitting holding in one hand a banner saying 'Democracy' and in the other a club marked 'Dictatorship'. After the war he returned to Japan and continued to draw cartoons and illustrations. He died in 1954. His son, Professor Kosei Ono, is a distinguished authority on comic art.

ORENS, CHARLES DENIZARD 'DENIZARD' (1879-1965)
Denizard was born in Pontru, France, on 8 May 1879. At the age of twelve he began an apprenticeship with a printer in Amiens, where he learnt lithography and etching, and also took evening classes at a local art school. In 1896 he began his studies at the École des Beaux-Arts in Paris and in 1898 exhibited at the Salon, receiving silver and bronze medals. During the Boer War he produced a number of anti-British postcards and from 1902 contributed to *Le Frou-Frou*, *Le Sourire* and others. He also drew anti-British cartoons on the Fashoda Incident and World War I, during which he served as a *soldat*

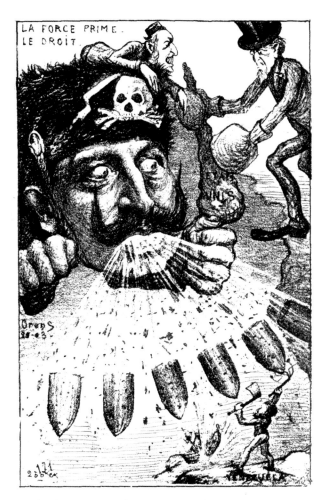

Charles Denizard Orens, French postcard, 1903

aerostier (balloonist) at Verdun. He died in Paris in 1965 and is buried in Père Lachaise cemetery.

ORLOV, DMITRY STAKHIYEVICH 'D.S.MOOR' (1883-1946)
Born in Novocherkassk, Russia, on 3 November 1883, Orlov studied physics, maths and law at the University of Moscow. A self-taught artist, during the 1905 revolution he drew anti-government cartoons for *Budilnik* and others. In World War I he designed many *lubok* (woodblock)-style propaganda prints. After the 1917 revolution he became an important poster artist, notably designing 'Have YOU Joined the Volunteers?' (1919) after Alfred LEETE, which was later reissued in World War II as 'Have YOU Helped the Front?' (1941). He also drew cartoons for *Krasnoarmeyets* and the Orkna Rosta agency under the pseudonym

'D.S.Moor' (earlier pseudonyms were 'Dor' and 'Mor'). He later contributed to *Pravda*, *Izvestia*, *Krokodil*, and *Bezbozhnik u Stanka*. During World War II he also produced a number of powerful anti-Nazi and anti-Italian posters. He died in Moscow on 24 October 1946.

ORR, CAREY CASSIUS (1890-1967)
Carey Orr was born in Ada, Ohio, on 17 January 1890, the son of Cassius Perry Orr, a lumberjack. At the age of thirteen the family moved to Spokane, Washington. He worked at first in a lumber mill and was briefly a professional baseball player before studying at the Chicago Academy of Fine Arts and taking the W.L.Evans Cartoon Correspondence Course. In 1911 he joined the *Chicago Examiner* as a cartoonist, moving to the *Nashville Tennessean* in 1914. In 1917 he transferred to the *Chicago Tribune* and remained there for forty-six years until he retired in 1963 (he won a Pulitzer Prize in 1961). In 1918 he was awarded a gold medal by the US government for his World War I drawings. He later produced a book, *War Cartoons* (1952). He died in Evanston, Illinois, on 16 May 1967.

OWEN, WILLIAM (1869-1957)
Will Owen was born in Malta, the son of Thomas Owen, a British naval officer (later an engineer commander). He returned to England in 1870 and, after studying at the Lambeth School of Art and at Heatherley's, began work at the Post Office Savings Bank's headquarters in London (c.1885-c.1912). Here a fellow clerk was the future novelist W.W.Jacobs. They became lifelong friends and after their first joint efforts in the *Idler*, Owen illustrated (from 1899) many of Jacobs' stories in the *Strand* magazine in a partnership that lasted more than forty years. He moved to France c.1912 but returned to the UK when war broke out. Owen also contributed cartoons and illustrations to *Bystander*, *Graphic*, *Passing Show*, *Humorist*, *London Magazine*, *London Opinion*, *Pick-Me-Up*, *Punch*, *Sketch* and *Tatler*, amongst others. In addition he drew the character 'Ally Sloper' in *Ally Sloper's Half Holiday* for a while after the death of its most famous artist, W.G.Baxter. He also designed posters and postcards (including the 'Nazi Nursery Rhymes' series for Photochrom in World War II) and drew for advertis-

ing, notably creating the Bisto Kids in the gravy advertisement 'Ah, Bisto!' (1919). His books include *Alleged Humour* (1917), a collection of his wartime cartoons for the *Sketch*. In World War II he contributed to *Blighty* from 1939 (including covers featuring 'Ginger Green – A.B.') and others, wrote and illustrated *What's the Dope?* (1944), an encyclopedia of services' abbreviations and illustrated B.S.Jones's *What's the Buzz?* (1943). Will Owen died on 14 April 1957.

PANN, ABEL (1883-1963)
Abel Pann was born Abba Pfeffermann in Kraslava, Latvia, the son of a rabbi. After studying art in Vitebsk he worked as a sign-painter. In 1898 he enrolled at the Academy of Fine Arts in Odessa and in 1903 moved to Paris where he continued his art studies at the Grand Chaumière academy. Here he also began drawing cartoons for *La Vie en Coulotte Rouge* (1902-5), *Mon Dimanche* (1907-13), *Le Rire* (1908-11) and others. In 1913 he was invited to Jerusalem and offered a job as head of the painting department of the Bezalel Academy of Arts and Design but on returning to Paris to settle his affairs was caught up in World War I. He then began a series of wartime paintings and posters and also contributed cartoons to *La Baïonnette* (1915) and others. One of his best known drawings was 'Le Défenseur de Paris' (The Defender of Paris, 1914) showing General Gallieni (military governor of Paris and responsible for its fortifications) as a huge porcupine bristling with bayonets and with cannons for toes during the 1st Battle of the Marne (won by the French) in September 1914. After the war Pann took up a teaching post in

Jerusalem but resigned in 1924 to concentrate on lithography. He died in Jerusalem in 1963.

PARRISH, JOSEPH LEE (1905-89)

Joe Parrish was born in Summertown, Tennessee, the son of a cola dealer. A self-taught artist, he began drawing cartoons for the *Nashville Banner* when he was twenty. After four years he moved to the *Nashville Tennessean* (1929) where he stayed for seven years, moving to the *Chicago Tribune* in 1936 and remaining there as daily editorial cartoonist until he retired in 1970 (though he continued to draw his weekly 'Nature Notes' series until 1982). A notable wartime cartoon was 'Destiny's Child' (*Chicago Tribune*, 2 January 1944) with Churchill, Stalin, Roosevelt and Chiang Kai-Shek looking happily at the 1945 baby while Hitler and Hirohito stand nervously behind them. He died in St Louis on 21 September 1989.

PARTRIDGE, SIR JOHN BERNARD (1861-1945)

Bernard Partridge was born in London on 11 October 1861, the son of Professor Richard Partridge FRS, president of the Royal College of Surgeons and professor of anatomy at the Royal Academy. His uncle was John Partridge, Portrait Painter Extraordinary to Queen Victoria. Educated at Stonyhurst College (with Sir Arthur Conan Doyle), he worked for six months in the offices of the architect H.Hansom (son of the inventor of the Hansom cab) and then spent two years with Lavers, Barraud & Westlake, Ecclesiastical Designers, producing altar-pieces, stained glass, etc. He then studied decorative painting under Philip Westlake (the brother of one of the company's partners), before attending Heatherley's (briefly) and the West London School of Art. He worked at first as a decorator of church interiors and then (as 'Bernard Gould') as a professional actor, appearing in the first production of George Bernard Shaw's *Arms and the Man* amongst others. His first cartoon was published in *Moonshine* and he also contributed cartoons and illustrations to *Judy* (from 1885), *Black & White*, *Illustrated London News*, *Vanity Fair* (caricatures as 'J.B.P.'), *Illustrated Sporting & Dramatic News*, *Pick-Me-Up*, *Sketch* and others. He began

drawing for *Punch* in February 1891, and remained with the magazine for more than fifty years. He became Second Cartoonist in 1899, and succeeded Linley SAMBOURNE as Cartoonist (1910-45). During the Boer War and both world wars he produced many memorable cartoons. These included 'The Triumph of "Kultur"' (*Punch*, 26 August 1914), 'Unconquerable' (21 October 1914, featuring the Kaiser and Albert, King of the Belgians) and 'John Bull's War Aim' (*Punch* 18 October 1939), after Emmanuel Frémiet and featuring a huge Nazi gorilla holding the maiden Freedom (see also Jerry DOYLE). Some of these were reproduced as postcards and posters. He also designed (for the Parliamentary Recruiting Committee) the much-plagiarised poster 'Take up the Sword of Justice' (1915) featuring the figure of Justice with the *Lusitania* sinking in the background. In addition he designed postcards for Blue Cross Quarantine Kennels (for soldiers bringing their pet dogs home) and discharge certificates for soldiers. His better known anti-Nazi and World War II cartoons included 'Bluff and Iron' (1938), 'The Wagnerite' (9 August 1939) and 'The Great Fight of Marathon' (11 February 1942). He was knighted in 1925. His last cartoon for *Punch* was published in July 1945. Bernard Partridge died in Kensington, London, on 9 August 1945.

PAUL, BRUNO (1874-1968)

Bruno Paul was born in Seifhennersdorf in der Lausitz, Silesia, on 19 January 1874, the son of a carpenter. After studying at the Dresden School of Applied Art (1886-94) he moved to Munich where he attended the Munich Academy (1894-1907). He then worked as a book illustrator while also drawing for *Jugend* and *Simplicissimus*. During the Boer War he produced a number of anti-British cartoons for these journals as well as for the German pro-Boer publication *Der Burenkrieg* (1900) for which he also designed the cover. A notable colour cover for *Simplicissimus* was 'English Concentration Camps' (1901) which featured a giant Edward VII and an even taller British soldier stamping on tiny Boer prisoners. He signed his work with a monogram made up of the letter B superimposed on a P. In 1907 he was appointed director of the art school at the Berlin Museum of Applied Art and produced very few cartoons after this

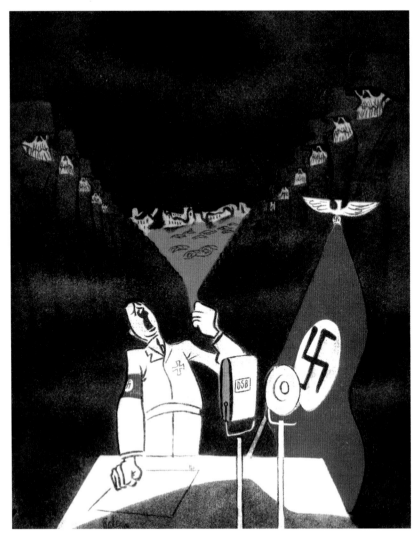

'Wherever a German soldier sets foot, there he will stay.'
Antonin Pelc from *Jesters in Earnest* (1943)

date. He later worked as an architect and was head of the United Government Schools for Fine and Applied Art (1924-32) but resigned in 1933 after the Nazis came to power and retired to Düsseldorf. After the war he moved back to Berlin and died there on 17 August 1968.

PEASE, LUCIUS CURTIS (1869-1963)

Lute Pease was born in Winnemucca, Nevada, on 27 March 1869, the son of Lucius Curtis Pease. Orphaned at the age of five he was brought up by his grandparents in Charlotte, Vermont, and studied at the Franklin Academy in Malone, New York State. He then worked in various jobs, including five years as an Alaskan miner, before becoming a reporter and sketch artist on the *Portland Oregonian* (1902-05), for which he interviewed Mark

Twain. In 1906 he was appointed editor of the *Pacific Monthly* in Portland and then moved to New Jersey in 1912 where he became political cartoonist on the *Newark Evening News* (1914-54). One of his World War I cartoons, 'In for a Pinch' (1918) showed the hand of Marshal Foch pulling the nose of Prince Willy over the River Marne. He remained with the paper through two world wars until he retired in 1954, winning a Pulitzer Prize for his work in 1949. He died on 16 August 1963.

PELC, ANTONIN (1895-1967)

Antonin Pelc was born on 16 January 1895 in Lisany, Czechoslovakia. He studied painting and drawing at the Prague Academy. He later moved to London where he drew cartoons about the Spanish Civil War (e.g. 'Senorita Franco', 1936) and the rise of the Nazis. Here he also contributed to *Cechoslovak*, the *Central European Observer* and others. A number of his wartime cartoons were also reproduced in *Jesters in Earnest* (1944) along with drawings by his fellow Czechs Walter TRIER, Stephen ROTH, Z.K. and Adolf HOFFMEISTER. One of these was 'Victory Club' showing Stalin smoking a Hitler pipe, Churchill using a Mussolini ashtray for his cigars and Roosevelt resting his feet on a Tojo-skin rug. He later emigrated to the USA with Adolf Hoffmeister and contributed to the *New York Times* and others. After the war he returned to Czechoslovakia, drawing for *Lidove Noviny*, *Sibenicky* and other journals, and became a professor at the College of Applied Arts in Prague in 1946. He died in Prague on 24 March 1967.

PELLEGRINI, CARLO 'APE' (1836-89)

Carlo Pellegrini was born in Capua, Italy, on 25 March 1839, the son of a nobleman (his mother was one of the Medici family). He later moved to Naples and fought with Garibaldi during the final months of the Italian War of Independence (autumn 1860). In 1864 he left

OUR WAR CORRESPONDENT
Carlo Pellegrini (Ape), *Vanity Fair*, 16 January 1875

PENNES, JEAN-JACQUES CHARLES 'SENNEP' (1894-1982)

Jean Pennes was born in Paris on 3 June 1894. A self-taught artist, his first drawing appeared in *Le Sourire* when he was sixteen (1909-13) using the pseudonym 'J.Sennep' (his surname backwards). In World War I he served in the French Cavalry and afterwards worked as a clerk in the Compagnie de Gaz in Paris. He also contributed to *Le Rire* (1910-39), *La Victoire* (1916-25), *L'Action Française* (1920-26), *Le Charivari* (including covers), *L'Echo de Paris* (1924-38), *Candide* (1925-44, including covers), *Paris-Soir* (1936-40), *Le Canard Enchaîné* (1944-5) and others and was appointed director of *Le Charivari* in 1926. Two Nazi collaborator characters who appeared in his cartoons were Count Adhemar and his wife Countess Hermengarde. Some of his wartime cartoons were reproduced in a book, *Dans L'Honneur et la Dignité: Souvenirs de Vichy* (In Honour and Dignity: Memoirs of Vichy, 1944). After World War II he worked for *Le Figaro* (1945-67) and *Point de Vue – Images du Monde* (1950-81). He was awarded the Légion d'Honneur. Pennes died in Saint-Germain-en-Laye, France, on 9 July 1982.

PETERSON, ARCHIBALD STUART (1900-76)

Stuart Peterson was born in Adelaide, Australia. After studying art at the National Gallery Schools in Melbourne he became editorial cartoonist on the *New Zealand Free Lance* (1927-34). In 1934 he moved to Sydney and worked freelance until he joined the *Sydney Sun* and *Sunday Sun* as editorial cartoonist after the death of Tom Glover in 1938. During the 1920s and 30s he also contributed to the *Sydney Bulletin*. Some of his war cartoons were included in the 1941 exhibition 'War Cartoons and Caricatures of the British Commonwealth' (National Gallery of Canada, Ottawa). He died in 1976.

PETT, WILLIAM NORMAN (1891-1960)

Norman Pett was born in Birmingham on 12 April 1891, the son of John Ernest Pett, a jeweller. Self-taught apart from a correspondence course at Percy Bradshaw's Press Art School, he contributed cartoons to *Punch*, *Passing Show* and others and drew strips for children's comics. However, he is best known as the creator of 'Jane' for the *Daily Mirror*. At first a single-panel weekly series, 'Jane's Journal' began on 5 December 1932 and featured

Naples for Rome and then travelled to Switzerland and France before arriving in London in November. A self-taught artist, he became the first and leading caricaturist on the newly launched *Vanity Fair* magazine. His first colour drawing, signed 'Singe' (French for 'Ape'), appeared on 30 January 1869 and was of Benjamin Disraeli. Among the 333 caricature portraits Pellegrini drew for *Vanity Fair* from 1869 to 1889 were a number of major figures from the wars of that period. These included the war correspondent W.H.Russell, General Sir Garnet Wolseley, General Valentine Baker (Baker Pasha) and others. He died in London on 22 January 1889 at the age of forty-nine.

PEM – see Matyunin, Pavel

EINZELPREIS **30** PF.

Schweiz 50 Rappen, Italien Lire 1,25
Ausland mit ermäßigtem Porto 27 Pfg.
übriges Ausland 32 Pfg.
Danzig 40 Guldenpfennig

8. JAHRGANG / FOLGE 18 / 3. MAI 1938

DIE BRENNESSEL

VERLAG FRANZ EHER NACHF. GMBH. BERLIN SW 68

„Väterchen" in seinem Jagdzimmer

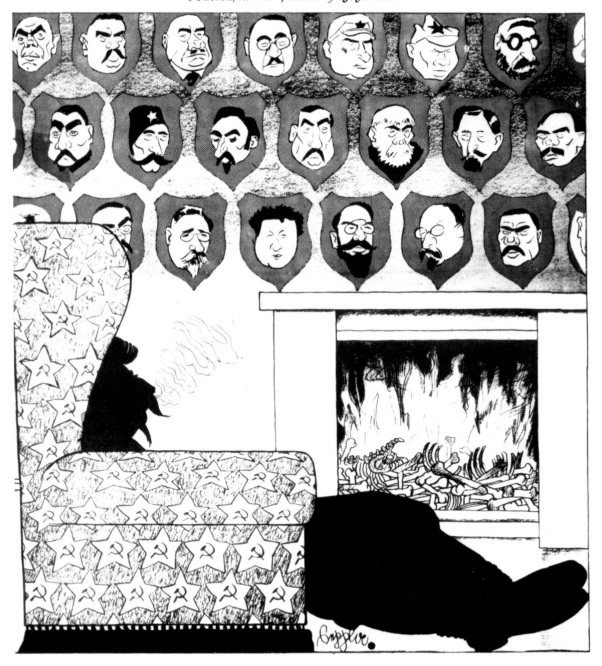

'LITTLE FATHER' IN HIS DEN – DREAM IN A MOSCOW HUNTING LODGE

Josef Plank (Seppla), *Die Brennessel*, 3 May 1938

a 'Bright Young Thing' and her dog. Originally based on Pett's wife Mary, it later became a daily multi-panel strip. When writer Don Freeman was engaged in December 1938 – introducing the idea of the character playfully shedding clothing during her adventures – and professional model Christabel Drewry (whom Pett met at the Birmingham Central School of Art) took over as Jane (1940), the feature became immensely popular. During World War II Jane's appeal was such that in 1943 the journalist Hannen Swaffer commented: 'The morale of the RAF depended on how much clothing she had left on in the *Daily Mirror* that morning. A legend grew up that Jane always stripped for victory. She was the anti-Gremlin.' She was also published in *Union Jack*, the US forces daily *Stars and Stripes*, the combined operations magazine *Bulldozer* and (from January 1944) *SEAC*, the daily newspaper of South-East Asia Command. In addition she was emblazoned on aircraft, tanks and submarines and appeared in Pett's own wartime magazine *Pett's Annual* (1944). When Pett retired in 1948, his assistant Mike Hubbard took over the drawing until the strip's final episode on 10 October 1959. 'Jane' calendars were also produced (1947-9) as well as merchandise such as belts and ties, and many books including *Jane's Summer Idle* (1946), *Jane's Journal* (1946), *Jane on the Sawdust Trail* (1947), *Farewell to Jane* (1960) and *Jane at War* (1976). In addition she appeared on stage and in two films, *The Adventures of Jane* (1949, starring Christabel Drewry) and *Jane and the Lost City* (1988). Pett created a similar striptease character, 'Susie', for the *Sunday Dispatch* in 1948 and continued to draw for children's comics until his death. Norman Pett died in Keymer, near Brighton, on 16 February 1960.

PICAROL – see Ferrer, Josep Costa

PILOTELL – see Labadie, Georges Raoul Eugene

PLANK, JOSEF 'SEPPLA' (fl.1930s-40s)
Josef Plank was a pro-Nazi German cartoonist who contributed cartoons (including covers) to the Berlin journal *Die Brennessel* from at least 1931 onwards. One of these, the cover from 23 August 1933, has a German

THE BRITISH ON SPIONKOP
Emmanuel Poiré (Caran D'Ache), 1900

family watching as a large fleet of enemy aircraft, formed into the shape of a huge skull and crossbones, appears in the sky above their burning town. Another cover, ' "Little Father" in His Den, Dream in a Moscow Hunting Lodge' (3 May 1938) has Stalin dozing beside a blazing hearth filled with the bones of his recently purged enemies in the Red Army, their heads mounted above the mantelpiece. He also drew for the *Illustrierte Beobachter* (including covers).

PLAUEN, E.O. – see Ohser, Erich

POIRÉ, EMMANUEL 'CARAN D'ACHE'
(1858-1909)
Born on 6 November 1858 in Moscow of French parents, Poiré's paternal grandfather was an army officer who had fought with Napoleon in his Russian campaign. After attending school in Moscow he went to Paris in 1875 to study under the military painter Edouard Detaille. He then enlisted in the French Army for five years with the

intention of becoming a military painter and began to draw sketches of army life under the pseudonym 'Caran d'Ache' (*karandash* is 'pencil' in Russian). His first drawings were published in *La Vie Moderne* in 1880 and *L'Illustration* (1880-1900). He also contributed to *La Chronique Parisienne* (1886-92), *Le Rire* (1894-1903), *La Caricature* (1882-1900), *Le Chat Noir* (1883-8), *L'Assiette au Beurre* (including the entire issue for 4 January 1902), *Le Journal Amusant* (1888-96), *Le Soleil du Dimanche* (1890-1902) and others. He also published a book, *Nos Soldats du Siècle* (We Soldiers, 1889). Best known for his '*histoires sans paroles*' wordless cartoon sequences, he greatly influenced the work of H.M.BATEMAN (and others) who described him as 'the greatest master of the art of telling a story in pictures, without words'. He also drew a weekly cartoon for *Le Figaro* (1886-1908) and in February 1898 set up (with J-L FORAIN) the short-lived anti-Dreyfus weekly journal *Psst...!* During the Boer War a special edition of *Le Rire* (17 November 1900) entitled 'Kruger le Grand et John Bull le Petit' was almost entirely filled with his anti-British cartoons. At the Chat Noir nightclub in Montmartre in the 1880s he also created shadow plays of the Napoleonic Wars using silhouette cut-outs from sheets of zinc. These were very popular and were seen by the Tsar of Russia himself. Poiré died in Paris on 26 February 1909.

PONT – see Laidler, Gavin Graham

POSADA, JOSÉ GUADALUPE (1852-1913)
Part Aztec Indian, Posada was born on 2 February 1852 in Aguascalientis, Mexico. A self-taught artist, he produced some 15,000 prints in his lifetime. His first job was as a political cartoonist on the short-lived journal *El Jicote* in 1871. He then moved to Leon and set up shop as a printer and commercial illustrator. In 1888, when the shop was flooded, he moved to Mexico City and worked for *La Patria Illustrada*, edited by Ireneo Paz (grandfather of the writer Octavio Paz) and others. He was later employed as a staff illustrator for a book publishing company. Posada was best known for his *calaveras* (skeleton drawings), especially during the Mexican Revolution of

CALAVERA HUERTISTA
José Guadalupe Posada, 1913

1910 in which President Porfirio Diaz was deposed by guerrilla bands led by Emiliano Zapata and Pancho Villa. He also drew satirical portraits of individuals, one of his last being 'Calavera Huertista' (1913) featuring President Huerta as a six-legged monster with a human skull. He died in Mexico City on 20 January 1913.

POULBOT, FRANCISQUE (1879-1946)
Francisque Poulbot was born on 6 February 1879 in Saint-Denis, Paris, the son of a school headmaster. His first cartoons were published in *Le Pêle-Mêle* (1895-1913). Perhaps best known (like the German Heinrich ZILLE) for his images of poor working people and street urchins (*gosses*), Poulbot also drew some powerful wartime cartoons. He contributed to numerous publications including *Le Rire* (1897-1926), *Chronique Amusante* (1898-1912), *Le Journal Pour Tous* (1899-1906), *Le Sourire* (1900-14), *La Baïonnette* (1915-19), *L'Assiette au Beurre* (1903-10), *L'Illustré National* (including covers), *Le Journal* (1903-39), *L'Anti-Boche* and *Le Parisien Libéré* (1944-5) and others. Among his Boer War drawings were a colour cover for *La Caricature* ('L'Angleterre Semeuse de Discorde',

24 November 1900), and a cover cartoon ('Traite de Paix' with Kruger as Jesus Christ being crucified by John Bull) for the special peace issue of *La Gavroche* (16 June 1902) entitled 'La Paix à la Mode John Bull'. Some of his World War I cartoons were reprinted in his books *Des Gosses et des Bonhommes* (1917), *Le Massacre des Innocents* (1918) and *Les Gosses dans les Ruines* (1919). He also designed wartime posters and postcards. Such was his fame that C.B.Cochrane even introduced a Poulbot sketch into his production of the West End play 'The Better 'Ole' based on the drawings of Bruce BAIRNSFATHER. He was awarded the Légion d'Honneur in 1928. Poulbot died in Paris on 16 September 1946.

POY – see Fearon, Percy Hutton

PROCTOR, JOHN 'P.O.P.' (1836-1914)

John Proctor was born in Edinburgh, Scotland, on 26 May 1836, the son of Adam Proctor, a plumber. He studied engraving with William Banks in Edinburgh for six years and then freelanced for various book publishers, notably Nelson & Sons. In 1861, the year of his marriage, he moved to London where he became staff artist for Cassell's publishers and helped set up *The Empire* weekly. He also began contributing to the *Illustrated London News*, *London Journal*, *Fun* (including whole-page political cartoons), *Illustrated Bit*, *Sketch* and others. In addition he drew the main two-page political cartoon for *Judy* (1867-8), succeeding Matt Stretch, and contributed (as 'P.O.P.') to *Sons of Britannia*, including the cover of its very first issue in 1870. He later drew for *Will o' the Wisp* and then became the main cartoonist on *Moonshine* (succeeding Alfred Bryan) where he remained for nine years throughout the Boer War. During the conflict he also drew for the *Penny Illustrated Paper*. He then joined *Funny Folks* (he even named one of his sons William Sawyer Proctor after the editor of the magazine). He died in Albury, Surrey, on 10 August 1914. His son John James Proctor also drew cartoons during the Boer War.

'PRUNE, PILOT OFFICER PERCY' –
see Hooper, William John

PRY, PAUL – see Heath, William

RADIGUET, MAURICE (1866-1941)

Maurice Radiguet was born in Paris on 12 July 1866. His first cartoons appeared in *La Journée* (1885-6) and *L'Eclipse* (1886-8) and he also contributed to *La Caricature* (1887-91), *Le Rire* (1895-1924), *Le Pêle-Mêle* (1897-1920), *Le Journal Pour Tous* (1899-1906), *Le Bon Vivant* (1899-1909), *Le Sourire* (1899-1910), *L'Illustré National* (1899-1923), *L'Indiscret* (1902-5), *L'Assiette au Beurre* (1904-12), *Fantasio* (1906-15), *La Baïonnette* (1915-17), *Le Journal Amusant* (1919-30), *Le Petit Journal Illustré* (1920-33) and others. During the Boer War an entire

Wilhelm: 'And me too, I've got allies!'
Maurice Radiguet, *Le Rire* (Paris), 5 December 1914

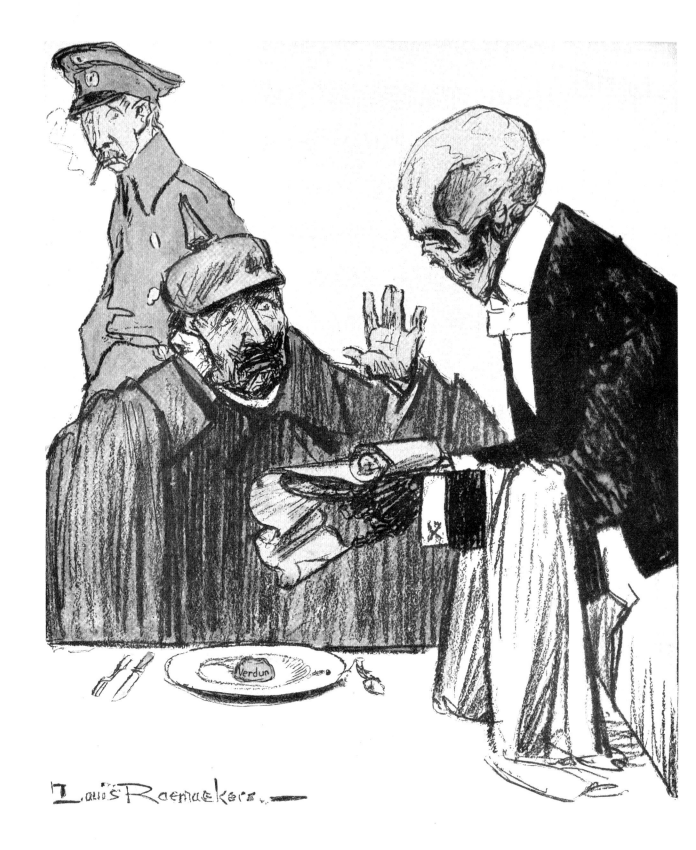

THE BILL
Louis Raemaekers, 1918

issue of *La Vie Pour Rire* (22 March 1902), entitled 'La Fin de Guerre' was devoted to his cartoons. The back cover of this ('La Fin') showed Edward VII hanging from a gallows pole. In World War I he created a series *Les Sauvages* (later a book) and also designed postcards. He died on 24 February 1941. His son was the writer Raymond Radiguet.

RAEMAEKERS, LOUIS (1869-1956)

Louis Raemaekers was born in Roermond, Holland, on 6 April 1869, the son of Joseph Raemaekers, a Dutch printer/publisher, and his German wife. After studying fine art in Amsterdam, Brussels and Paris he began work as an art teacher and painter. He first began contributing drawings to *Algemeen Handelsblad* (1906-9) before moving to *De Telegraaf*. He concentrated on political cartoons from 1912 and became famous for his work for the paper during World War I. His vicious, often bloodthirsty, anti-German cartoons led to his prosecution by the Dutch authorities for endangering their neutrality in the conflict (he was tried and acquitted). His drawings were none the less widely exhibited and published in magazines and newspapers in France and the UK such as *Land and Water*, *Daily Mail*, *Bystander*, *L'Illustration*, *La Grande Guerre*, *Le Matin*, *Le Journal*, *L'Humanité*, *La Baïonnette* and others. Some were also produced as postcards by George Pulman & Sons and (in French and English) by Imprimerie Elsevier (Amsterdam). To escape possible assassins after the German government offered a reward for his capture, dead or alive, he came to London in December 1915. An exhibition of more than 500 of his drawings at the Fine Art Society in London caused a sensation. Prime Minister Lloyd George was so impressed by his work that he persuaded him to go to the USA in 1917 in an effort to enlist American help in the war. In New York his drawings were syndicated by Hearst Publications to various journals and he was the main artist on *Puck* from 1917 until it closed in 1918. *The Times*' celebrated war correspondent, Sir Percy Robinson, held that Raemaekers was one of the six great men – including statesmen and military commanders – whose effort and influence were most decisive during World War I, and former US president Theodore Roosevelt said: 'His pictures should be studied everywhere.' A number of his drawings were also republished in book form including *The Great War: A Neutral's Indictment* (1916), *Raemaekers' Cartoons* (1916), *America in the War* (1918), *Raemaekers' Cartoon History of the War* (1919) and *The Caxton Edition of Raemaekers' Cartoons* (1923). In addition he illustrated a number of war books such as Emile Cammaerts's poetry collections *The Adoration of the Soldiers* (1916) and *Through the Iron Bars* (1917), Jo van Ammers Kueller's *A Young Lion of Flanders* (1916) and J.W.Robertson Scott's *The Ignoble Warrior* (1916). William Dowsing even wrote poems about his work: *War Cartoon Sonnets, Being Sonnets Based Upon Louis Raemaekers' War Cartoons* (1917). After the war he lived in Brussels before returning to Holland to concentrate on illustration work, but drew anti-Nazi cartoons in *De Telegraaf* in the 1930s. In June 1940 he moved to the USA and drew for *PM*, *New York Herald*, *Tribune* and others. Later director of a drawing school in Holland, he also painted portraits. Awarded the Légion d'Honneur (1916), he was made an honorary member of the Royal Society of Miniature Painters (1916). Louis Raemaekers died in Scheveningen, Holland, on 26 July 1956.

RAFF – see Hooper, William John

RAMIZ – see Gökçe, Ramiz

'RANKS AND REGIMENTS' – see Fenwick, Ian

RATA-LANGA – see Galantara, Gabriele

REED, EDWARD TENNYSON (1860-1933)

E.T.Reed was born on 27 March 1860 in Greenwich, London. He was the only son of Sir Edward James Reed KCB FRS, chief constructor of the Royal Navy (who also designed Japan's first battleship, the *Foo Soo*), and Lord of the Treasury in Gladstone's 1886 administration. He began to read for the Bar, but ill-health cut short his studies and instead he accompanied his father to Egypt and the Far East (1879-80). On his return he studied at Calderon's Art School and under Burne-Jones but, failing to get into the RA Schools, began work as a portrait painter. When this also failed he turned to il-

THE HEAD OF THE GERMAN VAM-PIRE
E.T.Reed, *Bystander*, 30 September 1914

lustration and cartoons. His first published works were drawings for his father's book *Japan: Its History, Religion and Traditions* (1880) followed by a sketch in the weekly *Society* (1888). Then, with the help of Linley SAM-BOURNE, he began to contribute to *Punch* (June 1889) and joined the staff the following year. He is perhaps best known for his popular anachronistic 'Prehistoric Peeps' series which first appeared in the *Punch Almanack* for 1893 and included a number on a Boer War theme. He later succeeded Harry FURNISS as the magazine's parliamentary caricaturist, illustrating the 'Essence of Parliament' feature (1894-1912) before moving to the

Bystander in 1912. He also drew political and legal cartoons for the *Sketch* (from 1893) and contributed to *Idler*, *English Illustrated Magazine*, *Passing Show* and others. E.T. Reed died in London on 12 July 1933.

RÉGAMEY, Félix Elie
(1844-1907)

Félix Régamey was born in Paris on 7 August 1844, the son of the painter Louis-Pierre Guillaume Régamey (1814-78). After studying with his father and with the painter Boisbaudran he first began to draw caricatures for *Le Journal Amusant* (1861-96) and *Le Boulevard* (1861-2). He later contributed to *La Vie Parisienne* (1864-90), *Le Petit Journal Pour Rire* (1868-75), *L'Eclipse* (1868-77) and others. He was particularly active in the period around the Franco-Prussian War when he also founded (during the Commune) *Le Salut Public* and *La République à Outrance*. One of his notable contributions to the latter was 'The Solemn Entry of the Emperor of Germany Into Paris', depicting Wilhelm I and Bismarck, accompanied by a cloud of crows, entering the city. It was published on 18 February 1871, less than two weeks before the Prussians entered Paris. Exiled in Britain after the Commune he later visited the USA. On his return to France in 1876 he became a teacher at the École des Arts Décoratifs and at the École d'Architecture in Paris and was appointed an inspector of drawing in schools in Paris in 1881. He died in Juan les Pins, France, on 6 May 1907.

RENARD, Jules Jean Georges 'Draner'
(1833-1926)

Draner was born on 11 November 1833 in Liège, Belgium, the son of a printer/publisher. First published in *Uylenspiegel*, he moved to Paris in 1861 (aged twenty-

PRUSSIAN INFANTRYMAN
Jules Renard (Draner), 1862

A TEMPORARY MEASURE TO STOP A HUNGRY ALLIGATOR'S MOUTH CLOSING
Albert René, c.1899

eight) and began to contribute drawings to *L'Illustration* (1862-90) under his own name. However, he soon adopted the pseudonym 'Draner' (Renard backwards) and later contributed to *Le Charivari* (1866-1904), *Le Journal Amusant* (1866-1912), *L'Eclipse* (1870-83), *Petit Journal Pour Rire* (1870-95), *La Caricature* (1880-91), *Le Petit Journal* (1908-12) and others. Amongst his Franco-Prussian War cartoons was the optimistic cover of *Paris-Comique* ('The Prussian Eagle', 27 August 1870) showing a French soldier shooting a Prussian eagle, which was published only a few days before the French were beaten at Sedan. He also produced the print 'L'Homme à La Boule' (1871), in which Bismarck is shown balancing on the globe with one foot in Prussia and the other in France. A specialist in military caricature, he illustrated many books and produced a series of 136 coloured lithographs of military types (1862-71). He also drew for *Ruy Blas* in World War I (notably a cover for the issue of 4 October 1914). Jules Renard died in Paris in 1926.

RENÉ, ALBERT (fl.1864-1915)
Albert René was a French cartoonist whose first cartoons appeared in *Le Journal Amusant* (1864-5). He also contributed to *Petit Journal Pour Rire* (1868-74), *Le Rire*

(1898-1915), *Le Petit Panache* (1905-10) and *La Baïonnette* (1915, including covers) amongst others. During the Boer War he produced a number of cover drawings for *La République Illustré* and *Le Charivari* (1898-1904). He also drew 'Un Boer de France', featuring the French hero of the Franco-Prussian War who fought and died for the Boers, Colonel J. De Villebois-Mareuil (1847-1900), which was used as the cover illustration for the special *Le Charivari* album *Boers et Anglais* (c.1900).

RETEMEYER, ERNST (fl.1890s-1910s)
Ernst Retemeyer was a German cartoonist who contributed to *Kladderadatsch* during the Boer War. Notable drawings include 'The People Eater' (1901), featuring Boer families fleeing from a huge lizard with the face of John Bull, and 'John Bull Rewards Tommy Atkins' (1902) which has John Bull paying his wounded soldiers in crutches instead of money.

RETROSI, VIRGILIO (1892-1975)
Virgilio Retrosi was born in Rome. After studying with Duilio Cambellotti he began to contribute to the Rome journals *La Casa* and *Noe e il Mondo*. During World War I he also designed a number of caricature postcards in colour including 'Armed Neutrality' (c.1915), featur-

THE PEOPLE EATER
Ernst Retemeyer, *Kladderadatsch* (Berlin), 1901

ing a giant spiked suit of armour held by chains, and 'Sunrise' (n.d.) in which a German helmet accompanied by hats representing the other Central Powers appears at dawn over the outline of Italy. He signed his work either 'Retrosi' or 'R' with a trefoil logo.

REVERE, PAUL (1735-1818)

Paul Revere was born in Boston, Massachusetts, on 1 January 1735. He worked primarily as a silversmith but also produced engravings. One of the members of the so-called Boston Tea Party (1773) he was later a lieutenant-colonel of artillery defending Boston harbour. His famous 'midnight ride' of 18 April 1775, warning of the approach of the British, was later immortalised by Longfellow in his poem 'Paul Revere's Ride' (*Atlantic Monthly*, January 1861) which was used to promote the Union cause in the Civil War. One of Revere's most successful early cartoons was the anti-British print 'The Bloody Massacre' (1770), based on a sketch

of the Boston massacre during the American War of Independence by Henry Pelham (John Singleton Copley's stepbrother). He died in Boston on 10 May 1818.

REYNOLDS, FRANK (1876-1953)

Frank Reynolds was born in London on 13 February 1876, the son of the artist William George Reynolds. He studied at Heatherley's and contributed to *Judy*, *Pick-Me-Up*, *Cassell's* and *Sketchy Bits* (including covers) amongst others. He was a staff artist on the *Illustrated London News* and *Sketch* in the early years of the century and in 1906 began contributing to *Punch*. In 1920 he succeeded his brother-in-law F.H.TOWNSEND as its art editor (1920-30). During the Boer War he contributed anti-Boer drawings to *Shurey's Illustrated* and others but he is particularly remembered for his anti-Kaiser pictures in *Punch* during World War I, notably 'Study of a Prussian Household Having its Morning Hate' (24 February 1915). His powerful drawing 'The Triumph of

Science and Civilisation' (*Sketch*, 2 September 1914), depicting a giant German soldier holding a flaming torch and walking over dead civilians as their village burns, was reproduced as the cover of the first ever issue of *L'Europe Anti-Prussienne* (15 October 1914). In World War II one of his most notable colour *Punch* cartoons was 'One Hundred Per Cent' (19 October 1942) showing a 'typical' German family with their entire household infused with Nazi and military symbolism. Frank Reynolds died on 18 April 1953. His son John Patrick Reynolds (1909-35), was also a cartoonist and comic illustrator (notably of W.C.Sellar and R.J.Yeatman's books *1066 and All That* and *And Now all This*) and created the famous twin-headed figures for Shell advertisements.

RIP – see Hill, Roland Pretty

ROBB, BRIAN (1913-79)

Brian Robb was born on 7 May 1913 in Scarborough, Yorkshire, and studied in London at Chelsea School of Art (1930-34) and the Slade (1935-6). While working as a commercial artist and illustrator, he began contributing cartoons to *Night & Day* (1937), *Strand* and *Punch* (1936-9). During World War II he served in the British Army in the Middle East and the cartoons he drew for *Crusader* and *Parade* were collected into a book, *My Middle East Campaigns* (1944). Amongst these was the series 'Little Known Units of the Western Front'. From 1945 he concentrated on book illustration and, after lecturing at Chelsea School of Art, he became head of the illustration department at the Royal College of Art (1963-78). Brian Robb died in August 1979.

ROBIDA, ALBERT 'ROBY' (1848-1926)

Albert Robida was born in Compiègne, near Paris, on 14 March 1848, the son of a carpenter. While studying to become a notary his first drawings appeared in *Le*

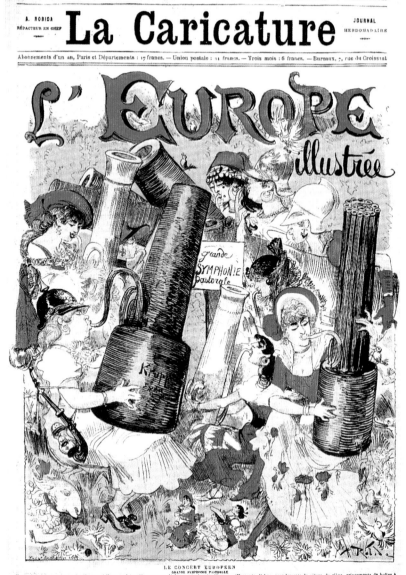

THE CONCERT OF EUROPE
Albert Robida, *La Caricature* (Paris), 1 July 1882

Journal Amusant (1866-71) and *Le Petit Journal Pour Rire* (1867-82). He later contributed to *Paris-Comique*, *La Vie Parisienne* (1871-91), *Le Petit Français Illustré* (1889-1905), *Les Annales* (1889-1920), *Le Rire* (1896-1916), *L'Europe Anti-Prussienne*, *La Baïonnette* (1915), *Fantasio*, *L'Assiette au Beurre* (including the entire issue for 30 August 1902) and others. In 1873 he moved briefly to Vienna, where he worked for *Der Floh*, and on his return to Paris he founded a new version of *La Caricature* (1880). In addition he produced a science-fiction war book, *La Guerre au Vingtième Siècle* (War in the Twenti-

eth Century, 1887) and at the end of World War I published a collection of his drawings of cities destroyed by the conflict (*Les Villes Martyres*). He died in Neuilly-sur-Seine, France, on 11 October 1926.

ROBINSON, BOARDMAN (1876-1952)

Boardman Robinson was born in Somerset, Nova Scotia, Canada, on 6 September 1876, the son of a sea-captain. He came to the USA in 1894 to study at the Boston Normal Art School. After studying art in Paris at the Académie Julian (1898-1900), the Académie Colarossi and the École des Beaux-Arts he worked as a painter in Paris and San Francisco. He became a staff artist and cartoonist on the *New York Morning Telegraph* in 1907 and moved to the *New York Tribune* in 1910. In 1914 he left the paper to visit Europe with the celebrated war correspondent John Reed (who in 1919 wrote *Ten Days That Shook the World*). He joined the staff of *Puck* magazine in 1915 and also contributed to *The Masses, The Liberator, Harper's Weekly* and *London Outlook* (1922-3). Some of his World War I cartoons were published in book form as *Cartoons on the War* (1915) and he also illustrated John Reed's *The War in Eastern Europe* (1916). Two of his best known World War I drawings were 'Belgium – The Return of the Goth' (*New York Herald-Tribune*, 1914), showing a huge knife-wielding ogre destroying a city, and 'Europe, 1916' (*The Masses*, October 1916) with Death riding a donkey towards a cliff-edge while holding a 'Victory' carrot on a stick in front of its head. He also drew a prophetic 1919 cartoon of the Versailles treaty signed by a dead hand and nibbled by a mouse. After the war he taught art at the Art Students' League in New York (1918-29), pupils including Edmund DUFFY and Jacob BURCK. He moved to Colorado Springs in 1930 and became director of the Colorado Springs Fine Art Center (1930-47). He died in Stanford, Connecticut, on 5 September 1952.

ROBINSON, WILLIAM HEATH (1872-1944)

Heath Robinson was born on 31 May 1872 in Islington, London, the third son of Thomas Robinson, a wood-engraver and principal illustrator for the *Penny Illustrated Paper*. His uncle Charles was an engraver and artist for *Illustrated London News*, and his older brothers were the illustrators Thomas Heath Robinson and Charles

Robinson. He studied at Islington School of Art (aged fifteen) and the RA Schools (1892-5), selling a drawing to *Sunday* magazine while still a student (1896). His first book illustrations were published in 1897 and he wrote and illustrated his first book, *The Adventures of Uncle Lubin*, in 1902. His first cartoons were published in the *Tatler* and *Bystander* in 1905 and he began producing whole-page comic features for the *Sketch* from 1906. He also contributed to *Strand, Humorist, London Magazine, Radio Times, London Opinion, Graphic* and others. During World War I he became an international figure – his drawings were even published in the French journals *Fantasio* (1915-16) and *Le Pays de France* (1916) – and the phrase 'Heath Robinson contraption' entered the *Oxford English Dictionary* in 1917. In 1918 he was invited to make drawings of the American Expeditionary Forces in France, some of which were published in the *Sketch*. He also published four anti-German cartoon collections, *Some Frightful War Pictures* (1915), *Hunlikely!* (1916), *The Saintly Hun: A Book of German Virtues* (1917) and *Flypapers* (1919). In World War II he had similar success with his book *Heath Robinson at War* (1941) and also illustrated R.F.Patterson's *Mein Rant* (1940) and Cecil Hunt's *How to Make the Best of Things* (1940). His advertising cartoons also included some on a war theme, such as the full-page series 'The War in the Air' (1941-42) for High Duty Alloys published in *Flight* and *The Aeroplane*. William Heath Robinson died in Highgate, London, on 13 September 1944.

ROBINSON, WYNDHAM (1893-1970)

Wyndham Robinson was born in London, the son of a journalist. Intending to become a fashion artist he studied at Lambeth Art School and Chelsea School of Art. However, on seeing Will DYSON'S drawings when a student he decided to become a cartoonist. In World War I he served in the Artists' Rifles and Royal Field Artillery in France, attaining the rank of captain, and after the war spent a year in Germany with the army of occupation. He then contributed illustrations to *Strand Magazine*, and fashion drawings to *Queen* before moving to Southern Rhodesia where he became a cattle and tobacco farmer for seven years. However, with the failure of his business in the slump of 1928 he turned to drawing once more. After being offered a job man-

aging an advertising agent's studio he moved to Cape Town and later worked as caricaturist and cartoonist on the *Cape Times* for five years, publishing a book *Cartoons from the Cape Times* in 1931. Returning to London, he became political cartoonist on the *Morning Post* c.1932 until it was absorbed by the *Daily Telegraph* in 1937. He later became political cartoonist of the *Star* and produced some powerful images for the paper during World War II before serving in Burma. He also contributed cartoons to *Night & Day*, *Punch*, *Men Only*, *Tatler*, *London Opinion* (including covers) and *Lilliput*. Some of his anti-Nazi cartoons appeared in his collection *Cartoons from the Morning Post* (1937) and he also illustrated R.C.Robertson Glasgow's *I Was Himmler's Aunt* (1940) and *No Other Land* (1941). Wyndham Robinson died in 1970.

ROGERS, WILLIAM ALLEN 'W.A.R.' (1854-1931)

William Rogers was born in Springfield, Ohio, on 23 May 1854. A self-taught artist, he joined the *New York Graphic* when he was nineteen. In 1877 he moved to

W.A.Rogers, 1906

Harper's Weekly, succeeding Thomas NAST, and remained there for twenty-five years. He then moved to the *New York Herald* for twenty years. In 1883 he was one of the first cartoonists to draw for *Life* and he also contributed to the *Washington Post*, *Century* and other publications. In addition he was a director of the School for Disabled Soldiers. During the Boer War he drew some notable cartoons, including 'The Tail End of the Campaign' (cover for *Harper's Weekly*, 12 January 1901) which showed a giant British lion holding Bloemfontein and Pretoria in its paws as a Boer is about to cut its tail. He also drew cartoons about the Spanish-American War, Russo-Japanese War and other conflicts and some of his World War I cartoons were published in his collection *America's Black and White Book* (1917). One of his best-known posters was 'Only the Navy Can Stop This' (1917). His drawings (which also appeared in the Paris edition of the *New York Herald*) earnt him the Légion d'Honneur. William Rogers died in Washington DC on 20 October 1931.

ROTH, STEPHEN (1911-after 1944)

Czech by birth, Stephen Roth, who signed his work 'Stephen', moved to Prague in 1931 and drew sports cartoons, joke illustrations and portraits for various papers and magazines before becoming political cartoonist on the anti-Nazi weekly *Demokraticky Stred* edited by Dr Hubert Ripka (later head of the Czechoslovak propaganda department in London during World War II) in 1935. Forced to leave Czechoslovakia in 1938, he went to Poland, then Sweden before arriving in London only days before war broke out in September 1939. By 1941 he was drawing for the Ministry of Information and contributing political cartoons to the *Central European Observer* and the Free Norwegian newspaper *Norsk Tidend*. His popular series 'Acid Drops' began to appear in the *Sunday Pictorial* in 1942. He also contributed to the *Star*, *Lilliput*, *Daily Mirror*, *Daily Mail* (sports cartoons) and others. In 1943 some of his war car-

THE BATTLE OF THE ATLANTIC
Stephen Roth, *Divided They Fall* (1943)

toons were exhibited at the Czechoslovak Institute in London, along with drawings by Walter TRIER, Adolf HOFFMEISTER, Antonin PELC and Z.K. (later published as *Jesters in Earnest*, 1944). Collections of his drawings included *Divided They Fall* (1943), *My Patience is Exhausted* (1944, with a foreword by the Czech Foreign Minister in exile Jan Masaryk) and *Finale* (1944). In an ironic twist, one of his futuristic cartoons, 'Cairo Reunion, 1955' (*Courier*, April 1944), produced for a special spoof 1 April 1955 Air Mail Edition of the magazine, features Churchill, Stalin and Roosevelt reminiscing about Hitler – by 1955 both Roosevelt and Stalin were themselves also dead.

ROUBILLE, AUGUSTE JEAN-BAPTISTE (1872-1955)

Auguste Roubille was born in Paris on 15 December 1872. His first cartoons were published in *Le Courrier Français* (1896-7), *Les Etoiles* (1896-7) and *Le Rire* (1896-1939). He later contributed to *Le Cri de Paris* (1898-

1916), *Le Sourire* (1899-1913), *L'Assiette au Beurre* (from its first issue 4 April 1901-08), *Le Journal* (1903-24), *Cyrano* (including covers), *Cocorico* and others. For thirty years, from its launch on 1 August 1906, he drew the cover illustration for *Le Rire*'s sister publication *Fantasio* (featuring the female figure of Fantasy) and was co-founder of *Le Canard Sauvage* in 1903. During the Boer War his anti-British cartoons were published in *Le Sourire* and elsewhere and a colour caricature of Kruger about to thrash John Bull was reproduced as a French postcard. His World War I cartoons also appeared in *La Grande Guerre* (1914-15) and *La Baïonnette* (1915-18, including covers) and *Le Rire Rouge* (including covers). The initials which formed his signature took the shape of an elongated face. He died in Paris in 1955.

ROWLANDSON, THOMAS (1756-1827)

Thomas Rowlandson was born in Old Jewry, London, on 13 July 1756, the son of a wool and silk merchant. When his father went bankrupt in 1759 he was brought

Auguste Roubille, *La Baïonnette*, 22 August 1918

THE CORSICAN AND HIS BLOODHOUNDS AT THE WINDOW OF THE TUILERIES
LOOKING OVER PARIS
Thomas Rowlandson, 16 April 1815

up by his uncle (a prosperous silk weaver). In 1772 (aged fifteen) he entered the Royal Academy Schools and then spent two years studying art in Paris. He began producing political and social prints in 1780 and in 1798-9 published a collection of eighty-seven colour plates, *The Loyal Volunteers of London and Environs: Infantry and Cavalry in Their Respective Uniforms, Representing the Whole of the Manual, Platoon and Funeral Exercise*. He also drew some very powerful cartoons during the Napoleonic Wars (including some based on prints by the Russian caricaturist Ivan TEREBENEV). Amongst these are 'The Two Kings of Terror' (November 1813) and 'The Corsican and His Bloodhounds at the Window of the Tuileries Looking Over Paris' (16 April 1815) both featuring Death and Napoleon. In 1809, Thomas Tegg issued a book of fifty-four of Rowlandson's caricatures of the scandal involving the Duke of York (commander-in-chief of the British Army) and the sale of military promotions by his former mistress, Mrs Clarke. The same year he became celebrated as the

illustrator of William Combe's *The Three Tours of Dr Syntax* (1809, 1820, 1821), creating thereby the first-ever cartoon character. He later illustrated the Peninsular War cautionary tale in verse, *The Military Adventures of Johnny Newcome; With an Account of His Campaign on the Peninsula and in Pall Mall* (1816), by 'Officer' (Lieutenant-Colonel David Roberts). Newcome was the first military cartoon character and his exploits were continued in *The Adventures of Johnny Newcome in the Navy* (1818) with a text in verse by 'Alfred Burton' (John Mitford). Thomas Rowlandson died in London on 22 April 1827.

RUPPRECHT, PHILIPP 'FIPS' (1901-75)

Born in Nuremberg, Germany, Fips served in the German navy in World War I and then moved to Argentina, aged twenty, where he worked on a cattle ranch and as a waiter. He returned to Nuremberg in 1925 and began contributing cartoons to the *Fränkische Tagespost*. His work then came to the attention of Julius Streicher who

TERROR-FLYERS
Philipp Rupprecht (Fips), *Der Stürmer*, July 1943

invited him to draw pro-Nazi and anti-Semitic cartoons (including covers) for *Der Stürmer*. Fips' first cartoon appeared in the issue for 19 December 1925 and he continued to draw for the paper until its last issue on 2 February 1945. With the outbreak of war he served at first in the Kriegsmarine but was later released to do wartime propaganda work. He also illustrated Nazi children's stories by Ernst Hiemer (editor of *Der Stürmer*) and published his own book *Juden Stellen Sich* (Jews Present Themselves, 1934). After the war he was sentenced to six years' hard labour in Eichstätt prison by the Allies and was released on 23 October 1950. He then worked as a painter and decorator in Munich where he died on 4 April 1975.

'SAD SACK, THE' – see Baker, George

SAÏD – see Levy, Alphonse Jacques

SALLON, RALPH DAVID MBE (1899-1999)
Ralph Sallon was born Rachmiel Zelon on 9 December 1899 in Sheps, Poland, the son of Isaac Meyer Zelon, a women's tailor. He came to England at the age of four and was brought up in London's East End. He later attended (briefly) Hornsey School of Art (1914) and after serving in the British Army in World War I moved to South Africa in 1922. His first caricature was published in the *Natal Mercury* in 1923. After two years he returned to England, studied at St Martin's School of Art and joined *Everybody's Weekly* (1925-45), while also contributing caricatures to *East Africa* (1930-39). Resident caricaturist on the *Jewish Chronicle* (c. 1930-91) he worked freelance for *Tatler*, *Bystander*, *Illustrated Sporting & Dramatic News*, *Daily Herald* (1943-8), *Daily Mail*, *Blighty*, *Daily Sketch*, *Observer*, *Daily Express* and others. During World War II he produced propaganda cartoons for aerial leaflets etc., including *Message*, the Free Belgium newsletter produced in London. A collection of his wartime caricatures, *Sallon's War* was published in 1995. After the war he was staff caricaturist on the *Daily Mirror* (1948-91). He was awarded an MBE in 1977. Ralph Sallon died in Barnet, Hertfordshire, on 29 October 1999.

SAMBOURNE, EDWARD LINLEY (1844-1910)
Linley Sambourne was born in Pentonville, London, on

UNDER THE CENSOR'S STAMP,
or How the Bear's Paw Comes Down on *Punch* in St Petersburg. And Yet the Jingoes Call Him 'Russophil'!
Linley Sambourne, *Punch*, 23 September 1878

4 January 1844, the son of Edward Mott Sambourne, an American-born wholesale furrier. His mother was a distant relative of the composer Thomas Linley (whose daughter Elizabeth Anne Linley was the wife of the playwright R.B.Sheridan). At the age of sixteen he was apprenticed as a draughtsman to John Penn & Sons, marine engineers, in Greenwich. Self-taught as an artist (apart from two weeks at the South Kensington Schools), he began working for *Punch* in 1867. He joined the staff in 1871 and remained with the magazine for more than forty years until his death. On 1 January 1901 he succeeded John TENNIEL as cartoonist. He also contributed to *Black & White*, *Sketch* (including covers), *Pall Mall Magazine* (including its first-ever cover, 1893), *Daily Chronicle*, *Illustrated London News* (including its Jubilee cover, 1892) and others. In addition he was an accomplished book illustrator. Known as Sammy to his friends, he greatly influenced Phil May ('Everything I know I learnt from Sammy') and was himself caricatured by SPY for *Vanity Fair* (1882). *Punch* cartoons by Sambourne and John Tenniel so upset Tsar Alexander II and Kaiser Wilhelm II that the magazine was censored in Russia and Germany and as a result Sambourne drew 'Under the Censor's Stamp' (23 September 1878), showing the Russian bear cutting up the magazine and 'Wilful William' (*Punch*, 24 March 1891), with the Kaiser tearing copies of it to shreds. Edward Linley Sambourne died at his home in Kensington, London, on 3 August 1910. His daughter Maud (Mrs Messel) was one of the earliest female artists on *Punch*, contributing from 1893, at the age of sixteen. (Her descendants include the designer Oliver Messel and Princess Margaret's former husband, the Earl of Snowdon, and their son, Viscount Linley.)

SANDFORD, MATTHEW AUSTIN 'MATT' (1875-1943)

Matt Sandford was born in Belfast in 1875, the son of John Sandford, a flax dresser. After studying at the Government School of Art in Belfast he began con-

tributing to *The Magpie* in 1898. He then joined the staff of the *Belfast Telegraph* and later moved to Manchester to work for the *Sunday Chronicle*. He came to London c.1900 and began to contribute to the *Graphic*, *Sunday Graphic*, *Illustrated Sporting & Dramatic News*, *Sketch*, *Evening Standard*, *Daily Sketch*, *Bystander*, *John o' London's Weekly*, *Cassell's* and *T.P's Weekly* amongst others. He later moved back to Manchester, where he drew political cartoons and caricatures for the *Manchester Daily Dispatch* during World War I, and then returned to London to work for the *Daily Sketch* and others. In 1922 he produced a book, *Sixty Daily Sketch Cartoons of Famous People as 'Matt' sees Them*, which included a caricature of the Irish Sinn Fein leader Michael Collins who was killed that year. He died in London on 30 December 1943.

SCALARINI, GIUSEPPE (1873-1948)

Giuseppe Scalarini was born in Mantua, Italy on 29 January 1873. His first cartoons were drawn for the Socialist daily *Avanti!* and the weekly satirical magazine

THE CHARIOT OF VICTORY
Giuseppe Scalarini, 1919

SEIZE BERLIN!
Johann Gottfried Schadow, December 1813

L'Asino. He also founded *Merlin Cocai* in Mantua in 1896 and contributed to *Pasquino*, *Codino Russo* and other publications as well as the German journals *Simplicissimus*, *Fliegende Blätter* and *Lustige Blätter*. He drew many powerful cartoons in World War I, notably 'War' (*Avanti!*, 7 August 1914), showing the figure of a woman draped over a recently fired canon which echoes an earlier drawing from the Franco-Prussian War by DAUMIER. During the twenty years of Mussolini's dictatorship he was imprisoned a number of times for his attacks on Fascism. He signed his drawings with a ladder (*scala* in Italian) followed by 'rini'. Scalarini died in Milan on 30 December 1948.

SCHADOW, JOHANN GOTTFRIED (1764-1850)
Johann Gottfried Schadow was born in Berlin, Prussia, on 5 May 1764, the son a master tailor. He studied at the royal sculpture studio under Tassaert and at the Berlin Academy of Fine Arts. In 1788 he succeeded Tassaert as director of the royal sculptor studio. Though probably best known for designing the monumental quadriga that surmounts the Brandenburg Gate in Berlin, he also produced a number of anti-French prints during the Napoleonic Wars (signed 'Gillray, Paris' or 'Gilrai' to avoid censorship laws). Amongst these was 'The Fencing Class' (April 1814), with General Blücher teaching Napoleon to fence. In 1805 he became rector of the Berlin Academy and its director in 1815. He died in Berlin on 27 January 1850.

CHURCHILL'S NEW YEAR HANGOVER
'Damn, look how my lies-and-illusions punch has
been received!'
Eric Schilling, *Simplicissimus* (Munich),
1 January 1942

SCHILLING, ERIC (1885-1945)

Eric Schilling was born in Suhl, Thuringia, on 27 February 1885, the fourth child of a gun manufacturer. After serving an apprenticeship with the master engraver Karl Kolb he worked as a rifle engraver in his father's company. At the age of eighteen he went to Berlin to study art at the city's academy. His first cartoons appeared in *Der Wahre Jakob* and in 1907 he began to contribute to *Simplicissimus*. He also drew for *Kladderadatsch* and others. He moved to Munich in 1918 and later became a shareholder in *Simplicissimus*. Schilling often signed his work simply with a capital S. Formerly vehemently anti-Nazi, in 1933 he became a supporter of Hitler's regime and even became Goebbels' favourite cartoonist. With the collapse of the Third Reich he committed suicide in his studio in Munich on 30 April 1945.

'We hold tightly and loyally together. Hurrah!'
Arpad Schmidhammer, *Jugend* (Munich), July 1900

SCHMIDHAMMER, ARPAD (1857-1921)

Arpad Schmidhammer was born in St Joachimsthal, Bohemia, on 12 February 1857. He studied art in Graz, Vienna and Munich and in 1896 became one of the first illustrators of *Jugend*. He also contributed to *Der Floh*, *Münchener Odinskarte*, *Der Scherer*, *Berliner Illustrierte Zeitung* and others. In addition he wrote and illustrated many children's books and designed theatre costumes. His cartoons were often signed with a frog or hammer symbol. Amongst his children's books was a World War I picture book, *Lieb Vaterland magst ruhig sein! Ein Kriegsbilderbuch mit Knuttelversen* (1914). He died in Munich on 13 May 1921.

'SCHMIDT THE SPY' – see Leete, Alfred Ambrose Chew

SCHOLZ, WILHELM (1824-93)

Wilhelm Scholz was born in Berlin on 23 January 1824. After studying at the Königlichen Akademie in Berlin he began work for the Berlin journal *Kladderadatsch* in 1848 (from its second issue) and became its main artist for nearly forty years (being later joined by Gustav BRANDT and Ludwig Stutz). He also contributed to *Freie Blätter*, *Berliner Krakeler* and *Berliner Grossmaul*. He was particularly well known for his caricatures of Bismarck (he created the trademark image of Bismarck's 'Three Hairs') and Louis Napoleon. He died in Berlin on 20 June 1893.

[NAPOLEON III]
Wilhelm Scholz, c.1870

SCHULZ, WILHELM (1865-1952)

Wilhelm Schulz was born on 23 December 1865 in Lüneburg, Prussia. Apprenticed at first to an art printing company, he later studied art in Berlin, Karlsruhe and Munich after receiving a grant from the Prussian Ministry of Culture. A regular contributor to *Simplicissimus* he also illustrated books for its publisher, Albert Langen Verlag. In addition he contributed cartoons to French magazines such as *Le Pêle-Mêle* (1899) and *L'Assiette au Beurre* (1907). He produced powerful anti-British cartoons during the Boer War, World War I and World War II. Wilhelm Schulz died in Munich on 16 March 1952.

'SCHWEJK, THE GOOD SOLDIER' – see Lada, Josef

SCHWEITZER, HANS HERBERT 'MJÖLNIR' (1901-80)

Hans Schweitzer was born on 25 January 1901, in Berlin, the son of a doctor. He studied at the Kunsthochschule in Berlin and was one of the first thirty members of the Berlin Nazi Party (he joined in 1926). A close friend of Joseph Goebbels, he helped set up *Der Angriff* in 1927 and drew cartoons for it. He also contributed to the *Völkischer Beobachter* and *Die Brennessel* amongst others. In addition he designed postage stamps and posters and illustrated a book lampooning quotations from Winston Churchill's speeches. He used the pseudonym 'Mjölnir' (the name of Thor's hammer in Norse mythology) from 1926. In 1935 he was appointed Reichsbeauftragter für Künstlerische Formgebung (Reich Instructor for Artistic Shaping) in the Reich Chamber of Culture – responsible for identifying and confiscating so-called 'degenerate art' – and from 1937 had the title of professor. After the war he worked as an illustrator. He died on 15 September 1980 in Landstuhl.

SCORFIELD, EDWARD SCAFE (1882-1965)

Ted Scorfield was born on 21 April 1882 in Preston, Northumberland, the son of Joseph Scorfield, an insurance agent. He worked at first as a marine architect. In World War I he served with the 66th Field Company, Royal Engineers, at Gallipoli and Salonika, and in Greece and Palestine, attaining the rank of sergeant. After the war he worked as a draughtsman with a shipbuilding company in Newcastle-upon-Tyne and began drawing cartoons for the *Newcastle Weekly Chronicle*. He then worked freelance as a cartoonist in London before applying for the job of main cartoonist of the *Sydney Bulletin* in 1925 to replace Norman LINDSAY. Selected by David LOW (by then working in London) as the best applicant he then moved to Sydney where he worked for the *Bulletin* for thirty-six years. Two wartime collections of his cartoons were published, *A Mixed Grill* (1943) and *A Mixed Grill No.2* (1944). He retired in June 1961 and died in Mosman, New South Wales, on 11 December 1965.

SEM – see Goursat, Georges

SENNEP, JEAN – see Pennes, Jean-Jacques Charles

SEPPLA – see Plank, Josef

CAMBRAI
'No stone will remain on top of another. That will be a splendid way to build a peace with Germany.'
Wilhelm Schulz, *Simplicissimus* (Munich), 5 November 1918

SHEPARD, ERNEST HOWARD OBE
(1879-1976)

E.H.Shepard was born on 10 December 1879 in St John's Wood, London, the son of Henry Dunkin Shepard, an architect. Educated at St Paul's School (with G.K.Chesterton and Compton Mackenzie), he studied art at Heatherley's in 1896 aged sixteen (with G.L.STAMPA) and then won a scholarship to the RA Schools (1897-1902). He worked at first as a painter (first exhibiting at the RA in 1901) and also contributed joke cartoons and illustrations to the *Graphic*, *Illustrated London News*, *London Opinion*, the *Sketch* and others. He was first published in *Punch* in 1907 and he subsequently worked for the magazine for nearly fifty years (until 1954), succeeding Raven HILL as Second Cartoonist (1935-45) and Bernard PARTRIDGE as Cartoonist (1945-9). In World War I he served in the Royal Artillery (1915-18) in France, Belgium and Italy, achieving the rank of major and being awarded the Military Cross at Ypres (1917). Best known as a book illustrator (notably for the 'Winnie the Pooh' books written by the assistant editor of *Punch*, A.A.Milne), he also drew some powerful anti-Nazi cartoons during the 1930s and 40s for *Punch*. These included: 'The Goose Step' (18 March 1936) commenting on Hitler's reoccupation of the Rhineland, 'Humpty Dumpty and the Roman Wall' (8 May 1940), featuring Mussolini as the eggman before Italy joined the Axis, and the Battle of Britain cartoon 'The Rock and the Storm' (25 September 1940) with Goering and the Luftwaffe being smashed against the white cliffs of Dover. (Goering called Shepard's drawings 'horrible examples of anti-Nazi propaganda'.) During the London Blitz he allegedly slept with his weekly *Punch* cartoon under his pillow. He was appointed OBE in 1972. E.H.Shepard died in Midhurst, Sussex, on 24 March 1976 aged ninety-six. His daughter Mary Shepard (who married *Punch*'s editor E.V.Knox) was also an illustrator.

SHOEMAKER, VAUGHN RICHARD (1902-91)

Vaughn Shoemaker was born on 11 August 1902 in Chicago, the son of William H.Shoemaker. After a brief period at the Chicago Academy of Fine Arts (1920-21) he joined the staff of the *Chicago Daily News* in 1922.

When the paper's editorial cartoonist, Ted Brown, left in 1925, Shoemaker took over his job and stayed with the paper for nearly thirty years, winning Pulitzer Prizes for his cartoons in 1938 and 1947. The 1938 prizewinner ('The Road Back?', *Chicago Daily News*, 11 November 1937), was on a war theme and showed a European soldier on Armistice Day going back in time along the road to war. In 1951 he left to work for the Herald-Tribune Syndicate and in 1962 moved to the *Chicago American*. One of his best known anti-Nazi cartoons was 'Take me to Czechoslovakia, Driver' (*Chicago Daily News*, 8 September 1938) with Hitler as the passenger in a taxi driven by Death. His wartime books included *1939 A.D.* (1940), *1940 A.D.* (1941), *'41 and '42 A.D.* (1942), *'43 and '44 A.D.* (1945) and *'45 and '46 A.D.* (1947). He later taught at the Chicago Academy of Fine Arts. He died in Carol Stream, Illinois, on 18 August 1991.

SILLINCE, WILLIAM AUGUSTUS (1906-74)

William Sillince was born on 16 November 1906 in Battersea, London, the son of William Patrick Sillince, a Royal Navy marine engineer. After studying at the Regent Street Polytechnic School of Art and the Central School of Arts & Crafts (1923-8) he began work as a designer in advertising (1928-36) for Haddons agency. He then turned freelance, contributing cartoons to *Punch* (1936-74, including whole-page political cartoons as deputy to Leslie ILLINGWORTH), *Bystander* and other magazines, and illustrating books. He published five wartime collections of his drawings: *We're All in It* (1941), *We're Still All in It* (1942), *United Notions* (1943), *Combined Observations* (1944) and *Minor Relaxations* (1945). After the war he taught part-time at Brighton College of Art (1949-52), was lecturer in graphic design at Hull Regional College of Art (1952-71) and contributed to the *Yorkshire Post* (1964-74). William Sillince died on 10 January 1974.

'SMILING THROUGH' – see Lee, Joseph Booth

SOKOLOV, NIKOLAI ALEKSANDROVICH –
see Kukryniksi

SOUPAULT, RAPHAEL (1904-62)

Ralph Soupault was born in Sables d'Olonnes, France, the son of a Socialist schoolteacher. His first cartoons were published in the Socialist daily *L'Humanité* in 1921 when he was aged seventeen. He also drew for *Le Chat Noir* (1922-23), *Dimanche-Illustré* (1924-31), *Le Rire* (1924-38), *Le Petit Parisien* (1924-43), *Le Charivari* (1926-37 and 1957-62), *Gringoire* and *Ric et Rac* (1929-39). After war service his views turned to the far right and he joined Jacques Doriot's ultranationalist Parti Populaire Français (PPP) and contributed to *L'Action Française* (1939-43), *Le Cri Du Peuple* (1940-43) and the Milice weekly *Combats* (1943-4). In 1941 he designed posters for *Le Cri du Peuple* and *Au Pilori*. and was a member of the editorial board of *Je Suis Partout* when it was relaunched in 1941 as a collaborationist journal. He produced two books of his work, *Danse Macabre* (1934) and *Ils Sont Partout* (1944). After the Allied invasion of France he fled to Germany in August 1944 and was arrested in Italy in March 1946. He was then sentenced to fifteen years' hard labour in 1947 but was released after three years on health grounds. He later worked under the pseudonyms Rio and Leno for *Rivarol*. Ralph Soupault died in Cauterets, France, on 12 August 1962.

SPY – see Ward, Sir Leslie Matthew

STAMPA, GIORGIO [LATER GEORGE] LORAINE (1875-1951)

G.L.Stampa was born in Constantinople (now Istanbul), Turkey, on 29 November 1875, the son of the architect G.D.Stampa. The family returned to Britain in 1877 and he studied at Heatherley's School of Art (1892-3) and the RA Schools (1893-5), where fellow students included William Heath ROBINSON. Stampa also later shared a studio with Savile LUMLEY. His first published drawing appeared in *Punch* in March 1894 and in 1900 he became a full-time illustrator and cartoonist working mainly for *Punch*. He drew nearly 2,500 illustrations for this magazine alone over a period of fifty-six years (1894-1949). He also contributed to *Bystander, Humorist, Graphic, Strand Magazine, London*

DAI PEPPER ON THE SOMME
J.M.Staniforth from Captain T.E.Elias (ed.),
New Year Souvenir of the Welsh Division (1917)

Opinion, Moonshine, Pall Mall Magazine, Sketch, Tatler and others and became well known for his drawings of Cockneys and street urchins. Deemed unfit for service in World War I and too old for service in World War II he none the less produced some poignant cartoons of both conflicts. Notable amongst these was 'Grit – The Morning After the Zeppelin Raid in Our Village' (*Punch*, 22 September 1915), showing a grocer putting up a sign saying 'Business as Usual During Alterations'. This was reproduced in *Punch* in 1941 during the London Blitz. G.L.Stampa died in London on 26 May 1951. His first cousin, Willie Heelis, married the children's writer Beatrix Potter.

STANIFORTH, JOSEPH MOREWOOD 'J.M.S.' (1863-1921)

J.M.Staniforth was born in Gloucester on 16 May 1863, the son of Joseph Staniforth who ran a cutlery business.

Soon after he was born the family moved to Cardiff, Wales, and at the age of fifteen he began an apprenticeship in the lithographic department of the *Western Mail* (1878). Ten years later he joined the editorial staff as an illustrator, drawing daily cartoons from 1893 for nearly thirty years and creating the character of Dame Wales (*Mam Cymru*). In addition, he drew regularly for the *Cardiff Evening Express* and the *News of the World* and contributed to *Punch*. More than 100 of his Boer War cartoons for the *Western Mail* were published as *Cartoons of the Boer War* (1900). Some of his World War I drawings also appeared later as *Cartoons of the War* (two volumes, 1914). His cartoon on the sinking of the *Lusitania* ('Lower Than Barbarism', 1915) was, with 'Remember Louvain' by Louis RAEMAEKERS and 'Unconquerable' by Bernard PARTRIDGE, one of the best-known cartoons of World War I. He died in Lynton, Devon, on 17 December 1921.

GLORY
Théophile-Alexandre Steinlen (1915)

STEINBERG, SAUL (1914-99)

Saul Steinberg was born in Romanic Sarat, Romania, on 15 June 1914. After studying philosophy briefly at the University of Bucharest he moved to Milan in 1933 to study architecture at the Regio Politecnico. While still a student he began to contribute cartoons to the Italian magazine *Bertoldo* (1936-9). After gaining a doctorate in 1940 he began work as an architect and started contributing to *Life* and *Harper's Bazaar*. Due to the rise of Fascism he was forced to leave Italy in 1941 and spent a year in the Dominican Republic (during which time he began contributing to the *New Yorker*). He arrived in the USA in 1943 and became a naturalised US citizen the same year. He then enlisted in the US Navy and served in military intelligence in China, North Africa and Italy. During this period he also contributed cartoons to *PM*, *Liberty* and other publications. After the war he gave up

architecture and concentrated on graphic art as a career. He died in New York on 12 May 1999.

STEINLEN, THÉOPHILE-ALEXANDRE (1859-1923)

Théophile Steinlen was born in Lausanne, Switzerland, on 10 November 1859, the grandson of a professor of drawing. At the age of nineteen he went to Mulhouse, France, to work as an industrial designer in a textile factory. In 1882 he moved to Paris and began to contribute to *Le Capitain* (1883) and *Le Chat Noir* (1883-91). He later drew for *Le Courrier Français* (1885-1911), *Le Rire* (1895-1906), *Gil Blas* (including covers), *Le Triboulet* (1896-1908), *L'Humanité* (1907-21) and *Les Hommes du Jour* (1911-21) amongst others. He also drew the first-ever cover for *L'Assiette au Beurre* (4 April 1901) and continued to contribute to the magazine until 1908. For Aristide Bruant's *Le Mirliton* (on which he worked with his friend Toulouse-Lautrec) he used the pseudonyms 'Treclau' and later 'Jean Caillou' (*Caillou* is the French equivalent of the Swiss/German *Steinlen* meaning pebble, or little stone). He became a

French citizen in 1901. During the Boer War he drew for *La Vie Illustrée* (notably a double-page cartoon for the 16 November 1900 issue on Kruger's visit to Europe), *Le Canard Sauvage* and others. In 1901 he co-founded (with Adolphe WILLETTE), the journal *Les Humoristes*. During World War I he contributed to *La Grande Guerre* (1915), *La Victoire*, *La Baïonnette* and others and designed some powerful posters such as 'En Belgique Les Belges Ont Faim' (1915) and 'Serbia Day' (1916). Some of his World War I cartoons were published as a book, *Croquis de Temps de Guerre* (1919). In 1917 he and Bernard NAUDIN were appointed official war artists. Steinlen died in Paris on 14 December 1923.

STEPHEN – see Roth, Stephen

STEVENS, G. A. 'GAS' (fl. 1910s)

G.A. Stevens was political cartoonist on the *Star* during World War I, being succeeded in 1919 by David LOW. He also contributed to *Strand Magazine* and others, and illustrated two collections of anti-Kaiser cartoons, S.Lupton's *An English ABC for Little Willie and Others* (n.d.) and Elphinstone Thorpe's *Nursery Rhymes for Fighting Times* (1915). The latter has a proud goose-stepping Mother Goose wearing a German helmet and holding a rifle on the front cover while the back cover shows a battered version of the same goose on crutches. In addition Stevens designed wartime postcards such as the 'Camp Silhouette Series' published by Photocrom.

G.A. Stevens (GAS) from Elphinstone Thorpe,
Nursery Rhymes for Fighting Times (1915)

STRUBE, SIDNEY CONRAD (1891-1956)

Sidney Strube was born in Bishopsgate, London, on 30 December 1891, the son of Frederick Strube, a wine merchant. He studied at St Martin's School of Art and began work as a junior draughtsman for a furnishing company. Then, after working in an advertising agency, he attended the John HASSALL School of Art (1910). During the 1910 election some of his caricatures were accepted by the *Conservative & Unionist* and he also had work published in *Bystander*, *Evening Times* and *Throne & Country*. When the latter publication refused a drawing he took it to the *Daily Express* who published it and by 1912 he had an exclusive freelance contract with the paper. In 1914 he published (with William F. Blood) *The Kaiser's Kalendar for 1915, or, the Dizzy Dream of Demented Willie*. After service as a PT and bayonet instructor in the Artists' Rifles in World War I he joined the staff of the *Express* as political cartoonist (1918-48). Here he created his 'Little Man' character with his umbrella, bow-tie and bowler hat, who became a national symbol of the long-suffering man-in-the-street. Some of his anti-Nazi and anti-Fascist cartoons for the *Express* appeared in his collections *100 Cartoons* (1931-5) and *Strube's War Cartoons* (1944). He also produced a number of memorable wartime government poster campaigns including 'Yield Not an Inch! Waste Not a Minute' and 'The Three Salvageers'. He left the *Daily Express* in 1948 and then freelanced for the *Sunday Times*, *Time & Tide*, *Everybody's* and *Tatler*. Strube (whose name rhymes with 'Ruby') was known familiarly as 'George' from his habit of addressing others by this name (his son really was called George). Sidney Strube died at his home in Hampstead on 4 March 1956.

SULLIVAN, EDMUND JOSEPH (1869-1933)

E. J. Sullivan was born in London on 6 September 1869, the son of the artist Michael Sullivan ARCA. His younger brother was the architect Leo Sullivan FRIBA (later vice-president of the Architectural Association). The family moved to Chesterfield when he was one and then to Hastings when he was six. At first he worked in his father's studio and he had his first drawing published in *Scraps* c.1884. Joining the *Graphic* (1899) as a staff artist aged nineteen, he then worked for the

THE PATH OF GLORY

E.J.Sullivan, *The Kaiser's Garland* (1915)

newly launched *Daily Graphic* (1890-93) with Phil May and the future influential art teacher A.S.Hartrick OBE (with whom he shared a studio at one point). He next moved to the *Penny Illustrated* as writer and artist and later joined the staff of *Pall Mall Budget*. He also contributed to many other publications including *English Illustrated*, *New Budget*, *Ludgate*, *Pall Mall Magazine*, *Black & White* and *Punch* amongst others. In addition he illustrated many books (from 1896), amongst them Carlyle's *The French Revolution* (1910) which received considerable critical acclaim. During World War I he drew powerful anti-German cartoons, forty-four of which were reproduced in *The Kaiser's Garland* (1915). He later taught book illustration and lithography at Goldsmiths' College, London (notable pupils included Graham Sutherland and Rowland Hilder). E.J.Sullivan died in London on 17 April 1933.

SZYK, ARTUR [LATER ARTHUR] (1894-1951)

Arthur Szyk was born on 16 June 1894 in Lodz, Poland. He studied at the Académie Julian in Paris and the Jan Matejiko Academy of Fine Arts in Krakow. During World War I he served in the Russian Army and began contributing to *Smiech* and other publications. After the Armistice he joined General Sikorski's Polish Army and fought against the Bolsheviks (1919-20). He began as a professional cartoonist in Warsaw in the 1920s before moving to Paris where he also worked as an illustrator. In 1934 he was sent to the USA by the Polish government where a touring exhibition of his work was displayed in the Library of Congress and elsewhere. On his return he was commissioned to draw a series of miniatures on the American War of Independence and these were presented by the Polish government as a gift to President Roosevelt in 1938. The following year he was in the UK and with the outbreak of World War II drew anti-Nazi cartoons for the British press. In 1940 he moved back to the USA where he continued to draw anti-German cartoons, some of which were published in *The New Order* (1941) and *Ink and Blood* (1946). Amongst his most memorable work were the wartime colour covers he drew for *Collier's* magazine, and cartoons for *PM*, the *New York Post* and other newspapers. A notable *Collier's* cover featured Emperor Hirohito of Japan as a bomb-carrying vampire bat flying over Hawaii for the issue of 12 December 1942, marking the anniversary of the bombing of Pearl Harbor on 7 December 1941. He died in New Canaan, Connecticut on 13 September 1951.

TAHIR, RATIP – see Burak, Ratip Tahir

TALBURT, HAROLD M. (1895-1966)

Harold Talburt was born in Toledo, Ohio, on 19 February 1895 and worked at first as a sign painter. He joined the staff of the *Toledo News-Bee* as a reporter on 1 January 1916 and later also contributed sketches to the paper (notably of the boxer Jack Dempsey in 1919). In 1921 he moved to the Washington bureau of Scripps-Howard syndication and in 1922 became its chief Washington cartoonist. In 1933 he won the Pulitzer Prize for his cartoon 'The Light of Asia' (*Washington Daily News*, 27 January 1932), commenting on the Japanese invasion of Manchuria. It shows the international anti-war treaty, the Kellogg-Briand Pact (1928), being held as a burning torch by the arm of Japan. His wartime collections include *Talburt* (1943) and *Cartoons: Largely Political* (1943). He died in Kenwood, Maryland, on 22 October 1966.

TENNIEL, SIR JOHN (1820-1914)

John Tenniel was born in London on 28 February 1820, the son of John Baptist Tenniel, a fencing and dancing master of French Huguenot extraction. He studied

FRANCE, SEPTEMBER 4TH 1870
'Aux armes, Citoyens;
Formez vos bataillons!' *La Marseillaise*
John Tenniel, *Punch*, 17 September 1870

briefly at the RA Schools but left to join the Clipstone Street Art Society. Despite being blinded in his right eye after a fencing accident, his skill as an artist was soon evident and he exhibited at the Royal Academy summer shows from 1837 to 1843. He also worked as a book illustrator (notably of Lewis Carroll's 'Alice' books) and began drawing for *Punch* in 1850 (remaining with the magazine for fifty-one years). His first big political cartoon appeared on 1 February 1851 and during the Crimean War he had considerable success with 'The United Service' (*Punch*, 4 March 1854), which was even reproduced on playing cards. However, his reputation was made by his cartoons on the Indian Mutiny of 1857, notably the two-page drawing 'The British Lion's Vengeance on the Bengal Tiger' (22 August 1857), published shortly after the massacre of British women and children at Cawnpore (it later became a very popular print). Another celebrated drawing of the Mutiny was Tenniel's 'Justice' (*Punch*, 12 September 1857) depicting the classical goddess of Justice ruthlessly cutting down mutineers with her sword. He also drew a number of cartoons on the US Civil War (many attacking Lincoln), including the two-page 'The American Juggernaut' (*Punch*, 3 September 1864) showing three harpies crushing soldiers of both sides under the spiked wheels of a huge cannon. When John LEECH died in 1864 Tenniel took over as the main cartoonist on *Punch* and in all produced more than 2,000 full-page cartoons as well as numerous smaller drawings for the magazine. During the conflict in the Sudan, believing that General Gordon would be relieved in Khartoum, Tenniel drew 'At Last' (7 February 1881) showing Gordon shaking the hand of Sir Henry Stewart who had been sent to relieve him. Unfortunately not only was Stewart himself dead by then but also Gordon had been killed by the Mahdi's troops. The following week came his more accurate drawing 'Too Late!' (14 February 1881) showing a grieving figure of Britannia. His famous two-page cartoon of Kaiser Wilhelm II sacking Bismarck, 'Dropping the Pilot', was published on 29 March 1890. (The Kaiser was later upset by cartoons about him in *Punch* and had them cut from issues distributed in Germany – see SAMBOURNE.) He was

knighted in 1893, the first cartoonist ever to receive this award. His very last cartoon, 'Time's Appeal' (*Punch*, January 1901), was on a war theme. It showed the female figure of Peace standing beside Old Father Time who holds a baby labelled '1901' and appeals to Mars holding the reins of a war-chariot nearby. Sir John Tenniel died, three days short of his ninety-fourth birthday, on 25 February 1914.

TEREBENEV, IVAN IVANOVICH (1780-1815)

Ivan Ivanovich Terebenev was born in St Petersburg on 10 June 1780. After studying sculpture at the St Petersburg Imperial Academy of Fine Art, he taught at a school in Tver, while also producing a number of public monuments. When Napoleon's Grand Army invaded Russia in June 1812 he turned to caricature and drew forty-eight popular anti-French satirical prints over the following three years, published by Ivan Glazunov of St Petersburg and distributed nationwide by itinerant printsellers. Some were also reproduced in journals, on sets of fine china and in book form. Perhaps Terebenev's best-known work is *Azbuka 1812 goda* (A Gift to Children Commemorating the Year 1812), otherwise known as *Terebenev's ABCs* (1814). This book is an anthology of his own personally selected anti-Napoleon cartoons, and uses rhyming couplets based on the pictures to teach children the Russian alphabet. It also includes some additional caricatures by two of his contemporaries, Ivan Ivanov (1779-1848) and Aleksei Venetsianov (1780-1847), the latter of whom founded Russia's first-ever cartoon magazine, *Zhurnal Karikatur* (Journal of Caricatures) in St Petersburg in 1808. Such was the influence of Terebenev's work that a number of his drawings were reprinted in London during the Napoleonic Wars. Some were even copied or redrawn for the British market by George CRUIKSHANK, including 'Napoleon's Fame' (10 May 1813), 'Journey of the Exalted Traveller from Warsaw to Paris' (30 May 1813), 'A Russian Peasant Loading a Dung Cart' (March 1813) and 'Russians Teaching Boney to Dance' (18 May 1813). At least two of Cruikshank's versions of Terebenev's drawings – 'Specimen of Russian Chopping Blocks' (8 January 1813) and 'A Russian Boor Returning from His

A MEDICAL CONSULTATION
Ivan Terebenev, 1812

Field Sports' (8 January 1813) – were also transfer-printed, in English and Russian, onto Staffordshire pottery jugs. Thomas ROWLANDSON was also influenced by Terebenev. His 'Blücher the Brave Extracting the Groan of Abdication from the Corsican Blood-hound' (9 April 1814), was published a month after the Russian original but has the Prussian General Blücher holding the dog Napoleon instead of Tsar Alexander I. Terebenev died on 16 January 1815, aged thirty-four. However, his legacy continued. In 1855 during the Siege of Sebastopol in the Crimean War, when Russia was again being attacked by France (this time with British help), the Imperial Government reprinted all of his images to inspire Russian troops and the residents of the city. Later still, after the invasion of the USSR by Germany in 1941 during World War II, a collection of anti-Napoleon drawings (including a dozen by Terebenev), together with modern cartoons against

Hitler, was published. It was entitled *Russia: Britain's Ally, 1812-1942* (1942). Terebenev's son Alexander (1815-59) became a celebrated sculptor.

THOMAS, HERBERT SAMUEL MBE
(1883-1966)

Bert Thomas was born in Newport, Monmouthshire, on 13 October 1883, the son of Job Thomas, a monumental sculptor who had helped decorate the Houses of Parliament. While he was apprenticed to an engraver in Swansea he began selling cartoons to the *Swansea Daily Leader* and others. When he was seventeen Sir George Newnes, MP for Swansea and founder of the *Strand Magazine*, saw some of his drawings and published them. In 1903 he began work in a London advertising agency and started freelancing for *Pick-Me-Up*, *Ally Sloper's Half Holiday* and *Punch* (1905-48) and in 1909 became a staff artist for *London Opinion* (1909-54). He also contributed

TAMING THE CROCODILE
Gordon Thomson, *Fun*, 26 July 1882

to the *Humorist*, *Men Only*, *Sketch*, *Passing Show*, *Radio Times*, *Bystander*, *Fun*, *Graphic* and the *World*. His drawings were also reproduced in the USA in *Life*, *Judge* and the *New York Times*. In World War I Thomas served as a private in the Artists' Rifles (1916-18) and was official artist for the government's War Bonds campaign, producing for it Britain's largest poster (of Drake facing the Spanish Armada), which covered the front of the National Gallery in Trafalgar Square (1918). His most famous cartoon was ''Arf a Mo', Kaiser!' featuring a grinning Cockney Tommy lighting a pipe before engaging the enemy. It was drawn for the *Weekly Dispatch* on 11 November 1914 as part of the paper's tobacco-for-troops fund. This and other contributions to the war effort earned him an MBE (1918). A number of his wartime drawings (with some by Wilton WILLIAMS) were published in a book *One Hundred War Cartoons from London Opinion* (1919). After the war he drew illustrations to the 'Cockney War Stories' letters column in the *Evening News*

(a collection of which, *500 of the Best Cockney War Stories*, was published in 1930). In World War II he again produced memorable posters, including some for the 'Is Your Journey Really Necessary?' series for the Railway Executive Committee (1942) and drew some powerful anti-Nazi cartoons for the *Evening News* including Goebbels as a rat being caught in a trap marked 'Truth from Britain' (8 September 1939) which was published less than a week after the declaration of war. During the war he also published *Close-ups Through a Child's Eye* (n.d.) featuring childlike colour caricatures of the Allied and Axis leaders, and illustrated H.Simpson's *Nazty Nursery Rhymes* (1940) and Percy Bradshaw's *Marching On* (1943). Bert Thomas died in Bayswater, London, on 6 September 1966. His son Peter also later drew for *Punch*.

THOMSON, JOHN GORDON (1840-c.1893)

A British cartoonist, Gordon Thomson was studying to become a civil servant at Somerset House, London,

when he had some early drawings accepted by *Punch* in 1861. After entering the Civil Service he continued to contribute to various publications including *London Society*, *Broadway* and *Sunday*, and he also drew for the *Graphic* during the Franco-Prussian War (1870-71). He then left his job to become political cartoonist on *Fun*, his first cartoon for the magazine being published on 10 September 1870. He remained with *Fun* for more than twenty years, his last drawing being published on 18 July 1893. Among his better known war cartoons is 'Stamping it Out' (*Fun*, 11 August 1880) showing John Bull in military uniform stamping out the Afghan scorpions during the Afghan Wars.

THÖNY, EDUARD (1866-1950)

Eduard Thöny was born on 9 February 1866 in Brixen, Austria (now Bressanone, Italy), the son of Christian Thony, a Tyrolese wood carver and sculptor of sacred images. His family moved to Munich when he was aged seven and he studied at the art academy there. While still a student he began to contribute to *Berliner Modewelt*, *Münchener Humoristische Blätter* and *Radfahr-Humor*. He moved to Paris in 1890 where he studied with the military painter Edouard Detaille. However, when he returned to Munich in 1896 he gave up painting and became one of the first artists to join the staff of the newly launched *Simplicissimus* magazine and he remained with the journal, producing more than 4,000 drawings for this title alone, until it folded in 1944. A specialist in military types, notably Prussian cavalry officers, his books included *Der Leutnant* (1908) and *Von Kadetten zum General* (1908). He died at his home (renovated by the cartoonist Bruno PAUL) in Holzhausen on the Ammersee near Munich on 26 July 1950.

TOWNSEND, FREDERICK HENRY LINTON-JEHNE (1868-1920)

F.H. Townsend was born in London on 26 February 1868. He attended the Lambeth School of Art (1885-9) with Raven HILL and Arthur Rackham and also studied wood-engraving at the City & Guilds of London Institute. While still a student he contributed to *Sunlight* magazine and some of his first illustrations were for the original publication of two of Oscar Wilde's earliest stories, 'Lord Arthur Savile's Crime' and 'The Canterville Ghost' in the *Court & Society Review*. He then began working regularly for the *Illustrated London News* and drew theatre sketches for *Lady's Pictorial*. He also contributed to *Black & White*, *Daily Chronicle*, *Fun*, *Strand*, *Pall Mall Gazette*, *Graphic*, *Pick-Me-Up*, *Sketch*, *Judy* and *Tatler* amongst others. He began drawing for *Punch* in 1896 and became its first-ever art editor (1905-20). He later studied etching under Sir Frank Short RA RI PRE (c. 1913) and was elected ARE in 1915. His first war cartoons appeared during the Boer War and he also illustrated *City of London Imperial Volunteers: Being the Story of the City Imperial Volunteers and Voluntary Regiments of the City of London, 1300-1900* (1900). During World War I he served in the Special Constabulary. One of his best-known cartoons from this period is 'Bravo, Belgium!' (*Punch*, 12 August 1914), published shortly after the declaration of war. It showed a small boy (Belgium) blocking the way to a field and its village behind as Germany, personified as an old man waving a big stick, tries to enter. (George MORROW later redrew it for *Punch* on 12 July 1933 as 'Bravo Austria!', featuring Hitler and Austria.) In 1915 he also drew a spoof of the famous Richard Doyle cover of *Punch* but featuring the Kaiser and a dachshund in place of Mr Punch and Toby (*Punch Almanack for 1916*, December 1915). Some of his wartime *Punch* cartoons were later reproduced in a posthumous book, '*Punch' Drawings by F. H. Townsend* (1921). He was the brother-in-law of Frank REYNOLDS. Townsend died suddenly on a golf course in Hampstead, London, on 11 December 1920 aged fifty-two.

TOWNSHEND, GEORGE 4TH VISCOUNT, 1ST MARQUESS (1724-1807)

George Townshend was born in London on 28 February 1724, the eldest son of the politician, Charles, 3rd Viscount Townshend. His younger brother was Charles Townshend, the chancellor of the exchequer whose taxation measures led to the loss of Britain's colonies in America. In 1741 his parents separated and he was brought up in the family of Prince William Augustus, Duke of Cumberland (George II's second son). In 1743 he volunteered to join the British Army in

F.H. Townsend, *Punch Almanack for 1915*, December 1914

Flanders and in April 1745 became a captain in the 7th Regiment of Dragoons under the Duke of Cumberland. He served under Cumberland at the battles of Dettingen (1743) and Fontenoy (1745) during the War of the Austrian Succession and at Culloden (1746) during the Jacobite Rebellion. In 1747 he became aide-de-camp to Cumberland, was promoted lieutenant-colonel in 1748 but resigned in 1750 and concentrated on politics (he was MP for Norfolk 1747-64). During the Seven Years' War, after the loss of the Mediterranean island of Minorca (a major British naval base) to France in 1756 he attacked Cumberland in the print 'Gloria Mundi' (a mock apotheosis of Cumberland standing on the globe). When Cumberland himself resigned in 1757, Townshend again entered the army. He served as ADC to George II in 1758, and was a brigadier under Wolfe in Canada (assuming command on his death in 1759). He was appointed a general in 1782 and eventually achieved the rank of field marshal. While on active service he made many hundreds of caricatures of military types and others which were published by Darly. Lord Lieutenant of Ireland (1767-72) he was created 1st Marquess Townshend in 1787. Townshend was the first artist to introduce personal caricature into political prints, paving the way for James GILLRAY and others. He also pioneered (with the Darly printsellers) the use of small caricature cards to send through the post and 'transparencies' which revealed figures when held up to the light. He died at his house, Raynham, in Norfolk on 14 September 1807.

TRIER, WALTER (1890-1951)

Walter Trier was born in Prague, Bohemia (then part of the Habsburg Empire) on 25 June 1890, the son of a German-speaking leather-glove manufacturer. He attended the Industrial School of Fine and Applied Arts and the Prague Academy (1905-6) before moving to the Munich Academy (1909) to study under Franz von Stuck, a former cartoonist. The same year (when he was nineteen) his first drawings were published in *Simplicissimus* and *Jugend*. In 1910 he joined the staff of the weekly *Lustige Blätter* and moved to Berlin, also contributing to the *Berliner Illustrierte Zeitung* (1910),

Die Dame (1923) and *Uhu* (1924). During World War I he drew many cartoons against the Allies for *Lustige Blätter* (including covers) and others. To raise funds for the Red Cross he also produced a large colour caricature map of Europe in 1914, with Russia swallowing up the West. He then designed costumes and stage settings for Max Reinhardt (1924), became a member of the Berliner Sezession group (1926) and began to illustrate Erich Kästner's children's books (fifteen titles 1929-51), the first of which (*Emil and the Detectives*, 1928) quickly became a classic. After the burning of 'subversive' literature in Berlin, including books illustrated by Trier, he moved to London in December 1936, beginning his long association as cover artist and cartoonist for *Lilliput* (1937-49). From the first issue he produced 147 cover designs for the monthly featuring his familiar couple and their black Scottie dog, often in war situations. During World War II he also produced political cartoons for the London-based German weekly *Die Zeitung* (1941-5), as well as for *Life* and the *New York Times*, and illustrated Elinor Mordaunt's *Blitz Kids* (1941) and John Betjeman's books column in the *Daily Herald* (1944). After the war he was commissioned to produce egg-shell caricatures of delegates to the United Nations Organisation (1945) and contributed to *Illustrated*. He emigrated to Toronto, Canada, in 1947 and designed advertisements for Canada Packers Ltd (one of Canada's largest food processors), Imperial Life Insurance and others. He also contributed caricatures to *Saturday Night Magazine*, covers for *New Liberty* and designed Christmas cards for William Coutts. He died near Collingwood, Canada, on 8 July 1951.

'TRUBSHAW' – see Fenwick, Ian

'THE TWO TYPES' – see Philpin Jones, William John

'UP FRONT' – see Mauldin, William Henry

UPTTON, CLIVE (1911-2006)

Clive Uptton was born in Highbury, London, on 12 March 1911, the son of Clive William Upton [*sic*], a touch-up artist for Swain's engravers who later worked for the *Daily Mail*. At the age of sixteen he studied at Southend Art School and (at nineteen) the Central School of Art in London (he later also studied at Heatherley's). An illustrator for *Strand Magazine*, *Tit-Bits*, *Tatler*, *Radio Times*, *Sphere* (including covers), *John Bull* (including covers) and others, he also produced advertisements, designed book jackets and drew illustrations for UK and US publishers. In 1939 he unsuccessfully applied for POY's old job as political cartoonist on the *Daily Mail* (Uptton's friend Leslie ILLINGWORTH was taken on instead). During World War II, he was political cartoonist on the *Daily Sketch* and *Sunday Graphic* (1939-42) and also supplied cartoons to *Tripoli Times* (1943), the Greek national weekly *Hellas* (1943) and drawings (including covers) to *Neptune* (the Merchant Navy magazine). Some of his best-known wartime cartoons were 'The Generous Friend' (*Daily Sketch*, 15 March 1940) about the Russo-Finnish War and occupying most of the front page, and 'Back to the Wall' (*Daily Sketch*, 1 November 1940) about the defence of Greece. His whole-page *Sunday Graphic* cartoons include 'The Will to Win' (9 June 1940) and 'We Kneel Only to Thee' (c.1940), the latter of which was also reproduced widely as a poster.

He later worked for the Ministry of Information and National Savings Committee, producing propaganda drawings, paintings and posters such as 'For a Healthy, Happy Job, Join the Women's Land Army'. Another famous poster was the prophetic D-Day landings six-colour drawing 'This is the Year' (reprinted in the *Sunday Chronicle*, 30 April 1944) issued by the Admiralty and also used by the Ministry of Aircraft Production and the Ministry of Supply. Uptton also served in the Home Guard during the war. He later won prizes for his posters in the National Outdoor Advertising Awards (1958, 1959) and continued to work as a landscape and portrait painter (commissions included portraits of Harold Macmillan and Anthony Eden) and illustrator until 1987 when his eyesight began to fail. He added an extra 't' to his name in the 1930s to differentiate himself from another illustrator called Upton. He died in Holland Park, London, on 11 February 2006.

'VADDING, PRIVATE' – see Zille, Heinrich

VALLOTTON, FÉLIX-EDOUARD 'F.V.' (1865-1925)

Félix-Edouard Vallotton was born in Lausanne, Switzerland, on 28 December 1865. After coming to Paris in 1882 at the age of seventeen to study art at the Académie Julian and the École des Beaux-Arts he decided to remain in the city and became a French citizen in 1900. His first cartoons appeared in *L'Escarmouche* (1893) and *Le Rire* (1894-8) and he also contributed to

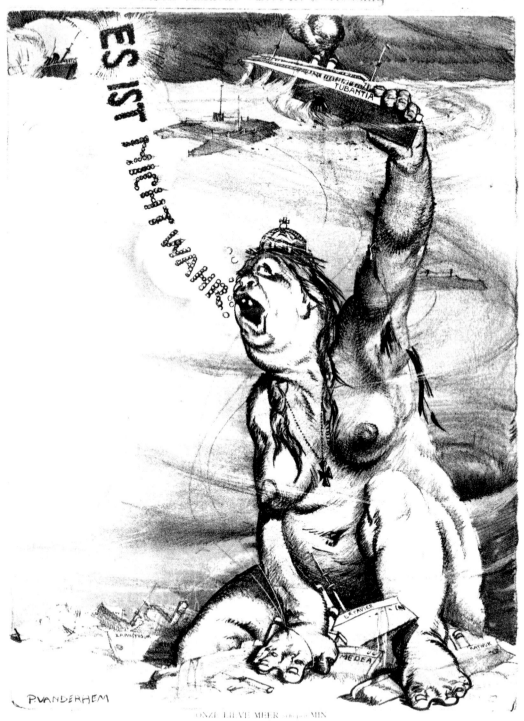

IT IS NOT TRUE

Piet Vanderhem, *De Nieuwe Amsterdammer*, 25 March 1916

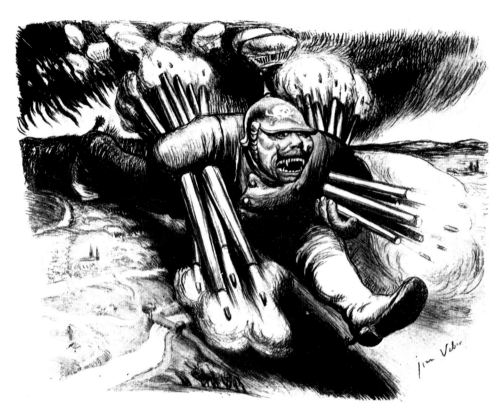

THE BEAST IS UNLEASHED
Jean Veber, 2 August 1914

Le Courrier Français, *Le Sifflet*, *La Revue Blanche*, *Le Cri de Paris* (1897-1902), *Le Canard Sauvage* and *Les Temps Nouveaux* (1900-02) as well as overseas journals such as *The Studio* (UK), *Jugend* and *Pan* (Germany) and *The Chap-Book* (USA). He also contributed to *L'Assiette au Beurre* (1902-03) and is particularly well known for his series of twenty-two lithographs 'Crimes et Châtiments' (Crimes and Punishments) which occupied the entire issue for 1 March 1902. In 1904 he gave up cartooning to concentrate on painting. However, during World War I he drew for *La Grande Guerre* (1914-15) and other publications. He also produced a series of woodcuts 'C'est la Guerre' (1916). He died in Paris on 29 December 1925.

VANDERHEM, PIET (1885-1961)
Piet Vanderhem was born in Wirdum, Friesland, Netherlands, on 9 September 1885, the son of Dirk Vanderhem, a merchant. Orphaned at the age of twelve he was brought up by his uncle and aunt. After studying at the Rijksschool voor Kunstnijverheid (School of Applied Arts) and the Rijksschool van Beeldende Kunsten (Academy of Fine Arts) in Amsterdam he spent a year (1907-08) in Paris. Returning to Amsterdam he worked freelance as an illustrator, book-cover designer and advertising artist and in 1914 began to contribute to *De Nieuwe Amsterdammer*. During World War I he drew some memorable covers for the paper, such as the one for 25 March 1916, in which a monstrous Germania proclaims herself innocent of torpedoing neutral ships while at the same time grabbing another and dragging it to the seabed. He also contributed to *De Kroniek* and from 1926 was political cartoonist on *De Haagsche Post*. He died in The Hague on 24 April 1961.

VEBER, JEAN (1864-1928)
Jean Veber was born in Paris, France, on 13 February 1864, the son of Eugene Veber. After studying with the painter Maillot he attended the École des Beaux-Arts. His first cartoons were published in *Le Mirliton* (1888) but he began drawing in earnest in 1894 when his brother Pierre, a journalist on *Gil Blas Illustré*, in-

vited him to illustrate his articles for the paper. He also contributed to *L'Illustration* (1894-1901), *Le Rire* (1894-1912), *Le Journal* (1895-9), *L'Assiette au Beurre* (from its first issue, 4 April 1901), *Lectures Pour Tous* (1901-9) and others. His attacks on Bismarck as a butcher (1897) and Kaiser Wilhelm II in Turkey (1908) caused considerable controversy, and copies of the special Palestine (1898) issue of *Le Rire* featuring his anti-Kaiser drawings were later air-dropped over the German trenches in World War I. However, he is perhaps best known for his bitter anti-British cartoons depicting concentration camps during the Boer War. These were published as a special issue of *L'Assiette au Beurre* (28 September 1901) entitled 'Les Camps de Reconcentration au Transvaal' and its back cover was 'L'Impudique Albion' ('Shameless Albion') which featured the face of King Edward VII imprinted on the naked bottom of Britannia. The original issue was banned by the French government for jeopardising a mutual defence pact with the UK and later editions had the buttocks covered with a blue petticoat. There were also Dutch and German editions (neither included the offending cartoon) and many of the drawings were reproduced as postcards in French and Dutch. The original French edition (still minus the back-page cartoon) was republished by the Germans in 1915 as a propaganda tool to try and divide the French and British. Veber largely gave up cartooning in 1912 to concentrate on painting and lithography, but drew for *Fantasio* (1915) and other journals during World War I. A notable cartoon from this period was the prophetic 'La Brute est Lâchée' ('The Beast in Unleashed', 2 August 1914), published the day before Germany officially declared war on France and invaded Belgium. He also served in the army during the war, achieving the rank of lieutenant and being awarded the Croix de Guerre and Médaille Militaire. He later also received the Légion d'Honneur. Jean Veber died in Paris on 28 November 1928. His nephew Jean-Pierre Veber (son of his brother Pierre) was also a cartoonist, producing drawings for the French collaborationist journals *Je Suis Partout* (1941-4) and *Notre Combat* (1943) during World War II.

VOLCK, ADALBERT JOHANN 'V.BLADA' (1828-1912)

Born in Augsburg, Germany, Volck emigrated to the USA soon after the 1848 revolution and lived at first in St Louis and Boston before settling in Baltimore, Maryland. After graduating from the Baltimore College of Dental Surgery in 1852, he worked as a dentist in Baltimore. With the outbreak of the American Civil War he began drawing secretly at night as 'V.Blada' (derived from his real name) and became the best known cartoonist of the Confederacy during the conflict. His cartoons were later published as *Confederate War Etchings* (1862-3), which was reprinted in 1917. One of his etchings from 1863 featured Abraham Lincoln as Don Quixote and General Benjamin Butler as Sancho Panza. After the war he returned to dentistry and also worked as a portrait painter. He died in Baltimore on 26 March 1912.

VOLTZ, JOHANN MICHAEL (1784-1858)

Johann Michael Voltz was born in Nördlingen, Swabia, on 16 October 1784, the son of a schoolteacher. He worked at first as a button maker before being apprenticed to an artist in Augsburg (1801-5). He was then employed by an art dealer in the town (1805-8) and in 1809 moved to Nuremberg where he began work for the art publishers Friedrich Campe. This led to many commissions and he eventually produced about 4,000 drawings for fifty-seven publishers in Germany, Switzerland and Holland. Amongst these are more than 100 satires on politics, war and other subjects between 1811 and 1832. These included more than thirty caricatures of Napoleon, the best known of which is 'The Triumph of the Year 1813' (1814) – also known as 'True Portrait of the Conqueror' or the Corpse Head portrait – in which bodies make up the Emperor's face. This may itself have been inspired by the head of King Herod (composed of children's bodies) by Giuseppe Arcimboldo (1527-93). In 1812 Voltz returned to Nördlingen and remained there (except for a period in Ausgburg, 1824-7) for the rest of his life. He died in Nördlingen on 17 April 1858. Four of his children also became artists.

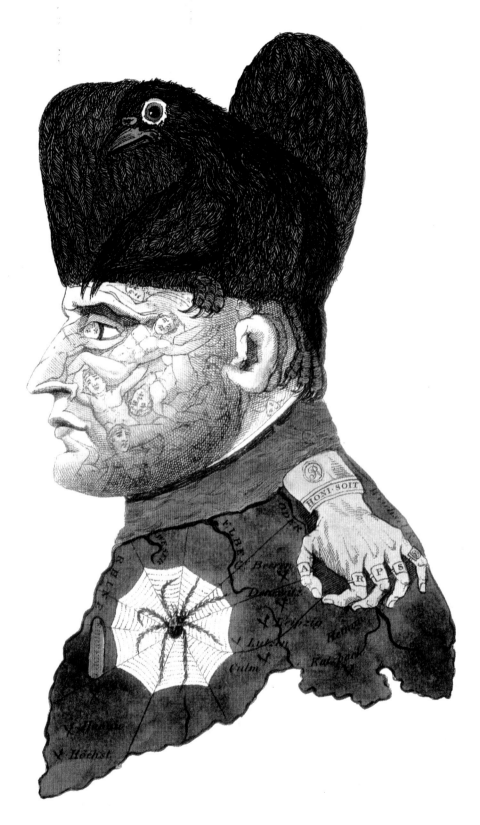

TRUE PORTRAIT OF THE CONQUEROR
Johann Michael Voltz, 1814

WALKER, JACK (fl.1911-24)

Born in the UK, Jack Walker was political cartoonist of the *Daily Graphic* and also contributed to the *Bystander*. Seven volumes of his World War I cartoons were published as *The Daily Graphic Special War Cartoons* (1914-15). He also drew most of the cartoons for *The Daily Graphic Home Rule Cartoons* (1913-14).

WALKER, J.C.
'MARKSMAN' (1892-1981)

J.C.Walker was born in Cardiff, Wales, in September 1892 and was an apprentice in a marine engineering firm at Barry Dock before joining the army aged nineteen. His first cartoons appeared in *Royal Magazine* and *Blighty*. In World War I he served on searchlight duty in France and drew for his regimental paper. After the war he returned to marine engineering as a draughtsman and advertisement designer (1919-24) while freelancing sports cartoons for the *South Wales Evening Express*. He joined the paper as sports and political cartoonist in 1926. During the Italo-Abyssinian war the Italian consul in Cardiff demanded his execution when he portrayed Mussolini as a monkey on the Axis organ. In World War II he served as an instructor of musketry in the Home Guard. He also began contributing to the weekly *News of the World* in 1939 and from 1941 drew the paper's front-page political cartoon as 'Marksman' (he was a Bisley shooting champion). After the war, not wanting to move to London, he gave up working for the *News of the World* to concentrate on the Cardiff-based *South Wales Echo*, *Evening Express* and *Sunday Empire News*. One of Walker's more enduring characters was the jovial 'Mr Fullerjoy', a typical man in the street who wore spectacles through which you couldn't see the eyes. J.C.Walker retired to Barley in Hertfordshire in 1966 and died there on 26 October 1981.

WALKER, WILLIAM HENRY (1871-1938)

William Walker was born in Pittston, Pennsylvania, on 13 February 1871, the son of the Rev. Ira T.Walker. The family moved to Kentucky when he was a child and he studied at the University of Kentucky (1888-9), the University of Rochester (1889-91) and the Art Students' League in New York (1891-3). He began

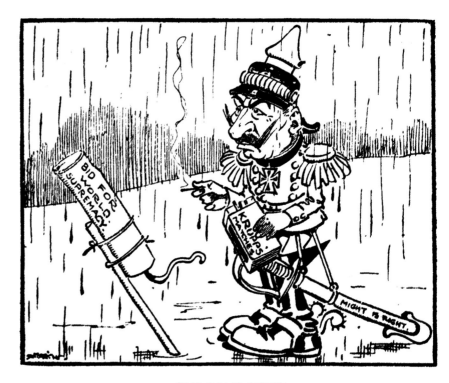

THE DAMP SQUIB
Jack Walker, *The Daily Graphic Special War Cartoons*, No.5 (1915)

contributing to *Life* magazine in 1894 and joined the staff in 1898. One of the few US cartoonists to oppose the Spanish-American War (1898), he became well known for his drawings on the conflict. A later cover cartoon was 'Our Expansive Uncle, But It's Only Temporary' (*Life*, 28 December 1899), showing Uncle Sam dancing with Death. He also produced some powerful drawings in World War I, notably one in 1918 which seemed to predict the coming of World War II 'in twenty years or so'. Walker retired from *Life* in 1924 to concentrate on painting. He died in Flushing, New York, on 18 January 1938. His younger brother A.B.Walker (1878-1947) was also a cartoonist.

WALLGREN, ABIAN ANDERS (1892-1948)

Wally Wallgren was born on 4 June 1892 in Philadelphia, the son of Abian Wallgren. He worked for the *Philadelphia Public Ledger* and *Washington Post* in the 1910s and during World War I served with the 1st Division, Fifth Marines, of the American Expeditionary Force. While on detachment for *Stars and Stripes* in Paris he began his 'Helpful Hints' cartoon series for soldiers which began with 'No.1. Do Not Sneeze into Your Gas Mask' (15 February 1918). Regarded as 'the BAIRNS-FATHER of the American Army' his work was very popular and half a million copies of his collected cartoons, *Wally, His Cartoons of the AEF* (1918), were sold in France. After the war Wallgren returned to the USA and worked for *Home Sector*, *American Legion Weekly* and others. Another book, *The AEF in Cartoons*, was published in 1933 and in October 1938 a new strip cartoon series 'Hoosegow Herman', featuring a similar hapless soldier, was syndicated and continued throughout World War II. He died in Upper Darby, Pennsylvania, on 5 April 1948.

WALTZ, JEAN-JACQUES 'HANSI' (1873-1951)

Jean-Jacques Waltz was born in Colmar, Alsace, on 23 February 1873, two years after Germany annexed the region following the defeat of France in the Franco-Prussian War. He was the son of Jacques André Waltz, an engraver who was later curator of the Museum of Unterlinden. After studying industrial design in Lyons he worked at first as a designer in the textile industry

and in 1908 began drawing popular cartoon postcards making fun of German tourists using the pseudonym 'Hansi' ('Hans' is the German equivalent of 'Jean' and 'I' is for 'Iakob', the German equivalent of 'Jacques'). In 1908 (French edition 1912) he published the best-selling satirical book *Professor Knatschke*, based on his anti-German series for the Mulhouse *L'Express*. He also contributed to *L'Illustration* (1910-18), *Le Matin* (1912-16), *La Grand Guerre* (1915), *Le Pays de France* (1916) and others. His repeated attacks on Germans resulted in him being fined 900 Marks in May 1913. His book *Mon Village* and a special anti-German issue of *Le Sourire* in 1914 also led to his being sentenced to a year in prison. However, he jumped bail and escaped to France. When World War I broke out he served as a corporal in the 152nd Infantry Regiment in the French Army and then as an interpreter officer. He continued to draw many anti-German postcards and designed posters. After the war he published two books of his memories, *Le Paradis Tricolore* (1918) and *L'Alsace Heureuse* (1919) and also (with E.Tennewat) *À Travers les Lignes Ennemis* (1922). Following his father's death in 1923 he succeeded him as curator of the Museum of Unterlinden. In World War II he escaped the Nazis by fleeing to Burgundy but was badly beaten up by the Gestapo in Agen in April 1941 and left for dead. He nonetheless survived and eventually escaped to Lausanne, Switzerland, in 1942. He was awarded the Croix de Guerre in both world wars and also the Légion d'Honneur. Waltz returned to Colmar in 1945 and died there on 10 June 1951.

WARD, SIR LESLIE MATTHEW 'SPY' 'DRAWL' (1851-1922)

Leslie Ward was born in London on 21 November 1851, the son of the painters Edward Matthew Ward RA and Henrietta Mary Ada Ward. He exhibited a bust of his brother and a painting at the Royal Academy when he was sixteen (1867) before studying architecture at the RA Schools (1871). He was then apprenticed to W.P.Frith RA and began contributing caricatures to *Vanity Fair* magazine in March 1873 (aged twenty-two). He subsequently produced more than 1,000 drawings for *Vanity Fair* (nearly half the magazine's entire output) over the next thirty-six

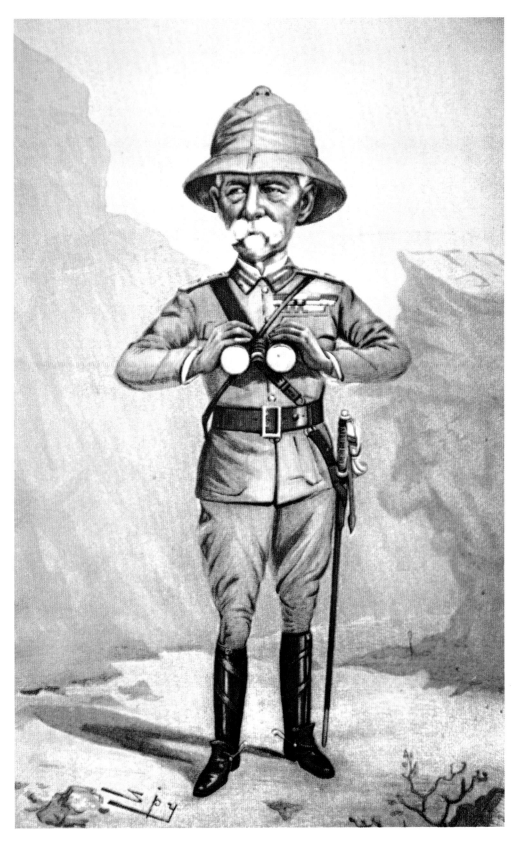

'BOBS' [LORD ROBERTS]
Leslie Ward (Spy), *Vanity Fair*, 21 June 1900

years (1873-1909) under the pseudonyms 'Spy' and 'Drawl' ('L.Ward' in reverse, for those caricatures not taken from life). Amongst these were caricatures of a number of war figures. From the Sudan conflict these include Kitchener ('Khartoum', 23 February 1899) while Boer War figures include Kruger ('Oom Paul', 8 March 1900, signed 'Drawl'), General White ('Ladysmith', 14 June 1900), Lord Roberts ('Bobs', 21 June 1900), General Baden-Powell ('Mafeking', 5 July 1900, signed 'Drawl'), Joseph Chamberlain ('The Colonies', 7 March 1901) and Churchill ('Winston', 27 September 1900), many of which were also produced as postcards. In addition he drew a double-page spread 'A General Group' (29 November 1900) featuring Buller, Roberts, White, Baden-Powell et al. He also worked for the *Graphic*, *Strand* and others. He was knighted in 1918. Leslie Ward died in London on 15 May 1922. His two sisters were also artists.

WEBER, ANDREAS PAUL (1893-1980)

Paul Weber was born in Arnstadt, Thuringia, on 1 November 1893. After studying art at the Kunstgeweberschule in Erfurt he first began producing lithographs in 1911-13. During World War I he served as a railway pioneer on the Russian front for two years and started drawing cartoons for the Tenth Army's newspaper. He began illustrating books in 1920 and in 1925 founded a printing company, Clan Presse. In 1932 he illustrated *Hitler – A German Fate*, an anti-Nazi pamphlet by Ernst Niekisch, who had been prime minister of Bavaria. It sold 50,000 copies before Hitler came to power in January 1933. Weber also contributed to Niekisch's magazine *Widerstand* (Resistance) until it was closed down by the Nazis. Weber was imprisoned from July to December 1937. In 1938 he visited Florida in the USA and in 1939 returned to Germany. By now no longer anti-Nazi, he drew a series of anti-British lithographs, *Britische Bilder* (1941), which were used as propaganda by the Nazis. In the final period of the war he served in the German Army. After the war Weber worked as a book illustrator (he illustrated more than 100 books), lithographer and painter. He died in Mölln, Germany, on 9 November 1980.

WEISZ, VICTOR 'VICKY' (1913-66)

Victor Weisz was born in Berlin on 25 April 1913, the son of Dezso Weisz, a Hungarian jeweller and goldsmith. At the age of eleven he began to take painting lessons and later attended the Berlin Kunstakadamie. On the death (by suicide) of his father in 1928 he began drawing caricatures freelance (his first sale, aged fifteen, was of a German boxer) until he joined the graphics department of *Das 12 Uhr Blatt*. By 1929 he was sports and theatre cartoonist on the paper, signing his work 'V. Weiß'. The same year he also began drawing anti-Nazi cartoons and when the paper was taken over by the Nazis in 1933 he lost his job. By 1935 Vicky had arrived in the UK (he became a British citizen in 1947) and one of his first published drawings was a caricature of Joachim von Ribbentrop, the newly appointed German ambassador (*Daily Telegraph*, 12 August 1936). He also began contributing to the *Evening Standard*, *Sunday Chronicle*, *Punch*, *Sunday Dispatch*, *Daily Mail*, *Daily Mirror* ('Nazi Nuggets' series), *Sketch*, *Lilliput*, *Men Only*, *Tatler*, *Time & Tide* (1936-43), *Daily Express* and others. After an unsuccessful trial to replace Will DYSON on the *Daily Herald*, he joined the staff of the *News Chronicle* on 26 September 1939, shortly after the outbreak of World War II, as its first-ever regular political cartoonist. One of his notable drawings was 'The Smile' (4 December 1942) showing Hitler looking stunned as the head of the Mona Lisa turns into Stalin after the Red Army's success at the Battle of Stalingrad (Leonardo's painting had been looted from the Louvre by the Nazis). A number of his wartime *News Chronicle* cartoons were published in a book, *Drawn by Vicky* (1944). He also drew wartime propaganda cartoons for *Vrij Nederland*. Vicky continued to work for the *News Chronicle* after the war but when the editor Gerald Barry left he moved to the *Daily Mirror* (1954) and the weekly *New Statesman*. In 1958 he joined the *Evening Standard* where he produced his most memorable creation, 'Supermac'. Intended to ridicule Prime Minister Harold Macmillan as an ageing Superman, it somehow developed into an endearing image. Victor Weisz committed suicide in London on 23 February 1966 at the age of fifty-two.

WERNER, Charles George (1909-97)

Chuck Werner was born in Marshfield, Wisconsin, on 23 March 1909, the son of George J.Werner. A self-taught artist, he studied at Oklahoma City University, and began work as an artist-photographer on the *Springfield Leader and Press* in Springfield, Missouri, in 1930. In 1935 he moved to the *Daily Oklahoman*, becoming editorial cartoonist in 1937 and drawing 'The Next Bite' (25 February 1938) showing a map of Germany and Austria transformed into the head of Hitler about to bite Czechoslovakia. He was awarded the 1939 Pulitzer Prize for 'Nomination for 1938' (*Daily Oklahoman*, 6 October 1938) which predicted the fate of Czechoslovakia as a result of appeasement. It showed the Nobel Peace Prize certificate lying on a tomb marked 'Grave of Czecho-Slovakia 1919-1938'. Werner was then twenty-nine years old, the youngest ever cartoonist to win the award (but see also Bill MAULDIN). In 1941 he left for the *Chicago Sun* and moved to the *Indianapolis Star* in 1947, retiring in 1994. He died on 1 July 1997.

'WHAT A WAR!' – see Wilkinson, Gilbert

WHITE, Cecil John 'unk white' (1900-86)

Unk White was born in Auckland, New Zealand, and emigrated to Sydney in 1922. He began freelancing for the *Sydney Bulletin*, *Melbourne Punch*, *Smith's Weekly*, *Pix* magazine and other publications. While in Europe (c.1927-30) he studied art briefly in Paris and worked in London for such journals as the *Tatler*, *Bystander* and *Sketch*. He then returned to Australia, working freelance again, mostly for the *Sydney Bulletin*. During World War II he drew many cartoons about 'Diggers' (Australian soldiers) and published a number of wartime collections of these, including *You'll Die Laughing* (1941), *Diggers* (1943), *The Aussies Are Here* (1943), *Unk White's Giggles* (1943) and *Unk White's Laugh Parade* (1944). He was also accredited as an official war artist in 1944 and went to New Guinea to draw for the Royal Australian Air Force. After the war he continued to work as a cartoonist but also drew illustrations for the 'Rigby Sketchbook' series. He died in Sydney in March 1986.

WHITELAW, George Alexander (1887-1957)

George Whitelaw was born on 22 June 1887 in Kirkintilloch, Dunbartonshire, Scotland, the son of Dr William Whitelaw, medical officer of health for the Kirkintilloch District. He studied at Glasgow School of Art for a year and first contributed drawings to *Boy's Own Paper*, *Chums* and *Captain* before beginning work as artist/cartoonist on the *Glasgow Evening News* at the age of seventeen. In 1915 he came to London as political cartoonist for the *Passing Show* and after service in World War I (working on camouflage in the Tank Corps) returned there in 1919. He began regularly producing theatre drawings for *Punch* (c.1930), drew celebrity caricatures for the *London Mail* and also contributed to *John Bull* (including covers, caricatures and political cartoons), *London Opinion*, *Bystander* and others. He succeeded Will DYSON as political cartoonist on the *Daily Herald* (1938-49) and drew some powerful cartoons for the paper during World War II. He died on 19 September 1957.

WILKE, Erich (1879-1936)

Born in Braunschweig, Bavaria, the younger brother of Rudolf WILKE, Erich Wilke drew cartoons for *Jugend*, *Simplicissimus* and *Lustige Blätter*. Amongst his World War I drawings was 'Alone Against the World' (*Jugend*, 28 April 1917), showing a German soldier facing a huge globe monster with crab-like claws advancing towards him. He died in Munich in 1936. His older brother Hermann (1876-1950) was also an artist.

WILKE, Rudolf (1873-1908)

Rudolf Wilke was born in Braunschweig, Bavaria, on 27 October 1873 and studied in Munich and at the Académie Julian in Paris in the 1890s. He later became a friend of Bruno PAUL, with whom he shared a studio. When the Munich journal *Jugend* was founded in 1896 Wilke became one its first contributors and he also drew for *Simplicissimus* from 1899. He produced a number of anti-British cartoons during the Boer War, notably 'Morgenbesuch' (Morning Visit, *Der Burenkrieg*, 1901) showing a drunken Prince of Wales (later Edward VII) receiving the news of the Boer General Cronje's capitulation at Paardeberg. His younger brothers Hermann

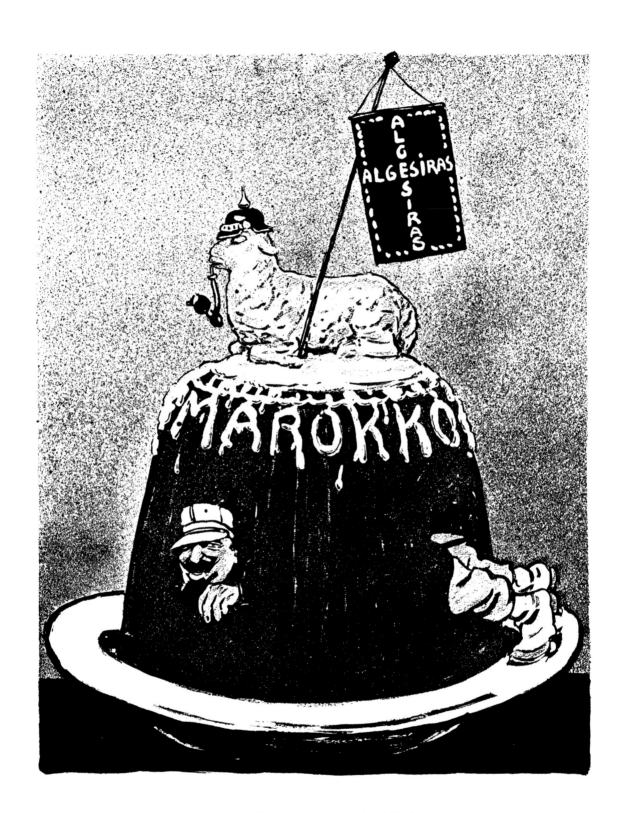

Erich Wilke, *Jugend* (Munich), 1908

(1876-1950) and Erich WILKE were also artists. Rudolf Wilke died suddenly in Braunschweig on 4 November 1908.

WILKINSON, GILBERT
(1891-1965)

Gilbert Wilkinson was born in Liverpool in October 1891, and studied at Liverpool Art School for a year. He then moved with his family to London and studied at the Bolt Court Art School and in the evenings at Camberwell and the City & Guilds Art School before becoming apprenticed to colour printers Nathaniel Lloyd for seven years. Greatly influenced by the work of Arthur MORELAND of the *Morning Leader*, Wilkinson had his first drawings accepted by the paper when he was still at Lloyd's and later deputised for Moreland when he was ill. He also began contributing cartoons to *London Opinion* and others. In World War I he served in the London Scottish Regiment (1915-19), attaining the rank of lance-corporal, and after the war returned to *London Opinion* and drew colour covers for *Passing Show* for thirteen years (1921-34) until it merged with *Illustrated*. He also contributed to *Strand Magazine*, *Punch*, *John Bull* (including covers), *Judge*, *Saturday Evening Post* and others and even turned down a staff job on *Life* magazine. Perhaps his most memorable creation was the daily topical sequence 'What a War!', featuring characters such as Ruby Rumour and Gertie Gestapo, which appeared in the *Daily Herald* during World War II and was also published in book form (*What a War!*, 1942, 1944). The series continued in peacetime as 'What a Life!' and later transferred to the *Sun* on the *Herald*'s demise in 1964. Other wartime features by Wilkinson included 'Mop and Dust, the War Office Chars' for *Illustrated*. Gilbert Wilkinson died in Pinner, Middlesex, on 10 June 1965.

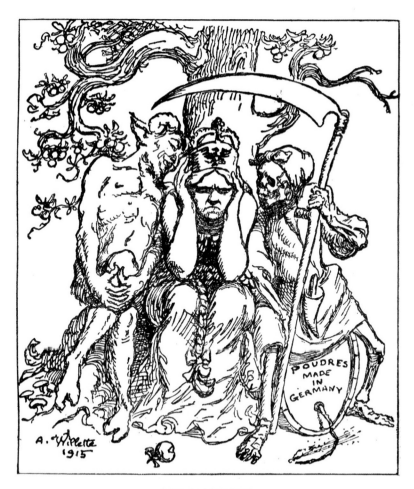

MELANCHOLIA
'But then you are forgetting, pious Germania, that the tree of Knowledge is also the tree of Evil.'
Adolphe Willette, *Le Journal*, 18 May 1915

WILLETTE, ADOLPHE LÉON (1857-1926)

Adolphe Willette was born in Châlons-sur-Marne, France, on 31 July 1857, the son of Colonel Willette, adjutant to General (later Marshal) Bazaine. After studying at the École des Beaux-Arts in Paris he began to contribute cartoons to *Le Figaro* and *L'Evénement Parisien* in 1880. He later drew for *Le Chat Noir* (for which he designed the masthead illustration), *Le Triboulet* (1882-8), *Le Courrier Français* (1884-1907, including Boer War covers), *Le Rire* (1894-1926), *Fantasio* (1914-25), *La Baïonnette* (1915-16), *Le Journal* (1915-21), *L'Echo de Paris*, *La Semaine Illustré* (including the entire issues for 6 and 29 December 1901) and *L'Assiette au Beurre* (1901-9). He also worked for the British magazine *Pick-Me-Up* and the German *Simplicissimus* and

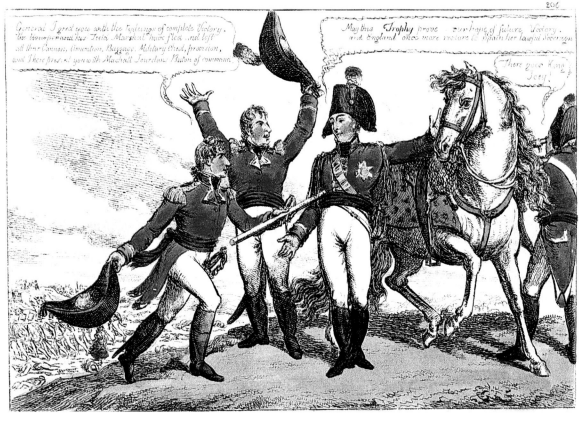

WELLINGTON AND GLORY, OR THE VICTORY OF VITTORIA –
HE CAME, HE SAW, HE CONQUERED
Charles Williams, 1813

founded three short-lived journals: *Le Pierrot* (1888-91), *La Vache Enragée* (1896-7) and *Le Pied de Nez* (1901). He also co-founded, with Théophile STEINLEN, *Les Humoristes*. He drew anti-British cartoons during the Boer War, some of which were reproduced as postcards. One notable postcard, addressed to Tsar Nicholas II (who had sponsored the Hague Peace Conference in 1899 and visited France in 1901), showed Kruger carrying a cross as South Africa burns. It was accompanied by verse pleading with the Tsar to help stop the war. He also drew vehemently anti-German cartoons for *Le Rire Rouge* and others during World War I, having lost two sons in the war. Some of his World War I cartoons were published in a book, *Sans Pardon* (1914-17), whose cover was a drawing of a bloody severed child's hand (one of many atrocities the Germans were accused of). One of his best-known wartime posters was 'Valmy' (1918) alluding to the Battle of Valmy during the

French Revolution, which was used for the French Fourth National War Loan campaign. He was awarded the Légion d'Honneur. Adolphe Willette died in Paris on 4 February 1926.

WILLIAMS, CHARLES 'CHARLES ANSELL' (fl.1797-1830)

The British caricaturist Charles Williams was chief artist for the London print publisher Samuel Fores from c.1799 until 1815, when he was succeeded by George CRUIKSHANK. He drew a number of anti-French cartoons during the Napoleonic Wars and was the first caricaturist to draw the future Duke of Wellington in his print of September 1808, which shows General Wellesley cutting off the pigtail of French General Junot after the British victory at Vimeiro in the Peninsular War. He also drew 'The British Atlas, or John Bull Supporting the Peace Estab-

lishment' (1816) commenting on the burden of the armed forces on the British tax-payer, with Louis XVIII at the top of John Bull's load (supported by British bayonets) and in the distance Napoleon on St Helena guarded by British ships. In addition he illustrated Alfred Thornton's *Post Captain or Adventures of a True British Tar by a Naval Officer* (1817), and two books by John Mitford: *The Adventures of Johnny Newcome in the Navy* (1819) and *My Cousin in the Army, or John Newcome and the Peace Establishment* (1822). He also drew cartoons on the scandal involving the British commander-in-chief, the Duke of York, during the Napoleonic Wars.

WILLIAMS, WILTON (fl.1914-40)

A London-based artist, Wilton Williams worked for *London Opinion* and the *Bystander* in World War I. A number of his wartime cartoons were later published (with those of Bert THOMAS) in a book, *One Hundred War Cartoons from London Opinion* (1919). In the 1920s he designed railway posters, contributed illustrations (often of glamorous women) to various magazines and produced advertising drawings. During World War II he also drew for *Blighty* and others.

'WILLIE AND JOE' –

see Mauldin, William Henry

WILSON, DAVID (1873-1935)

David Wilson was born on 4 July 1873 at Minterburn Manse, Co. Tyrone, Northern Ireland, the son of a clergyman. He was educated at the Royal Belfast Academical Institution and began work for the Northern Bank, Belfast, while attending the local art school in the evenings. He moved to London in 1890, drawing political and joke cartoons for the *Daily Chronicle* (from 1895),

VICTORY!
Wilton Williams, *London Opinion*, 16 November 1918

Magpie (from 1899), and other publications during the Boer War. He also contributed to *Punch* (1900-14), his first cartoon being on the Boer War (6 June 1900). In 1910 he became chief cartoonist on the *Graphic* (1910–16) and also contributed to *Bystander, Fun, Sketch, Strand* and others. Notable Wilson cartoons from the *Passing Show* include 'German "Freedom of the Seas"' (20 May 1916) and the cover for 23 November 1918 ('At Last!') showing St George with the severed head of a dragon labelled 'German Militarism'. In addition he produced propaganda posters during World War I including 'Red Cross or Iron Cross?' (1915), 'Once a German – Always

HOW THE HUN HATES!

THE HUNS CAPTURED SOME OF OUR FISHERMEN IN THE NORTH SEA AND TOOK THEM TO SENNELAGER. THEY CHARGED THEM WITHOUT A SHRED OF EVIDENCE WITH BEING "MINE LAYERS". THEY ORDERED THEM TO BE PUNISHED WITHOUT A TRIAL. THAT PUNISHMENT CONSISTED IN SHAVING ALL THE HAIR OFF ONE SIDE OF THE HEAD AND FACE. THE HUNS THEN MARCHED THEIR VICTIMS THROUGH THE STREETS AND EXPOSED THEM TO THE JEERS OF THE GERMAN POPULACE.

BRITISH SAILORS! LOOK! READ! AND REMEMBER!

HOW THE HUN HATES!
David Wilson, poster c.1915

a German!' (1918, originally published in the December 1917 issue of the *Monthly Record* of the British Empire Union) and 'How the Hun Hates!' (c.1915). He also illustrated Adolphe A.Braun's *Wilhelm the Ruthless, A Verbal and Pictorial Satire* (1917). In the 1930s he taught commercial art at St John's Wood Art School and flower painting in watercolour by correspondence course from his home at 22 Downton Avenue, Tulse Hill, London. He died in London on 2 January 1935.

WINGERT, RICHARD C. (1919-93)
Dick Wingert was born in Cedar Rapids, Iowa, on 15 January 1919, the son of a painter. He studied at the John Herven Art Institute in Indianapolis (1937-40). In February 1941 he joined the 34th Infantry Division of the US Army and was sent to Ireland in 1942. After having some cartoons accepted by the US Army journal *Stars and Stripes* he moved to London. He is best known for his World War II 'Hubert' strip about a sloppy soldier who was allegedly based on Wingert's room mate in London. A collection of the cartoons, *Hubert, Cartoons from 'The Stars and Stripes' US Army Newspaper, by Sgt Dick Wingert*, was published in 1944. The strip continued after the war, syndicated by King Features. He died on 24 November 1993 in Indiana.

WOLPE, WILLI (1904-58)
Willi Wolpe was born in Berlin in 1904, the son of David Wolpe, a leather tanner. He was the younger brother of the composer Stefan Wolpe. After studying at the Bauhaus he began publishing cartoons in various journals. However, his anti-Nazi drawings led to his arrest and imprisonment in 1933. During his incarceration he was tortured and lost the sight of his right eye. He was released nearly three years later and left Germany for Czechoslovakia. When the Germans invaded in 1939 he fled to London, but on the outbreak of World War II was interned on the Isle of Man as an enemy alien. However, by 1941 he had obtained his release and began to work for British and US publications, such as the *Daily Mail*, *Time* and the *New York Herald-Tribune*, signing his work 'Woop' or 'Wooping'. He also drew for, and helped found, the Free French journal *La Marseillaise* (1942-3) and continued to draw for its successors *La Bataille* (1945-9, including covers) and *Le Rouge et Noir*. When its editor moved to Algeria to found *Combat* Wolpe followed and contributed to the magazine (1943-5). Other magazines he worked for in World War II included *Rafales* (1944-5), *Le Clou* (1944-6) and *Le Courrier de Paris* (1945-7). After the war he returned to France to work for *L'Aurore* until 1958. He died in Neuilly, France, in 1958.

WOODWARD, GEORGE MURGATROYD [OR MOUTARD] 'MUSTARD GEORGE' (1760-1809)
George Woodward was the son of William Woodward, a steward at Stanton Hall, Derbyshire. He came to London c.1785 and in 1790 drew a series of six caricatures on 'Symptoms of Drunkenness'. An amateur artist, he had many designs engraved by his friend Thomas ROW-

LONG FACES AT BAYONNE
or King Nap and King Joe in the Dumps
George Woodward, August 1808

LANDSON (and some by Isaac CRUIKSHANK). Especially well known for his 'British Sailor Ashore' series of prints and for such characters as 'General Discontent', his Napoleonic Wars drawings include 'Long Faces at Bayonne or King Nap and King Joe in the Dumps' (August 1808) after Allied successes in Spain. The main illustrator of *Tegg's Caricature Magazine* (1807-9), he also published a number of collections of his work (from 1796). He died at the Brown Bear Hotel in Bow Street, London, allegedly with a glass of brandy in his hand, in November 1809.

WREN, ERNEST ALFRED 'CHRISTOPHER' (1908-82)

Chris Wren ('Chris' was a nickname that stuck) was born in Hampstead, London, on 5 July 1908. He was a descendant of the architect Sir Christopher Wren. After studying at St Martin's School of Art (1922) he worked as a commercial artist with G.S.Royds advertising agency (1926-39). His first aeroplane caricatures were published in *Aeroplane* magazine (1932) and he also contributed illustrations and cartoons to W.E.Johns's *Popular Flying* and *Flight* (signing them 'Christopher'). In 1934 he joined 604 Squadron Royal Auxiliary Air Force as successively a rigger, armourer and (when the RAAF merged with the RAF in 1941) aircraft recognition instructor. He was then Air Recognition Training Officer, Combined Operations (1943-4) and later served in technical intelligence (1944-5), achieving the rank of flight-lieutenant. He is best known for the creation of the 'Oddentifications' series of wartime aeroplane caricatures (with accompanying verses) which were published in the *Aeroplane* at the suggestion of Sir Peter Masefield, then technical editor of the magazine. The first drawing (of a Handley Page Hampden) appeared on 14 March 1941, the last in August 1947, and a book *Oddentifications* was published in 1942. The series was such a success that similar cartoons were drawn by the German and Japanese forces. In addition, models of twelve of the caricature planes created by Wren were later produced by Astral Aero Model Co. He also drew more than 100 caricatures of aircraft for Masefield's *The Aeroplane Spotter* (from 3 April 1941). After the war he was editor of the *Inter-Services Aircraft Recognition Journal* (1945-8), press relations officer of the Society of

British Aircraft Constructors (1946-8) and editor of *Esso Air World* (1963-78). However, he also continued to draw cartoon series for *Aeroplane* such as 'Wrenderings' (from 25 September 1947) and 'Wroundabouts' (from 1948). Sir Peter Masefield later said that, 'The aviation business looks on Chris Wren as being to aviation what David LOW was to politics.' He died on 9 December 1982.

the music of a winged devil who is conducting an orchestra of cannons, machine-guns and other weapons of war on a balcony above. The US government's accusation that the drawing would 'obstruct recruiting and enlistment' was rejected by the court and Young was acquitted. Some of his wartime cartoons were later republished in books. After World War I he founded his own short-lived paper *Good Morning* (May 1919-October 1921). He died in New York on 29 December 1943.

YEFIMOV – see Efimov, Boris

YOUNG, ARTHUR HENRY (1866-1943)

Art Young was born near Orangeville, Illinois, on 14 January 1866. The family moved to Monroe, Wisconsin, when he was one year old. He studied at the Chicago Academy of Design and at the Art Students' League in New York. His first drawings appeared in the *Nimble Nickle* (Chicago) and *Judge* magazine in 1883 and his first jobs were working for the *Chicago Evening Mail* and the *Chicago Daily News* (1884-7). In 1889 he attended the Académie Julian in Paris but ill-health forced him to return before completing his studies. In 1892 he joined the staff of *Chicago Inter-Ocean*. He also contributed to *Puck* and *Life* as well as the British weekly *Pall Mall Budget*. He later became art editor of *The Masses* and contributed to the *Saturday Evening Post*, *Cosmopolitan*, *Nation*, *New Leader*, *Dawn* (an anti-war paper) and others. In 1917 he was arrested under the Espionage Act and stood trial for treason in the USA for his anti-war cartoon 'Having Their Fling' (*The Masses*, September 1917). This showed an editor, a capitalist, a politician and a church minister dancing to

ZEC, PHILIP (1909-83)

Philip Zec was born on 25 December 1909 in London, the son of Simon Zec, a Russian émigré tailor. After attending St Martin's School of Art he set up his own commercial and photographic studio (aged nineteen), working for J.Walter Thompson and other agencies. When Basil Nicholson (creator of the 'night starvation' campaign for Horlicks) joined the *Daily Mirror* as features editor in 1937 he invited Zec to be political cartoonist for the paper (1937-54). Zec's most notorious cartoon, 'The Price of Petrol Has Been Increased by One Penny – Official' (5 March 1942), depicted a torpedoed sailor clinging to a raft and led to a storm of controversy. His original caption, changed by 'Cassandra' (William Connor, who often wrote his captions) had been 'Petrol is Dearer Now' and the drawing was one of a series attacking profiteers. However, to the government it appeared as subversive, unpatriotic and 'Worthy of Goebbels at his best' (Herbert Morrison, then Home Secretary). Questions were raised in the House of Commons and for a time the *Mirror* was under threat of closure. Other notable cartoons were

Heinrich Zille, detail from cover of *Vadding in Frankreich*, Book II (Berlin, 1915)

his VE-Day drawing 'Here You Are! Don't Lose it Again' (8 May 1945) – which was reproduced over the entire front page of the *Daily Mirror* on 5 July 1945 prior to the General Election – and ' "Hitler is Spending Christmas With His Friends" – Official' (22 December 1939), showing Hitler at an empty dinner table laid for twelve, which was attacked in the *Volkische Beobachter*. Another drawing, 'Ain't it Grand to be Blooming Well Dead' (18 October 1939), using the title of a popular song and showing a happy sailor from HMS *Ark Royal* which Nazi propaganda radio repeatedly claimed had been sunk, was unfortunately published just after the ship had indeed been sunk. Zec also illustrated two wartime children's books by E.F.Herbert: *Wimpy the Wellington* (1942) and *Blossom the Brave Balloon* (n.d.). After the war he became head of the strip-cartoon department and a director of the *Daily Mirror*, and succeeded Hugh Cudlipp as editor of the *Sunday Pictorial* (1950-52). He later moved to the *Daily Herald* as political cartoonist (1958-61). In addition he was a director of the *Jewish Chronicle* for twenty-five years and editor of *New Europe*. Philip Zec died in London on 14 July 1983. His brother Donald Zec was

a distinguished film journalist.

ZILLE, HEINRICH (1858-1929)

Heinrich Zille was born in Radeburg, Dresden, on 10 January 1858, the son of Johann Traugott Zille, a watchmaker and goldsmith. In 1867 the family moved to Berlin to escape debt collectors. Here Zille studied art at the Königlichen Kunstschule. After graduating he drew fashion designs and produced other commercial and advertising work while also studying at the lithographers Winckelmann & Söhne. From 1880 to 1882 he spent his military service as a grenadier and as a guard at Sonnenburg Prison. At the turn of the century he was contributing drawings to *Simplicissimus*, *Jugend*, *Münchener Illustrierte*, *Wochenschrift*, *Lustige Blätter* and other publications, becoming especially well known for his drawings of Berlin street life. During World War I he produced a series of cartoons for *Ulk* featuring 'Private Vadding' which were later published as books, *Vadding in Frankreich* (books I and II) and *Vadding in Ost und West* (1915-16). He died in Berlin on 9 August 1929.

INDEX